JEWISH WOMEN

JEWISH WOMEN

A WORLD OF TRADITION AND CHANGE

BY

JOAN ROTH

JOLEN PRESS

Dedicated to Shira Lian Roth Gorelick, my granddaughter, born April 7, 1994. To Leonard Sanders, whose friendship and support made this book possible, and to Bryn Cohen for her creativity and enthusiasm, which are a continued source of empowerment.

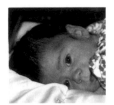

Special thanks to Harriet Lyons, Robert Schirmer, Alan Treitman, Ronnie Horn, Melanie Roth Gorelick, Alison Roth, Nick Curto, Sir Moshe Barr-Nea, Zarina Benun, Randy Daitch, *B'nai B'rith Messenger*, Odette Blumenfeld, Ilona Seifert, Miriam Feldman, Professor Johanna Spector, Anna Mogyorosy, Nadia and Khadija Bourabah, Graphic Lab Inc., the Memorial Foundation for Jewish Culture, United Jewish Appeal National Women's Campaign, Babu Yacob, New York Federation Women's Campaign, Sam and Jean Frankel, Martin Bloch, Mimi Feigelson, Ephriam Isaac, Moses Sharabi, Shlomo Geraffy, Simha Siani, Elijah Jhirad, Richard Campisi, John Stier, Mesfin Ayelegne, Emma and Leonid Lib, Jana and Yuri Dashevsky, Seema Boesky, Sam Daniel, Queenie and Samuel Hallegua, Fiona Hallegua, Ahuva Gold, Bonnie Galinsky, Zipporah Greenberg, Miriamna Gluckstern, Esther Linder, the women of Moshav Modi'im, Emunah Witt, Anna and Jerry Krill, Natasha Singer, *The Foward*, Noreen, Romiel and Lyle Daniel, *News India*, Roberta and Michelle Mahana, *The Jewish Press*, Republic of Yemen Mission to the United Nations, Dina Abramowicz, Susan Starr Sered, Project Kesher and *The Woman in Jewish Law and Tradition* by Michael Kaufman.

Design by Ruder-Finn
Photographic Prints by Sid Kaplan
Printed by Rapoport Printing Corp.
Library of Congress
Cataloging-in-Publication Data
Roth, Joan
Jewish Women *A World of Tradition and Change* / by Joan Roth:
preface by Shoshana Cardin; introduction by Rabbi Susan Schnur
Catalog Card Number 94-74523 Limited Edition 94-93939 Trade
 ISBN 0-942160-11-8; 0-942160-12-6
Copyright © 1995 by Joan Roth
All rights reserved
A Jolen Press book
Published by Sander Tilatitsky Inc.

CONTENTS

PREFACE

BY SHOSHANA CARDIN

Nearly a century ago, Mark Twain wrote a most intriguing essay on Jews and concluded that "All things are mortal but the Jew; all other forces pass, but he remains. What is the secret of his immortality?"

Today, world Jewry wrestles with that not-so-rhetorical question, seeking answers to enable that immortality to continue. Joan Roth has sought to ask the question of Jewish women — women whose lives instruct, reflect and transmit the particularity of Judaism, its beauty and ritual, even as they adapt to change.

In "Jewish Women: A World of Tradition and Change," Joan Roth has given us a photographic celebration of women whose strength of commitment to the ways of their mothers has enabled them to continue their traditions and rituals though they are as different from each other as their societies are different — Bukhara from Ethiopia, India from Israel. The common denominator is their Jewishness, not in physiognomy but in spirit, not in name but in deed, reflecting the universality, as well as particularity, of Judaism.

Roth is more than a photographer; she is a biographer, a commentator on society, and a poet. Her visual images are her story; poignant and captivating lyrical, visual poems, stories of women whose faces and lives reflect melodies remembered, rituals to be learned, traditions

recalled, as handed down from mother to daughter to granddaughter.

Through Roth's sensitivity and artistry, we join with her, meeting and visiting with women whose lives mirror ours, in celebrations, life passages, joy and sorrow. Each, in her unique fashion, has relived our tradition and influenced her family to be Jewish, to perpetuate our shared heritage.

This remarkable and unique photographic odyssey, reflecting the diversity among Jews in the 20th century, is a celebration of Jewish sisterhood. Engaged in traditional rituals, these women represent both the past and the future, determined to maintain Jewishness, while adapting to the customs and mores of their contemporary societies. Roth's powerful images create an almost three-dimensional experience, an intriguing invitation to see more and learn more about our partners in shared history and heritage.

It is because of such Jewish women, beautifully depicted in this epic photographic tribute by Joan Roth, that future generations will continue to ponder the enigmatic immortality of the Jew.

INTRODUCTION

BY RABBI SUSAN SCHNUR, *LILITH* MAGAZINE

I first met Joan Roth in 1991 when she fell into our *Lilith* editorial offices on 57th Street looking for all the world like a photograph from one of her own well-known exhibits: that of Manhattan bag ladies. Dwarfed by no less than six shopping bags and giving the impression of having some oddly rich inner life, she was soon cozying every surface in our office—every sill, chair, radiator—with photographs of Jewish women. "Here's a beautiful bride in Kiev," she swooned. "I fell in love with this Holocaust survivor at a nursing home in Budapest." "Do you believe this woman? I cherish her—I met her on a mountaintop in Yemen." "Oh, this is the adorable caterer of Bukhara." "Don't you just love this amazing Moroccan face?" Roth's obvious photographic skill, and her deep human warmth, transfixed all of us. In a world where strategic Madison Avenue packaging often substitutes for meaningful content, Roth's presence was a stunning breach.

Roth's creed is personalism—an understanding that we find ourselves through others, and others through ourselves. Roth calls it (borrowing from the Hasidim) *mochin degadlus*—each of us a bud on a shimmering tree of life whose roots get watered in heaven.

Walter Benjamin used to explain what he called "two categories of great storytellers." Spawned from either seafarers or peasants, the former would tell of faraway places, while the lat-

ter would tell of the past—known only to the most refractory of locals. Roth's "stories," one might say, unite both traditions: She travels far from home in order to "hear" her narratives, but she is rendered mute until she tills them in familial soil.

Joan Roth tells me early on, "If I was good with words, I wouldn't have to take all these photographs." What follows in quotes is a conflation of conversations I've had with her over the years: our joint attempt to explain what prompts her to pick up her Leica, what moves her to adore Jewish women the world over.

"In the last 12 years, I've gone on some 40 trips to Jewish communities in Ethiopia, Yemen, Israel, Morocco, India, Bukhara, Ukraine, Hungary, Romania and Bulgaria. My purpose is always to photograph Jewish women.

"I almost always travel alone, though on occasion I travel with a translator. Once in a while I have a benefactor, but usually I take on small jobs back in New York to subsidize my shoestring trips.

"The scariest thing, traveling alone, is feeling safe. But I was given courage long ago by an extraordinary photography teacher of mine, Lisette Model. She told me, 'Darling, if you don't wake up and SEE, you're going to miss your whole life.' When I'm feeling shy and fearful about traveling, I think of Lisette saying, 'It's easier to do something than to try to do something.'

"Most photographers have their itineraries all planned, but I never know ahead of time what I'm going to do, who I'll meet, whether I'll even meet any Jews. If I do meet Jews, will they be receptive to me or rejecting? How will they perceive me as a woman traveling alone? I like to stay totally naive of the communities I'm visiting, ignorant of their politics, of their communal structure, because this way I get images that are fresh to my eye; I learn from the women I photograph, not the other way around.

"In Bukhara, the women said their husbands would never let them travel alone. I think I inspire women when they see me, a plain, low-budget, 52-year-old woman on her own. Often I have to ask Jewish men for permission to photograph. In Yemen, the men asked me, 'Why do you want to photograph our wives, and not us?' In Samarkand, the men were also puzzled—why didn't I photograph people, instead of women?

"My children, two daughters, are grown now. I started my traveling once they left for college. It would have been nice to have started this career earlier, but… what can I say? So I had to learn my craft the old way, by apprenticing here and there, finding one remarkable teacher, and then another. Slowly, I started seeing more and more with my camera. I noticed women living on the street, it was like they had dropped from the sky.

"I was always (needless to say) interested in women's issues, so my first project, in the early

'70s, was an exhibit and a book called 'Shopping Bag Ladies of New York.' Over the course of eight years, I got to know many women. I prepared a watershed report on homeless women for the Manhattan Bowery Project—my work was really the start of consciousness around the issue of homelessness.

"After photographing the women's movement for many years, my Jewishness began to rekindle. I had met the late Rabbi Shlomo Carlebach, and, because of him, had started to study Jewish texts, to observe Judaism again. (His spiritual teachings, in fact, inspired me to do this book.) In 1983, at a Shabbat dinner with Shlomo, I heard about the plight of Ethiopian Jews and I said, 'I have to go there.' It seemed like a chance to go back into biblical times visually. The woman sitting next to me said, 'I know how you can do it,' and she connected me with some people on a rescue mission.

"One day in Ethiopia these strangers, Jewish men and women, came running down this mountain to greet me and others. And this woman, Abeba, she puts her arms around me, gives me a kiss, then says in English, 'My sister. My sister,' with a kind of conclusive simplicity. I almost fainted. She captured my heart forever.

"She took me by the hand into her *tukul* (hut) and showed me her laundry, her bedroom. Then she started to nurse. I had no idea one day this would be such a beautiful photo. I was only

thinking of Abeba, 'How beautiful you are.' Here is this woman! What breathtaking strength and beauty."

ॐ

A profound dividend of getting older is that there eventually comes a time—in our forties, fifties, sixties—when we can at last invite into our lives all of our influences. For Roth, these influences include numerous people. Her professional gurus are most specifically Lisette Model and the master printer and photographer to whom she apprenticed for seven years, Sid Kaplan ("his darkroom has magic walls"). Roth also feels "taught" by the long-term loan of thousands of women's faces, borrowed on acetate. This last decade, she says, has been—finally—a gratifying artistic time of actualizing mentors' values, of making one's peace, and of repatriating much love.

"I recently took a photograph of a Berber woman making *challah*. She spoke only Arabic; I spoke only English (I usually can't talk to the women I photograph). But I knew she was honored to have me in her beautiful home, as I was honored (despite the bad lighting for photos) to witness her important *challah*-making. Every moment in life is important—we both understood that the other understood this, and this made for an incredible bond. We were embracing each other, you might say, through the medium of camera and *challah*. We were speaking clearly to

each other: 'Your task matters to me. Your life gives meaning to my life.'

"When I first saw the photographs I took of this incredible woman, I felt oddly connected to my grandfather. He had been an embarrassment to me when I was a child—the last Black Hat in the neighborhood. He spoke no English; I spoke no Yiddish. He was so religious that when he was 100 and couldn't walk to synagogue anymore on the Sabbath, the rabbi gave him a cot in the basement. I remember a bed and *Zeide* sitting on it, and my girlfriends making fun of him: they didn't realize he was my grandfather, all he was was a little old Jewish man in these clothes, so typical!

"Every Passover we had to go to a mineral springs in Mt. Clemens, Michigan. And we would stay at this hotel—the smell was terrible from the minerals—and *Zeide* would lead the *seder* from a porch area, three or four rooms filled with tables. And I never understood a word. Endless *seders*. I certainly wasn't interested in understanding any of it—all I wished was that it didn't exist. Why were we the only family? My girlfriends all went to Florida for *Pesach*.

"And so I'm in this *challah*-world with this beautiful Berber woman, and it's like I'm finally talking to my grandfather—the camera was like I had learned Yiddish; I could finally talk to *Zeide*. Though I disliked all these religious things we had to do because of *Zeide*, there was also some-thing so special about having to do them.

"One of the reasons I choose to travel is that I have all these stereotypes in my head that I want to get rid of. Like, 'An Indian woman IS …' and then I go to that place and it's not what I imagined at all. It's just another woman—with all these qualities that are more incredible than I ever could have dreamed. What I try to capture in these exotic women is not their exoticism, but something beyond that. They have to make this pottery, they have to live in these huts, but under-neath: they're me.

"In Yemen, a woman comes up to me one day in the marketplace, and immediately I realize she empathizes with me. Here I am standing there feeling very alone—terrified. Will someone wel-come me in this community? Crazy me! How am I going to meet anyone?

"And I see this woman approaching me cov-ered head to toe in a *sharshaf*, a whole opaque body veil; she's a black apparition. She takes my hands. She shows me her hands to examine, palms up, then I show her mine. That's all, that's the whole thing.

"Well, I look for this woman for years—every time I go to Yemen: Is this her? Is this her? I was always trying to locate through different veils HER. But I had nothing to go on. I'd never seen a face, I had only a feeling.

"So one day in Israel I enter a Yemenite apart-

ment in an absorption center. Here is this family dressed in semi-Western garb. I notice there's a photograph of me on the wall! A woman comes up and takes my hands. I know right away it's my apparition. We hug and hug, that's the whole story.

"Sometimes, I like the camera because it's wordless—nothing distorts the connection. But sometimes even the camera gets in the way; beyond the camera, even faces get in the way—the real connection is on the other side of all of this.

"My grandmother (on my father's side) died very young. Of what, I don't know. The feeling was: it was tragic, don't ask!, she was young. Mine was a family of 'not knowing.' So I go to Tarascha, this little village my father and his parents came from near Kiev. And this maniac driver who is taking me around runs down the street yelling, 'Anyone Jewish? Anyone Jewish?' I think maybe I'll find a house, a family, a grave, something connected to my grandmother, something with my family name, Altman.

"Well, it turns out this adorable old Jewish woman (a childhood playmate of my father's maybe?) is acquainted with a family named Altman. So she throws on her babushka and bustles me up the road. I spend all afternoon with the Altmans. They take out photos; I take out photos. They take out more photos; I take out more photos. But it's so frustrating—we have nothing to

share but dog-eared scraps from a missing puzzle. Like my Detroit family, these Altmans are also a family of 'not knowing.' Suddenly we realize we share this family trait—'not asking, not knowing.' We take out some schnapps. *Nu*, we're related.

"Of course, I pay homage to my 'Unknown Grandmother' everywhere I go, as well as paying homage to my mother. When I was a child, though my mother always went to synagogue with us on *Shabbos*, I remember her saying, 'I don't have to attend synagogue to feel close to God. Even at home I just open my window and talk to God.'

"My father loved his *Shabbos*—his little family, his little *Shabbos* table—that was enough. Just that we should be well, and he should give everything away. This Sabbath table in the photograph

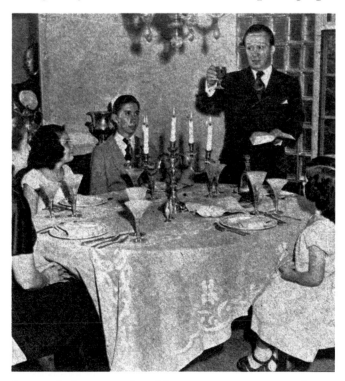

here: it is a work of beauty, courtesy of my mother. Her *Shabbos* tables were altars. This beautiful candelabra, this ornate chandelier, this damask tablecloth , a lacy thing, I don't know

what it is. Lovely dishes, special rose-colored crystal glasses that we used only on *Shabbos*. I thought everything connected to my mother was beautiful, and it was. I see something in this photograph—this silver ice bucket or planter, there were two of them, what happened to them? Well, this is what my parents had in common: *Shabbos*.

"And so I realize as I take pictures of Jewish women — Ethiopian Jewish women sweeping out their huts on Fridays, putting out their fires, making everything immaculate, whole villages of women baking *challah* out of *teff* (grain) using cow-dung fuel, Romanian Jewish women wrapping up their lunches at the kosher food hall, Ahmedabad Jewish women lighting candelabras, Hungarian Jewish women drinking tea on their porches, Pune Jewish women leaving the *mikveh*, white-garbed Jewish women listening to Torah with stones on their heads, Moroccan Jewish women baking 13 *challahs* every week (one for each tribe and one for God), ultra-Orthodox Jewish women sunbathing on Ladies' Beaches, Russian Jewish brides waving flowers at their collective wedding, Bukharan Jewish women twisting cotton wicks for *Shabbos* — all of them are creating shrines of beauty, all of them my mother's *Shabbos* table. These rose-colored glasses of my mother's that we used only on *Shabbos*—what were they for? They were glasses for a queen. But they were just for us."

One recent day in Roth's dining room, as we share some fruit, my eyes fall again on her photographs of the Berber woman making *challah*. "I remember this woman's husband," says Roth. "He couldn't understand why I was taking pictures of his wife. He said to me, 'This is abnormal! Photographing women making *challahs!*'

"You'd think I was photographing secrets of the universe," Roth jokes, and then she becomes totally absorbed, lost in this painstaking photographic print—a woman in the trance of her own creation. "Photographing secrets of the universe," she muses finally, putting the picture down. "I guess I am."

Joan Roth's subjects are never posed, never asked to move this way or that; Roth never switches or dims lighting: "I went to this wedding in Bukhara," she explains, "and when I got there the *chuppah* (canopy) was still folded against the wall. So I think, oh no, if they put the *chuppah* up on this side of the room, I'll have beautiful light; but if they choose that side, the picture will be horrible. I don't want to influence their plans— but I'm sure they'll choose the right spot.

"Well, they choose the terrible spot," she continues, "what could I do. Still—it's a successful picture, because it tells the story of how it was: this particular bride and groom, and all the people! Sometimes you see a person, and no matter what you do, the photo is going to be beautiful. Like this woman I saw marching down the street

in Safed during *Lag B'Omer*—the whole world was on her face."

To Roth, beauty is not something to impose on the cosmos—it is perhaps only something one patents in God's service. Edith Wharton used to talk about "two ways of spreading light: to be the candle or the mirror that reflects it." Joan Roth would call herself the mirror.

Many of the communities that Roth has photographed on these pages no longer exist; others are rapidly disappearing: the Jewish communities of Ethiopia, Yemen, Bukhara, Samarkand, Morocco, the smaller commonwealths of Budapest, Bucharest, Cochin, Bombay, Pune, Ahmedabad. Roth understands that her compulsion to photograph these communities transcends the personal, is indeed a Jewish formulary: *zakhor*—remember the past, especially in a world that neglects it.

We are all of us exiles from the past (and from childhood, too). Judaism as well comprehends that exile is the heart-myth of our people, that exile is Jewish art—a kind of turning and turning of the past that is not duplicative, but is, rather, a creative retranscription, a way to weave meaning into our lives by connecting ourselves up with Before. This is Roth's fundamental accomplishment.

Kierkegaard once explained memory as being "merely a minimal condition." "By means of memory," he wrote, "the experience presents itself to receive the consecration of recollection." That is, recollection involves the integrative task of joining "that" with "this," "then" with "now," "them" with "us." Recollection involves responsibility: both personal and communal.

May we, with Joan Roth, appreciate nostalgia as an indifferent gift. Beyond longing at the Western Wall, may our lodged *petek* (petition) speak to the authentic—continuous and self-actualizing—art of exile (whether in India, America, Israel or Samarkand).

Joan Roth is a poet, not a philosopher, her Leica attentive to flesh and blood, not iconography. Along with the many women who gather together on these pages, she sings with the Hebrew poet Uri Greenberg:

To you philosophers of eternity, one penny;
For the lives of our souls after death,
One penny.

I choose to live as a body, to ache;
The nails on these pink fingers
Matter to me.

more than her own century of experience; the paths of

many women are reflected in her wrinkles. Collective

memories of struggle and suffering, of joy and hope,

form a topography of human accomplishment filled

with haunting but universal secrets. The one face melds

into the many; the many blur into one. Women in

Bukhara, Yemen, Ethiopia, India, Morocco, Eastern

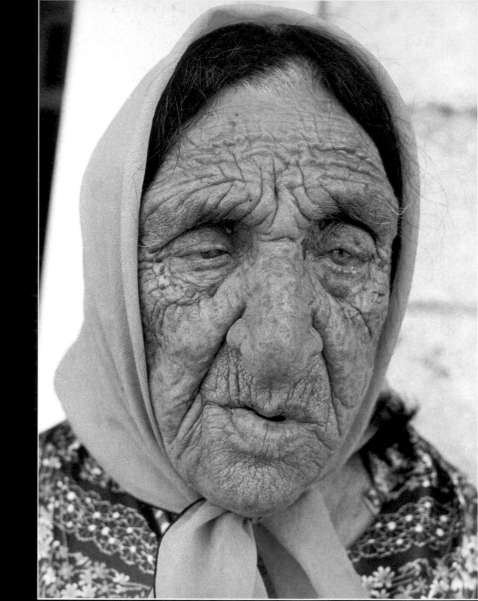

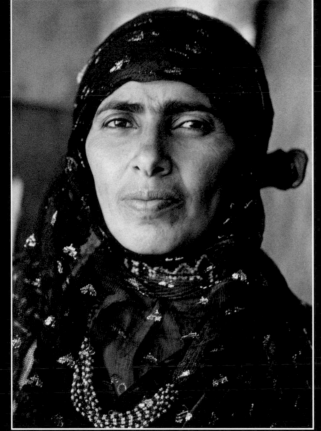
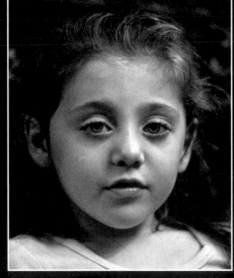
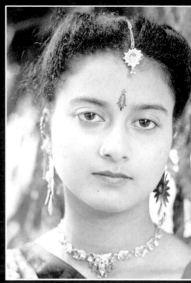

(clockwise from top left)
Saadah, Yemen; Chernovtsy, Ukraine;
Ahmedabad, India; Saadah, Yemen; Vilna,
Lithuania; Waleka, Ethiopia; Bukhara; (center)
Uman, Ukraine; Jerusalem.

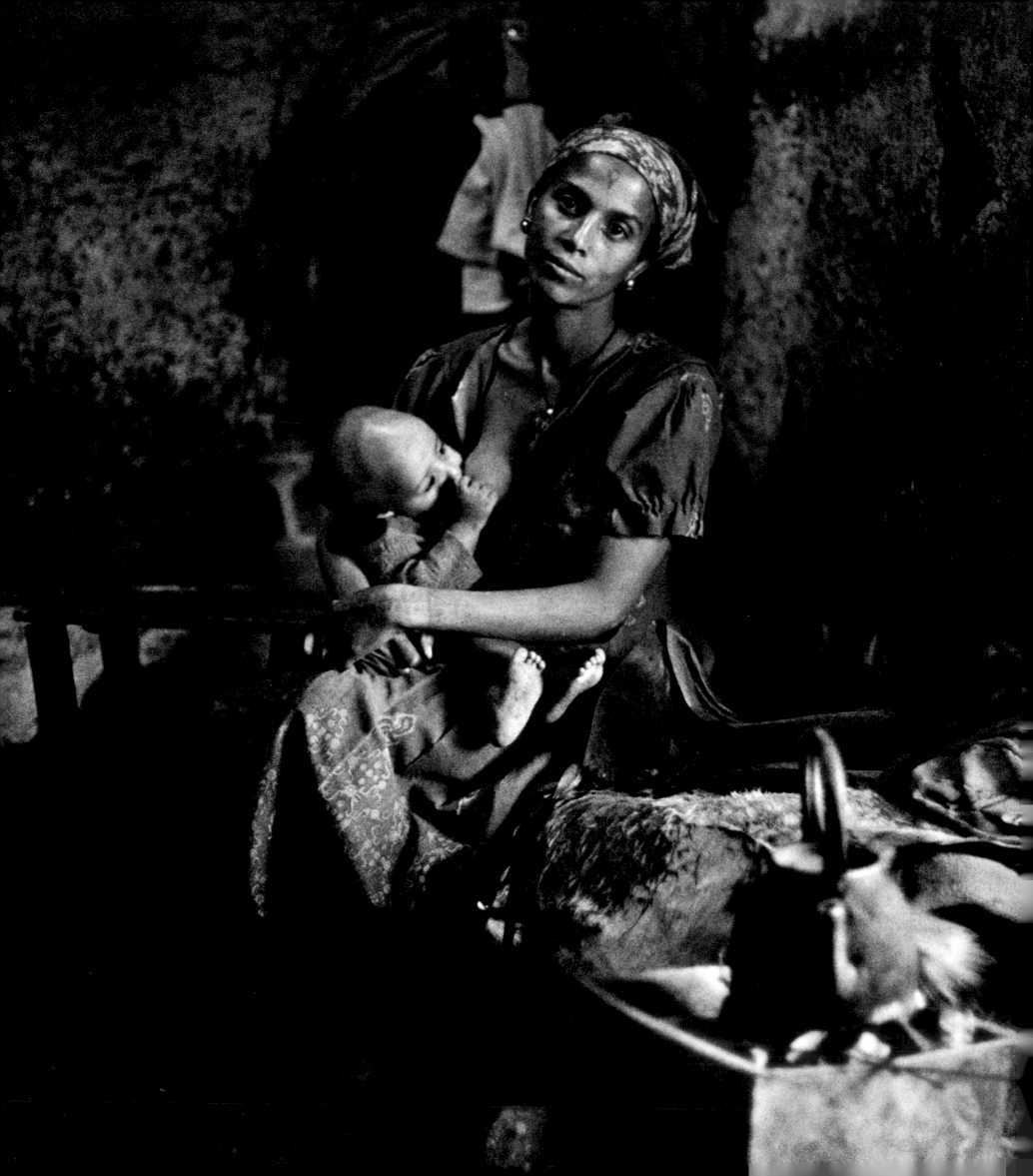

ETHIOPIA

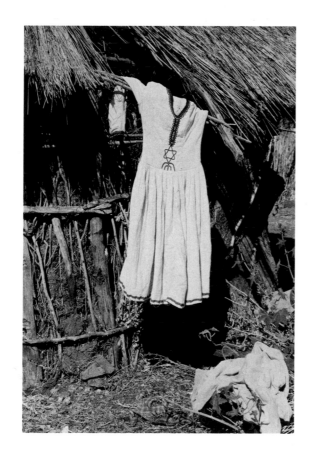

The extraordinary beauty of Abeba Abebe (facing page), nursing her fifth child, evokes the lineage of the biblical Ruth and the Queen of Sheba, the great matriarchs from whom she descends. ❧ The story of Ruth has a prominent place in Torah and Ethiopian culture, since the messianic prophecy will be fulfilled through her. A Moabite woman, Ruth followed Naomi to Israel saying, "Your people shall be my people, and your God my God." ❧ Sheba, too, embraced the God of Israel and bore Solomon, King of Israel and great-great grandson of Ruth, a son. Menelik I grew up in his father's court, then returned to Ethiopia as the first Jewish king.

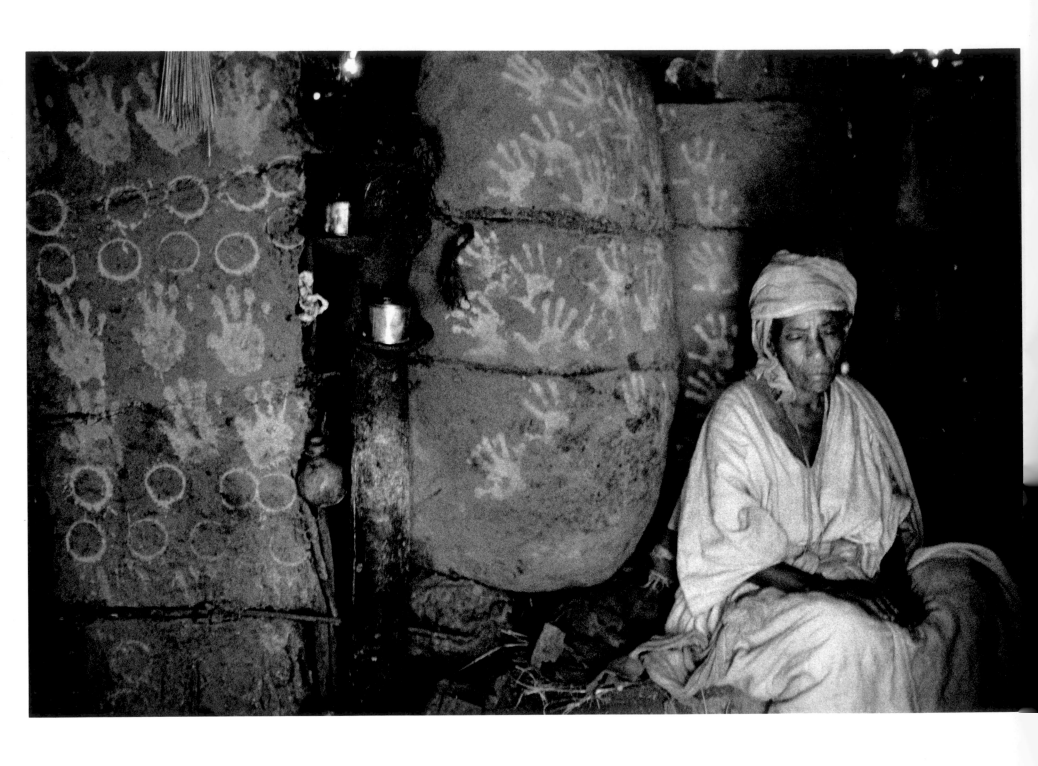

Imprints of open hands and circles on this woman's earthen storage bins symbolize the blessing and protection of the *qes* (priest).

(previous page) A dress embroidered with the star of David dries on the roof of a *tukul* (hut).

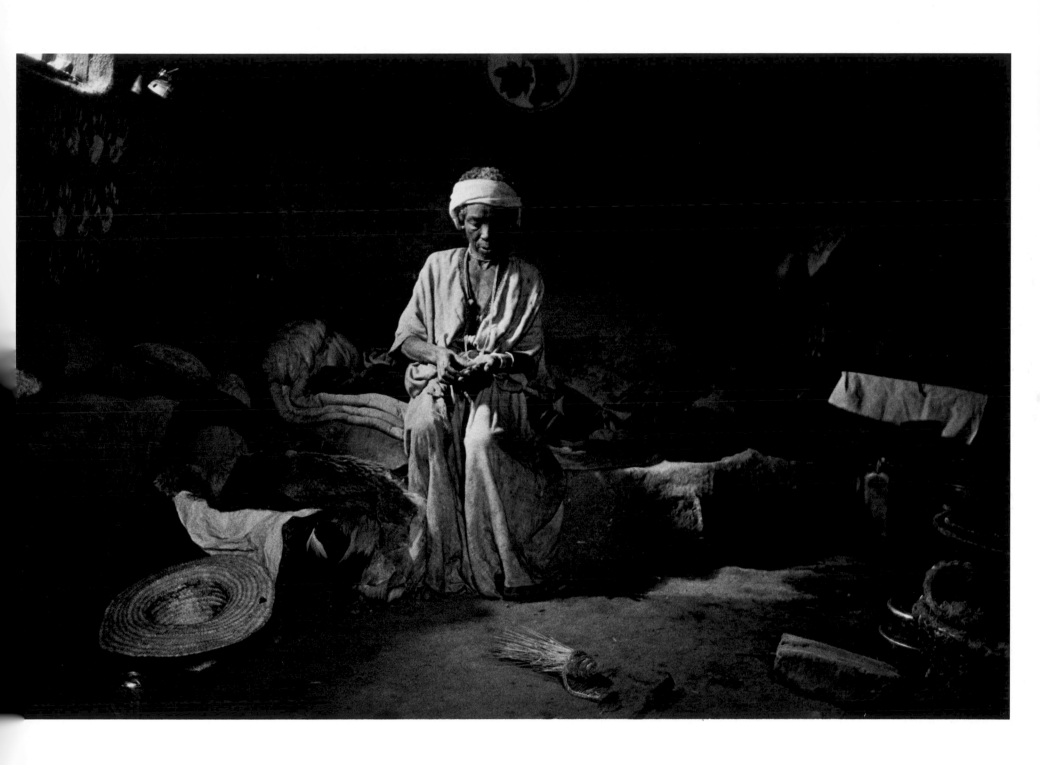

As a faint light filters through her window, a potter molds an earthen water jug while sitting on a mud sofa in her living room.

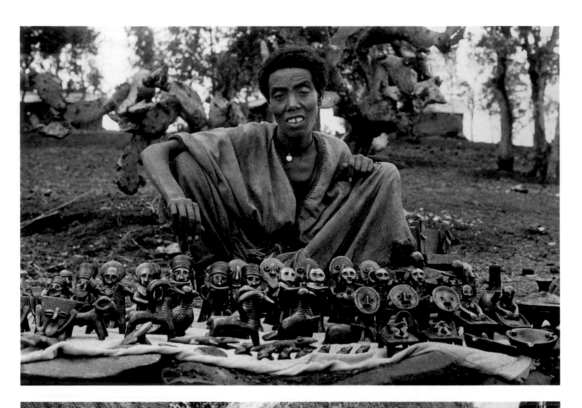

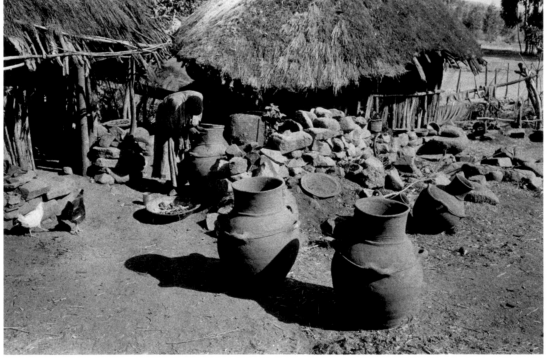

(top) A woman sells statues depicting daily life and traditional themes.

(bottom) Earthen pots are sculpted in the sun.

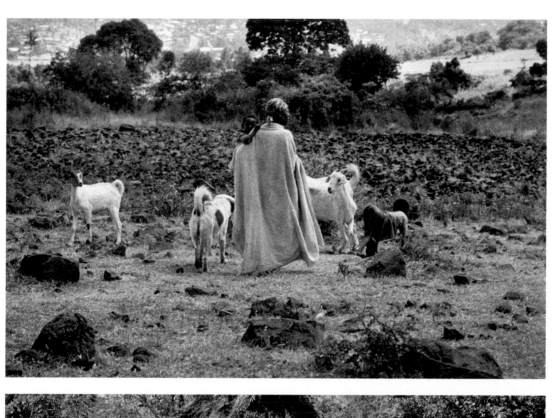

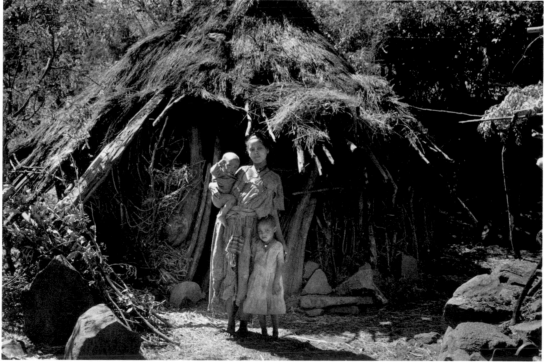

(top) A mother herds sheep with her two sons, one sadly crippled by polio.

(bottom) Children visit their mother outside the menstrual hut.

After a woman gives birth, she moves into a maternity hut where she stays
forty-four days with a boy, eighty-eight with a girl.

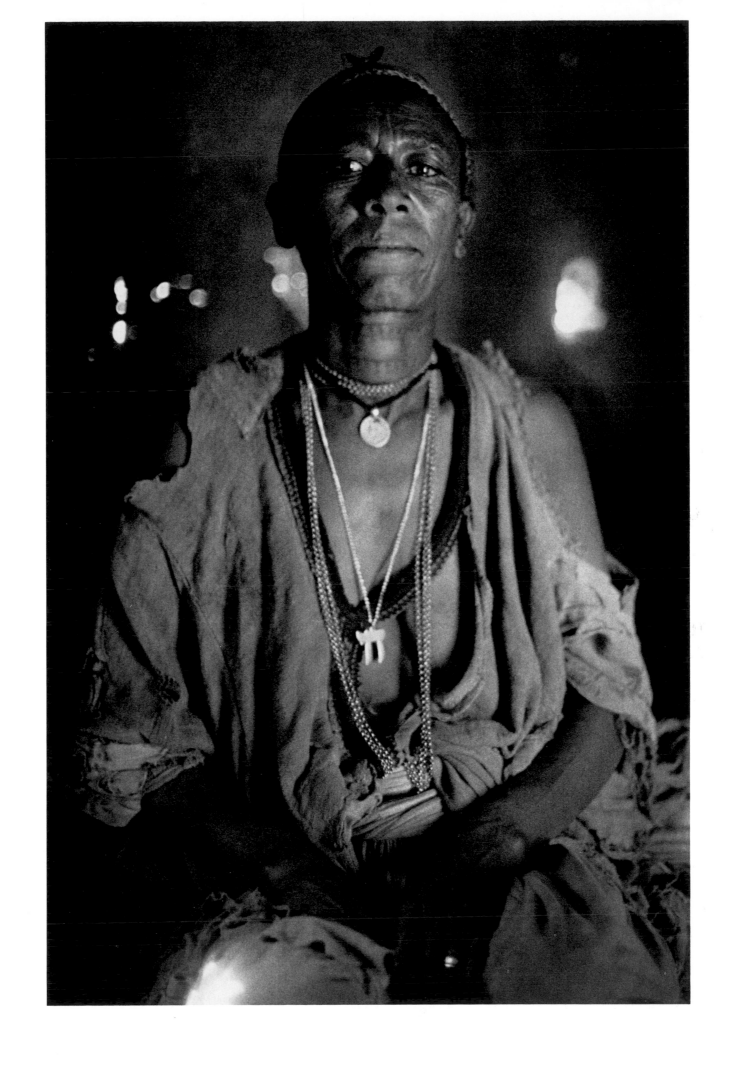

A gold chain with the Hebrew word *chai* (life) hangs among necklaces, amulets and tattoos.

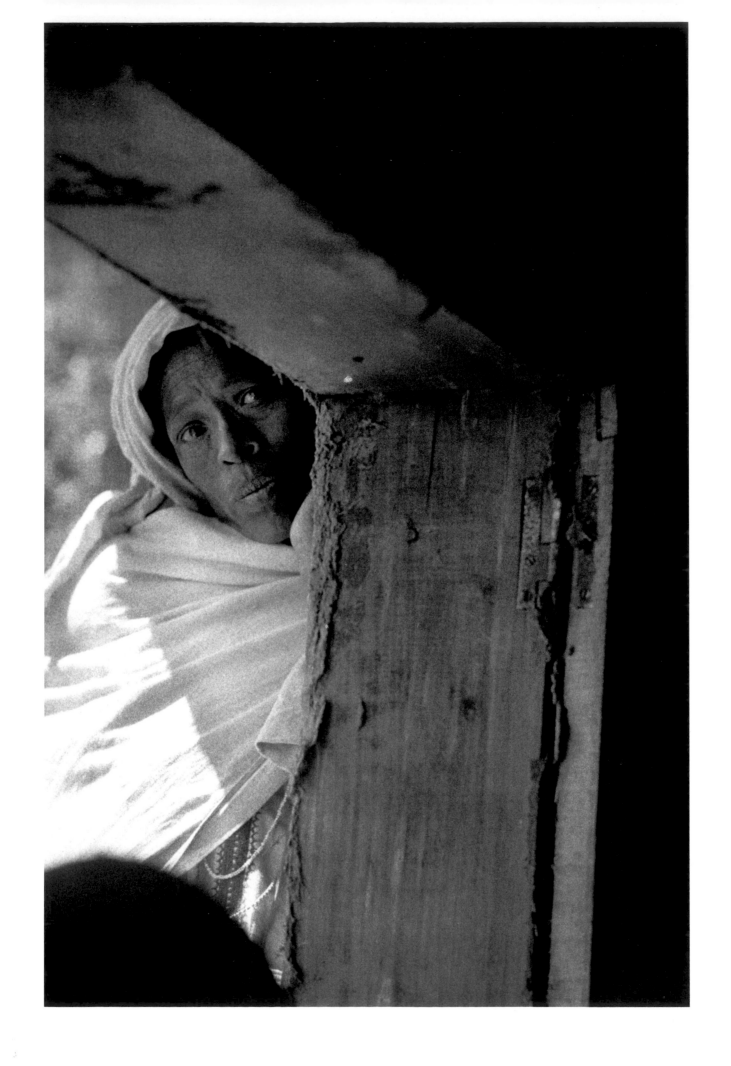

A woman peeks inside the synagogue, which she is not allowed to enter.

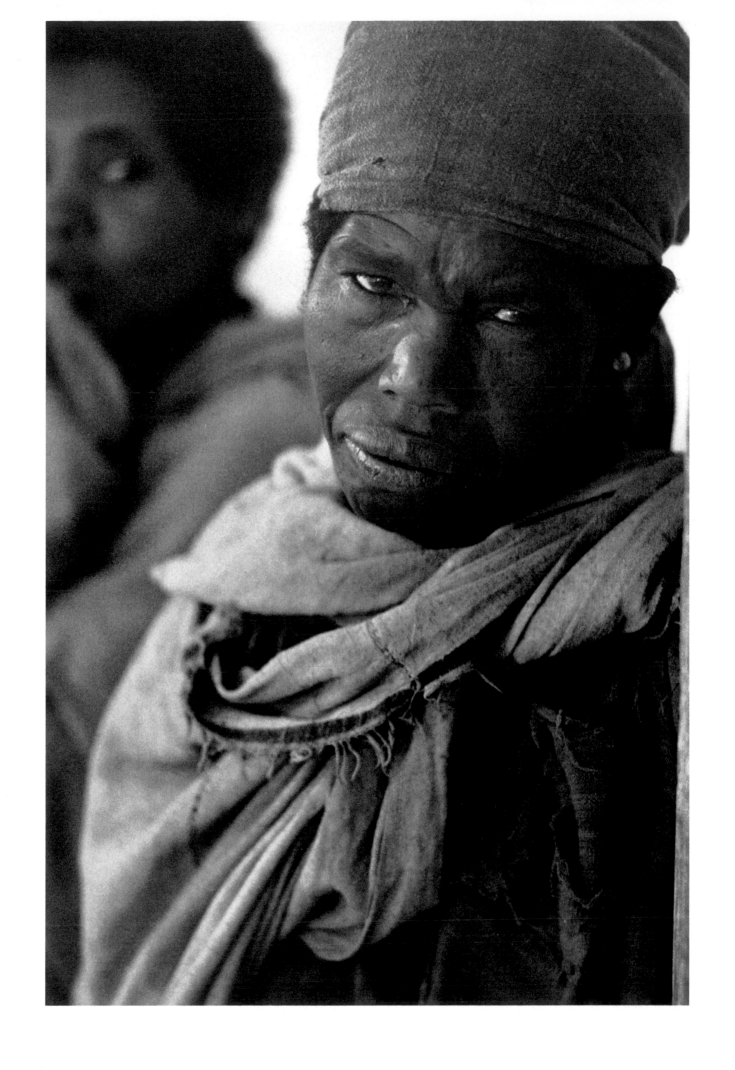

An Ambober villager outside her synagogue listens to a service.

(overleaf) After Operation Moses, the first exodus to Israel in 1984, women and children remained behind in their villages until they, too, would be airlifted.

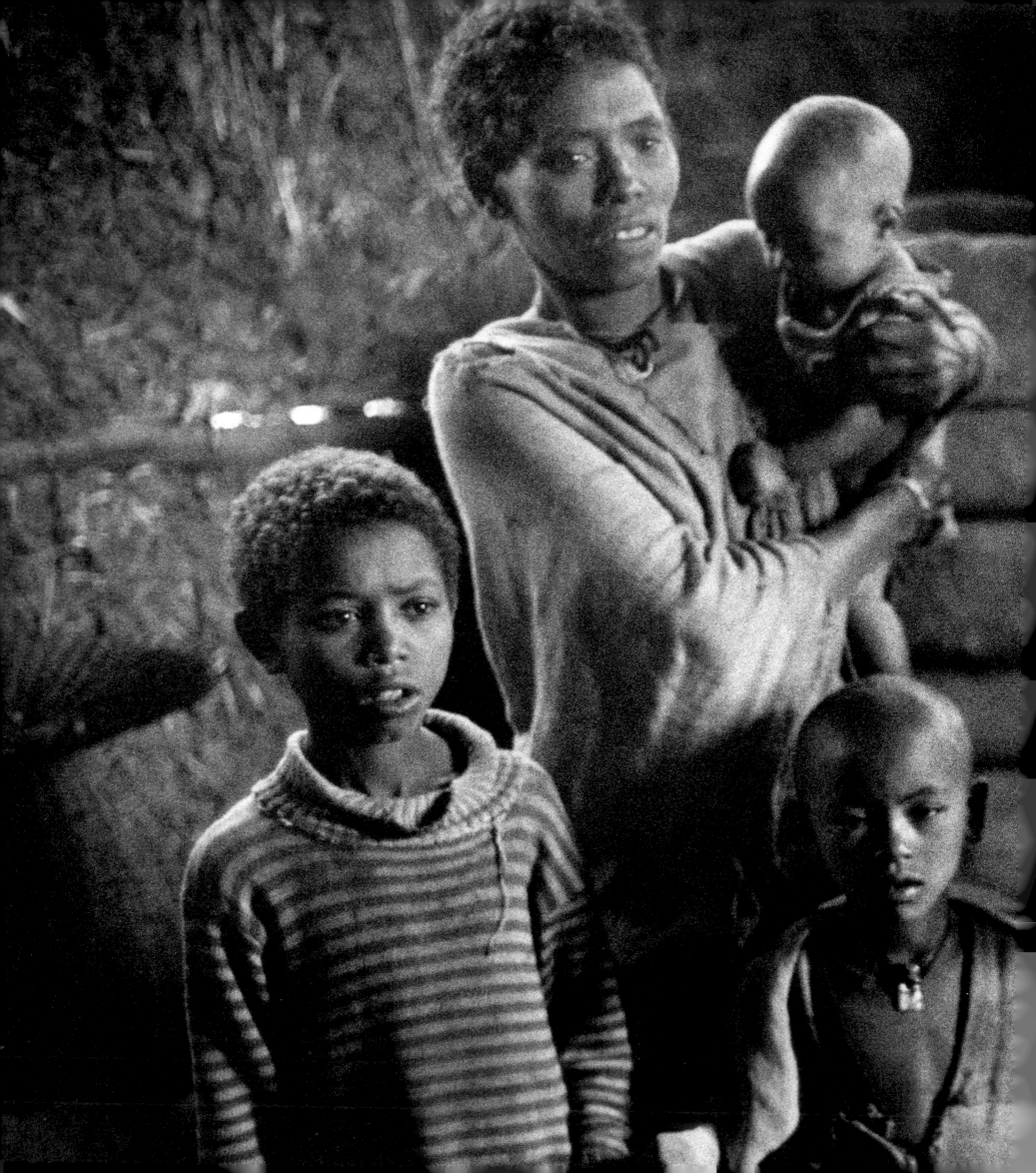

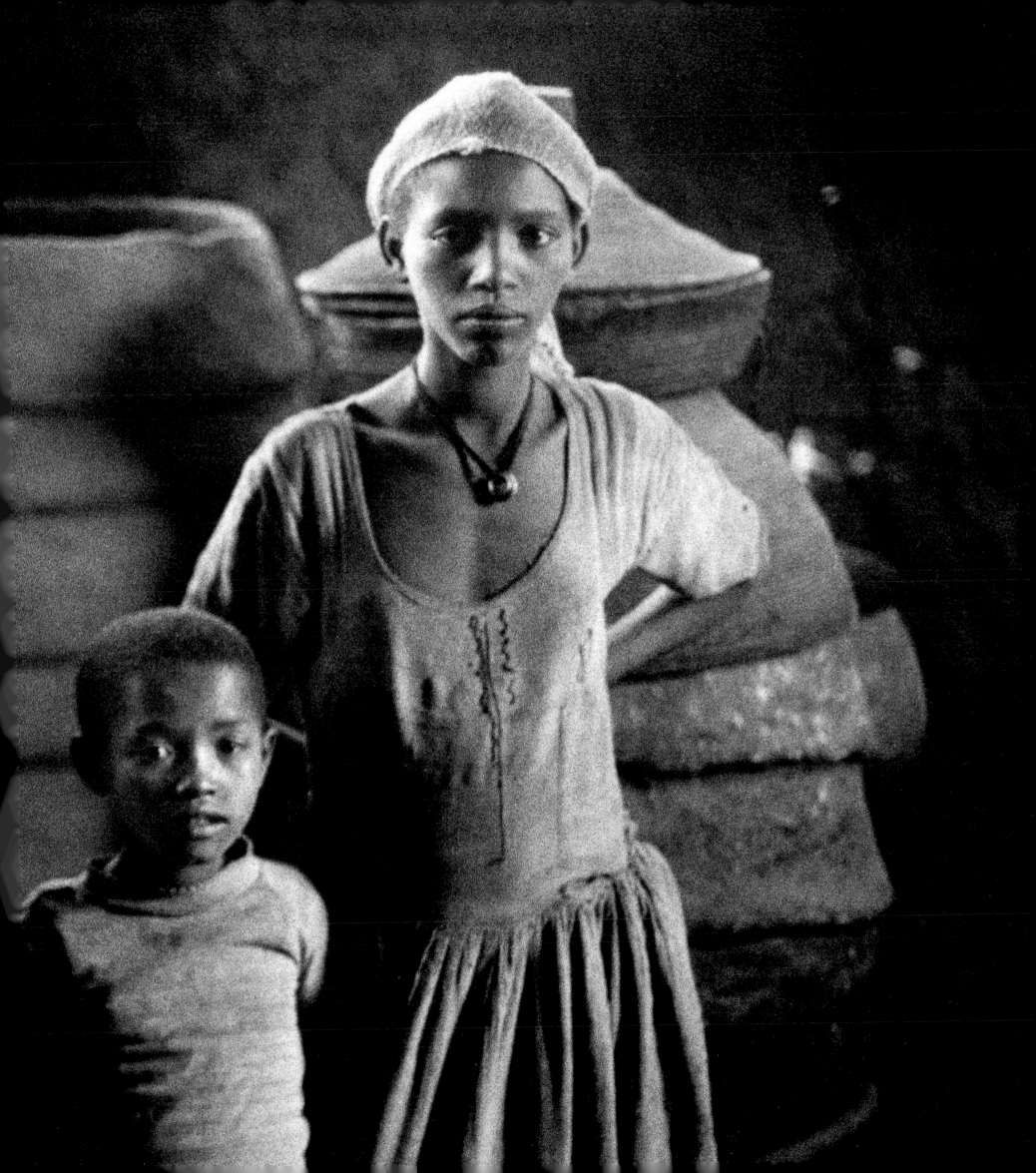

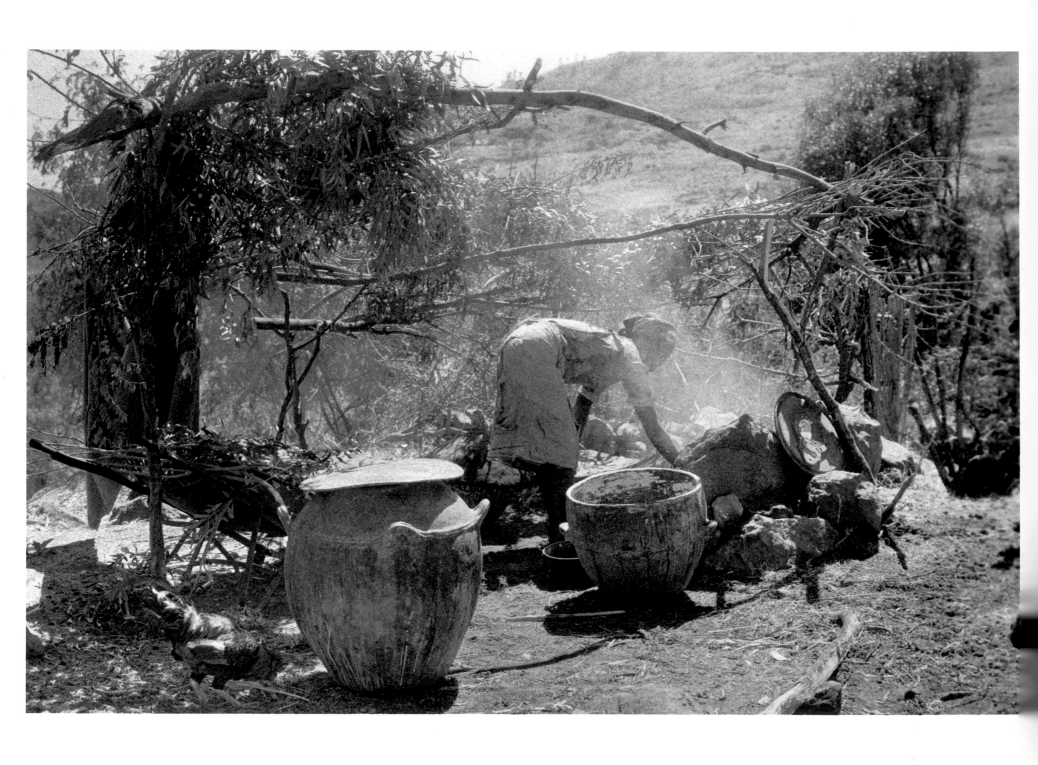

On Friday, villages smell of fresh bread as women bake for the Sabbath. Traditionally, women baked *ðabbo*, a bread made from wheat, in their kitchen, an outside structure of sticks.

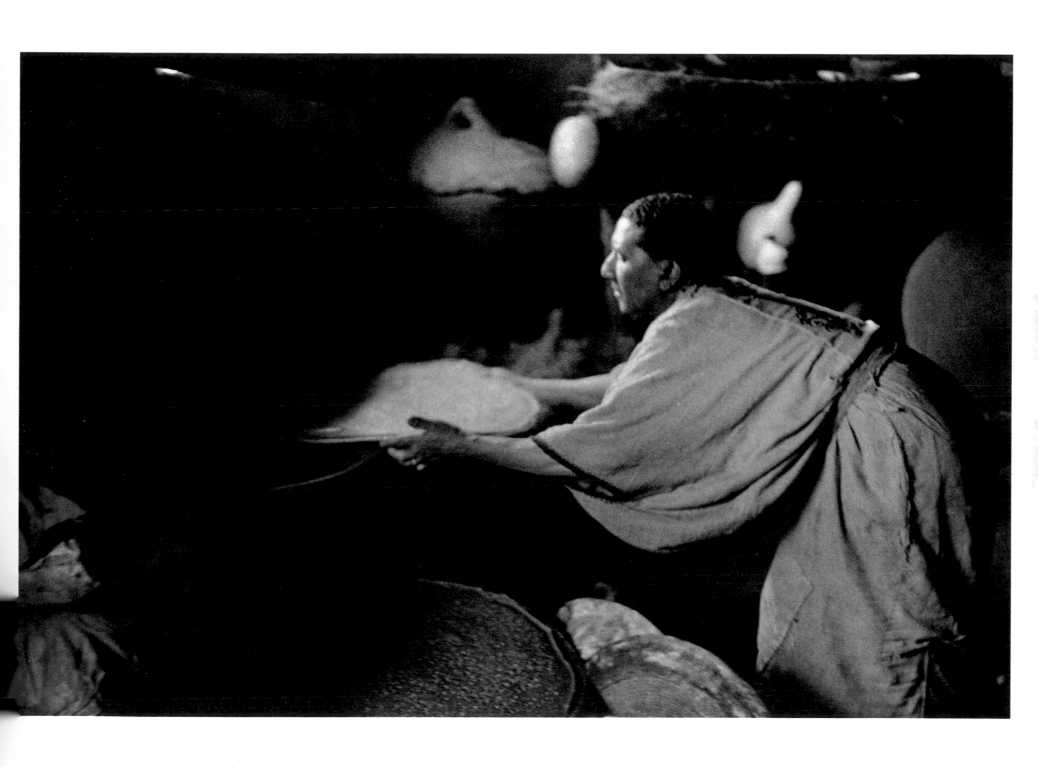

Aklil Yewebshat bakes *injera* (flat round bread) made from *teff*, a high-protein grain indigenous to Ethiopia, inside her *tukul*.

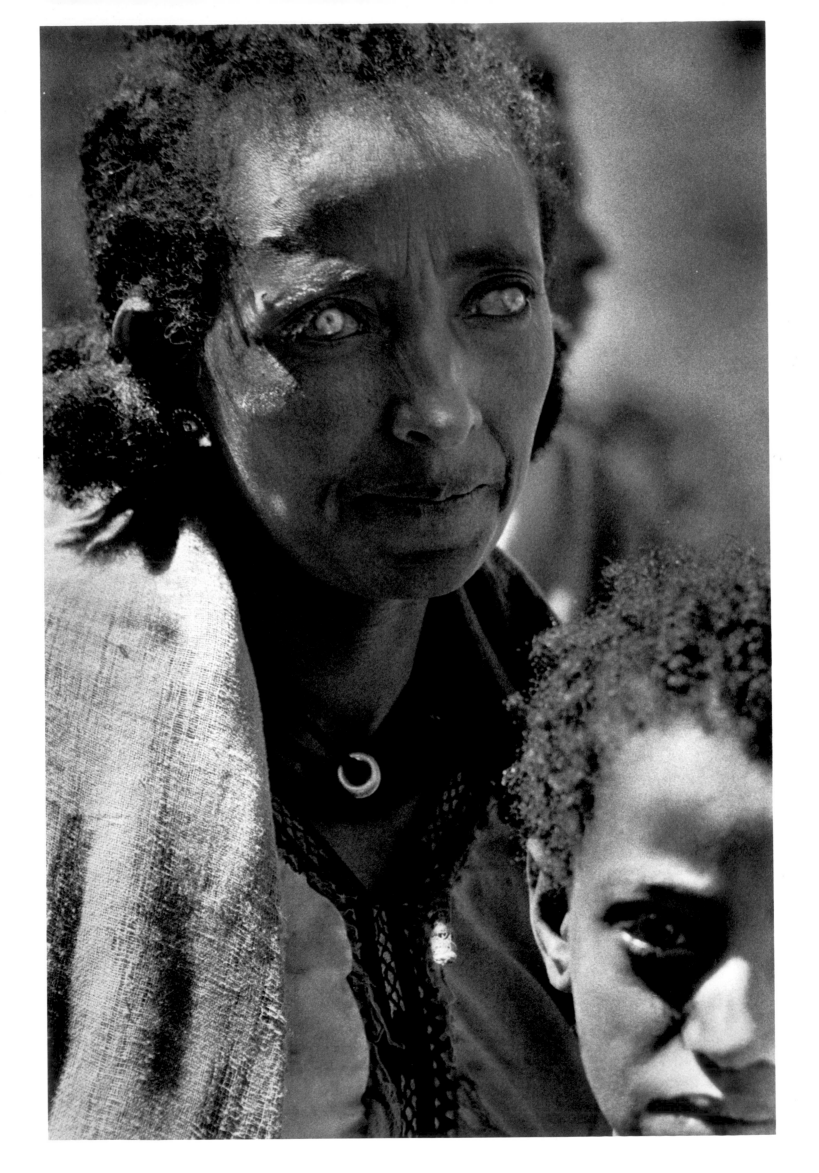

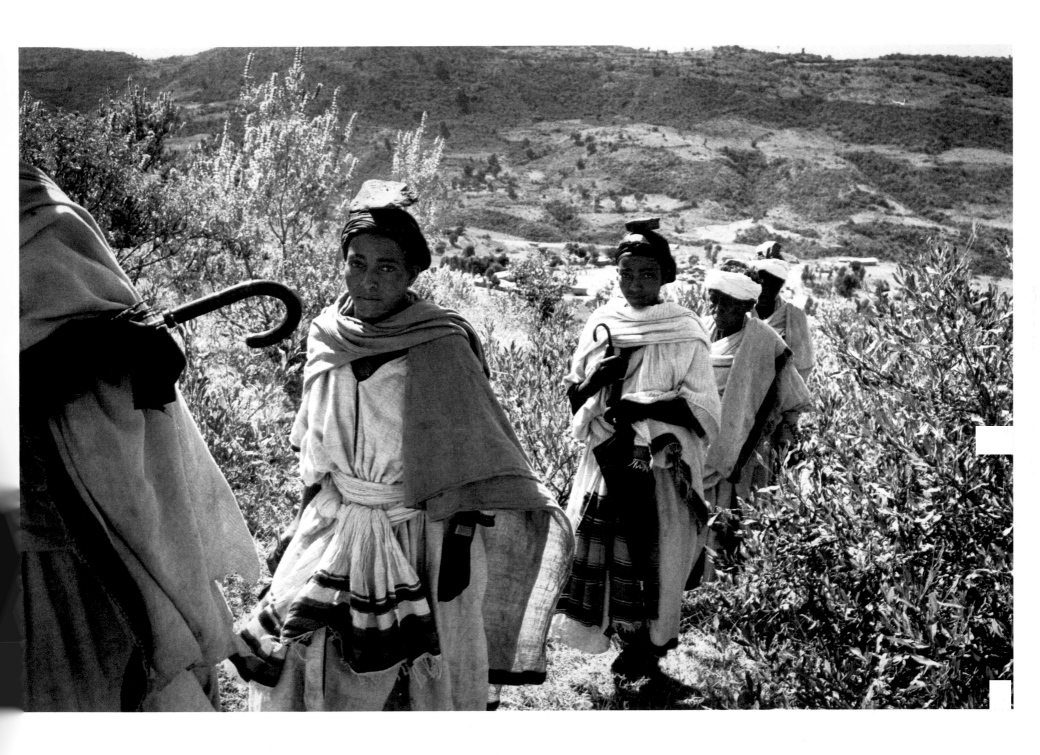

(facing page) Bayush Mekuanent's plea: "I live in this area and cannot work properly because of blindness. I have three children and I cannot help them because of a shortage of money. Please help me to exist through life with my children."

(above) Women carry stones on their heads in a penitential ritual. When they arrive at the top of the mountain, the women place their stones in a circle around the *qesoch* (priests) and sprinkle grain over them in a ceremony called the *ammeyan*.

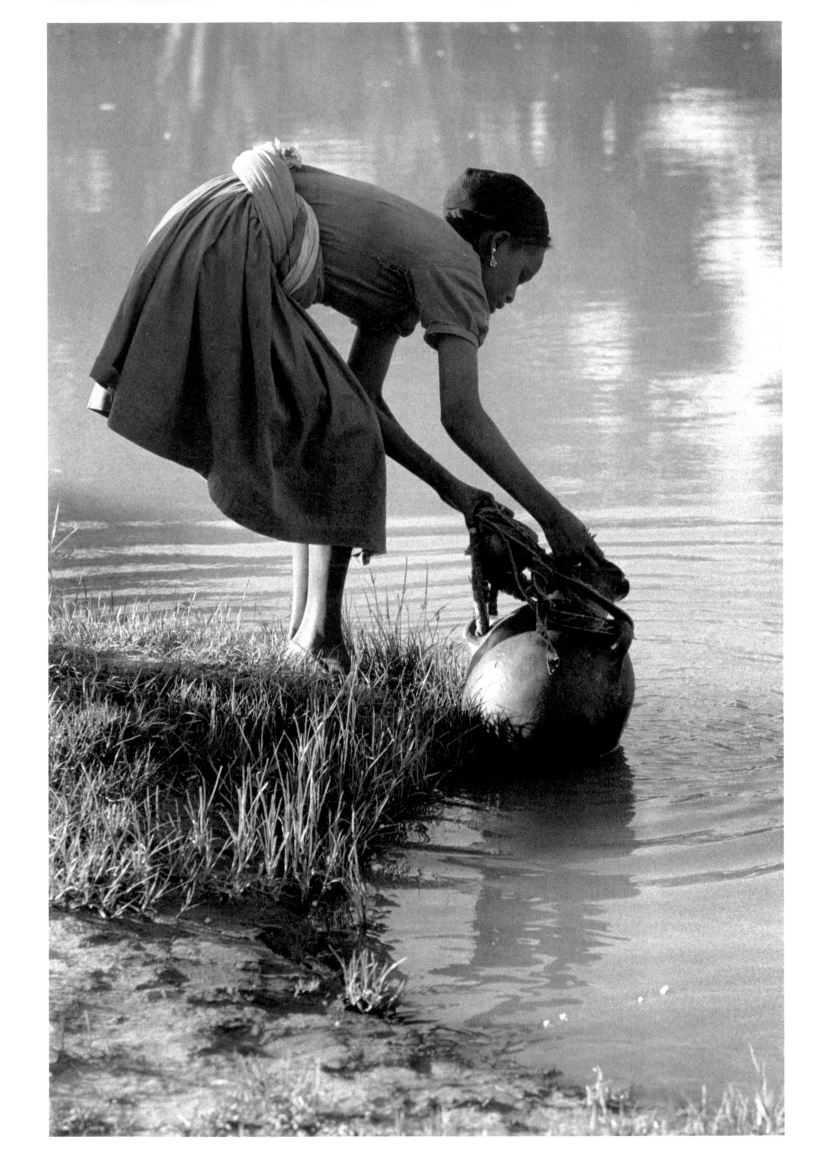

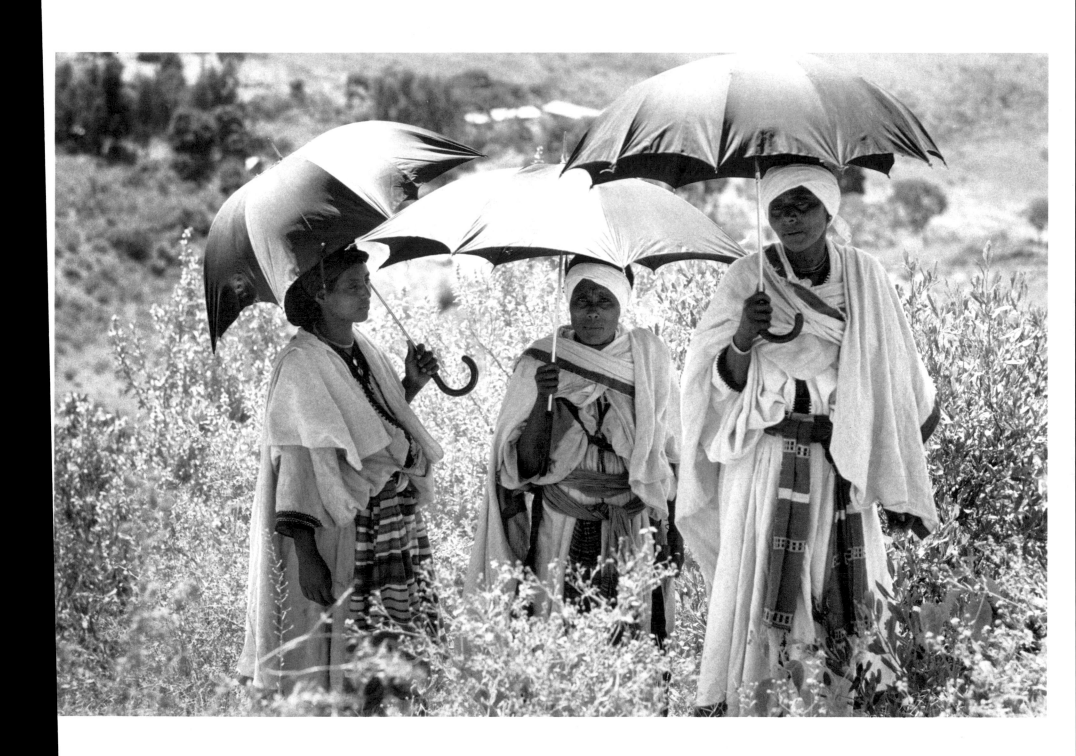

(facing page) In the spirit of the biblical Rebekah, this woman dips her pitcher to draw enough water to serve others.

(above) Umbrellas are used as protection from the scorching sun.

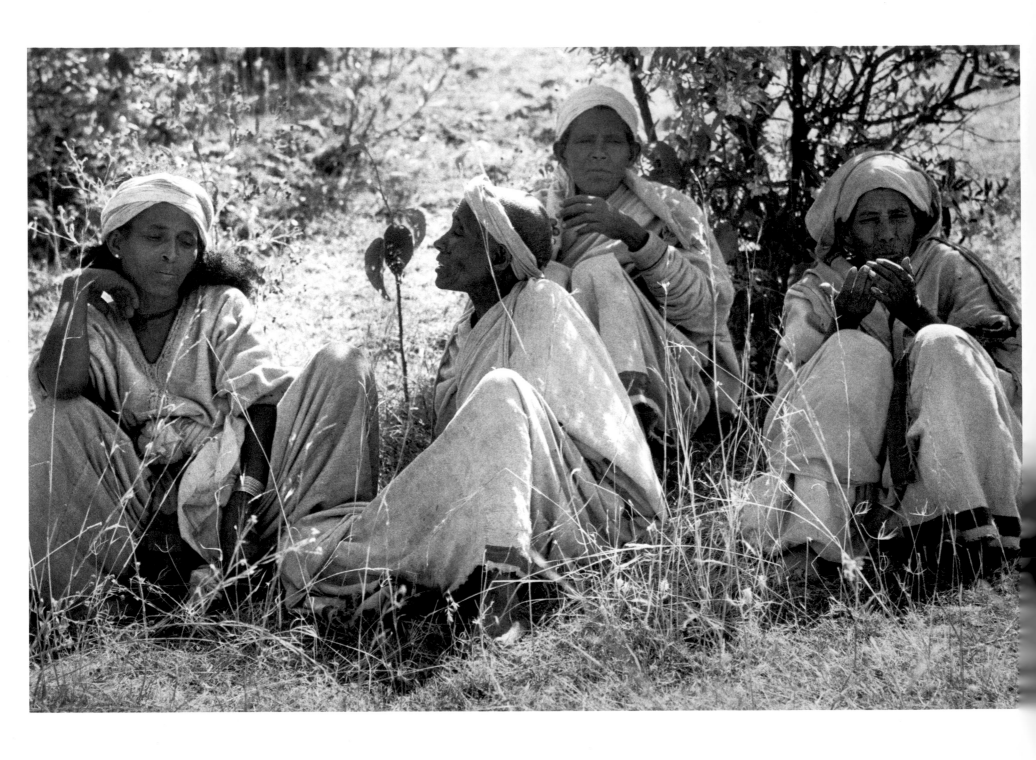

(above) Seven weeks after *Yom Kippur,* Ethiopian Jews gather on a mountaintop to listen as *qesoch* read the *Orit* (Torah).
Women sit apart from men, wave their hands and trill their tongues in a high-pitched ululation.

(facing page) Two women pray: bowing three times, then prostrating themselves, they say, "Hear me, *Abram Amlak, Isshag Amlak, Uaqob Amlak.*"

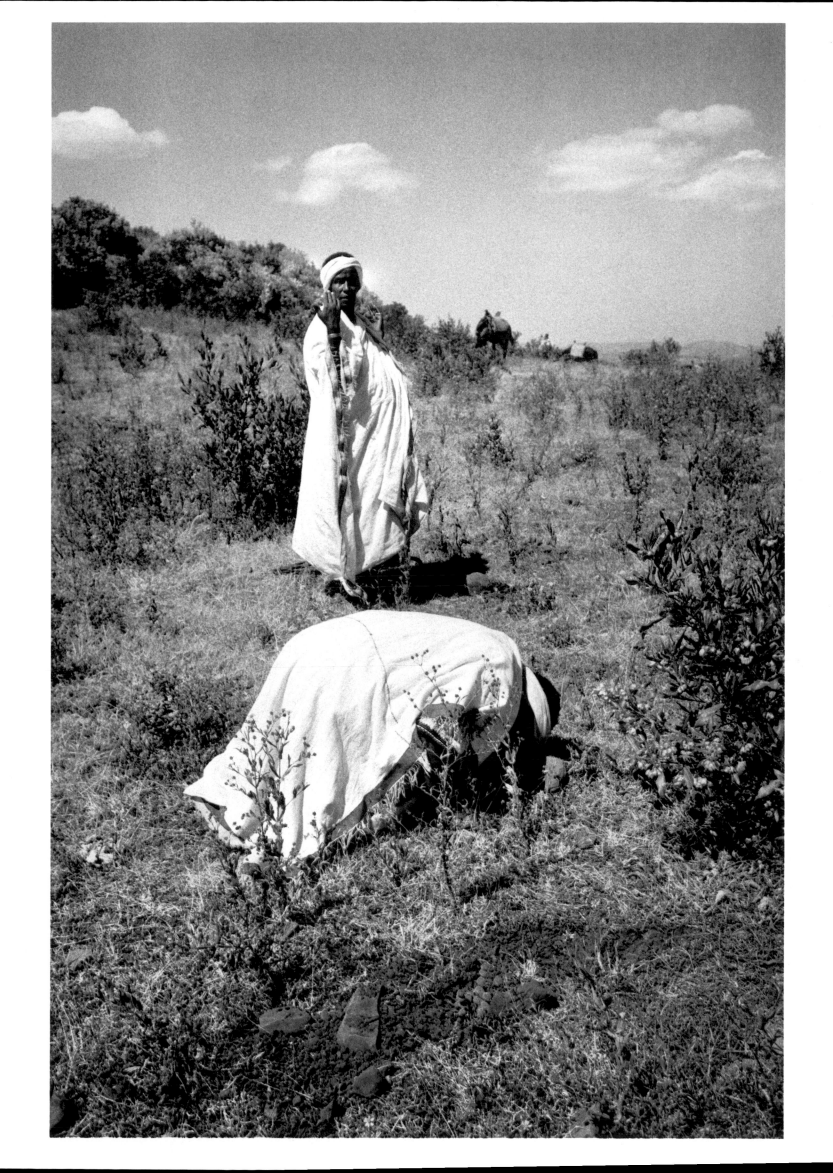

A Jewish star made of paper hangs
beside the photograph of this young woman's
husband who left for Israel—testimony to her belief
that she will join him.

as a literary critic for radio. Until her daughters joined

the synagogue chorus, she was indifferent to being a

Jew. "If I had felt deeply connected to my religious

heritage or ethnic identity, I would not have survived

here," she explains. ॐ Viaja, like all Jewish

women, is the *akeres babayis* (mistress of the home).

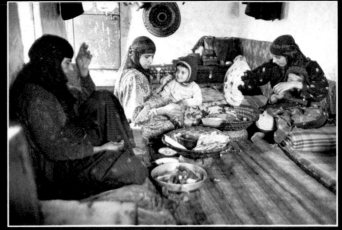

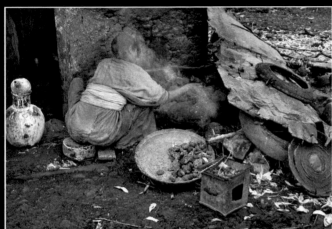

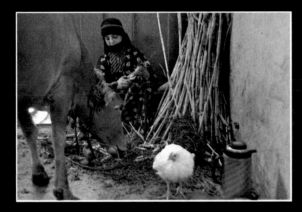

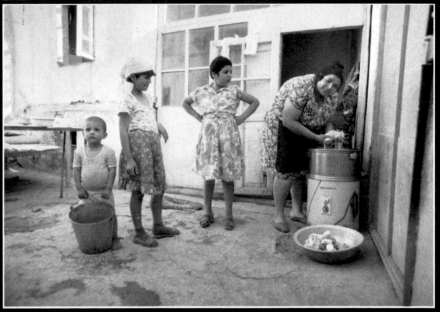

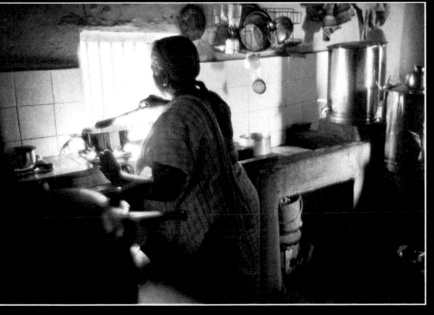

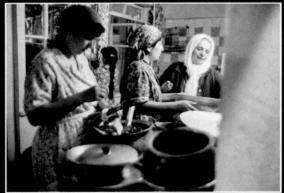

(clockwise from top left)
Agadir, Morocco; Women eat
separately, Saadah, Yemen;
Washing clothes, Bukhara;
Koshering pots, pans and silver-
ware, Bukhara; Winnowing the
grain, Waleka, Ethiopia; Washing
pots and pans, Pune, India;
Feeding a cow, Raydah, Yemen;
Baking bread, Waleka, Ethiopia.

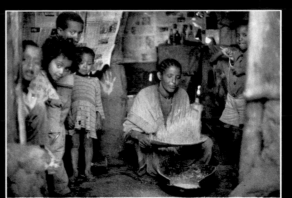

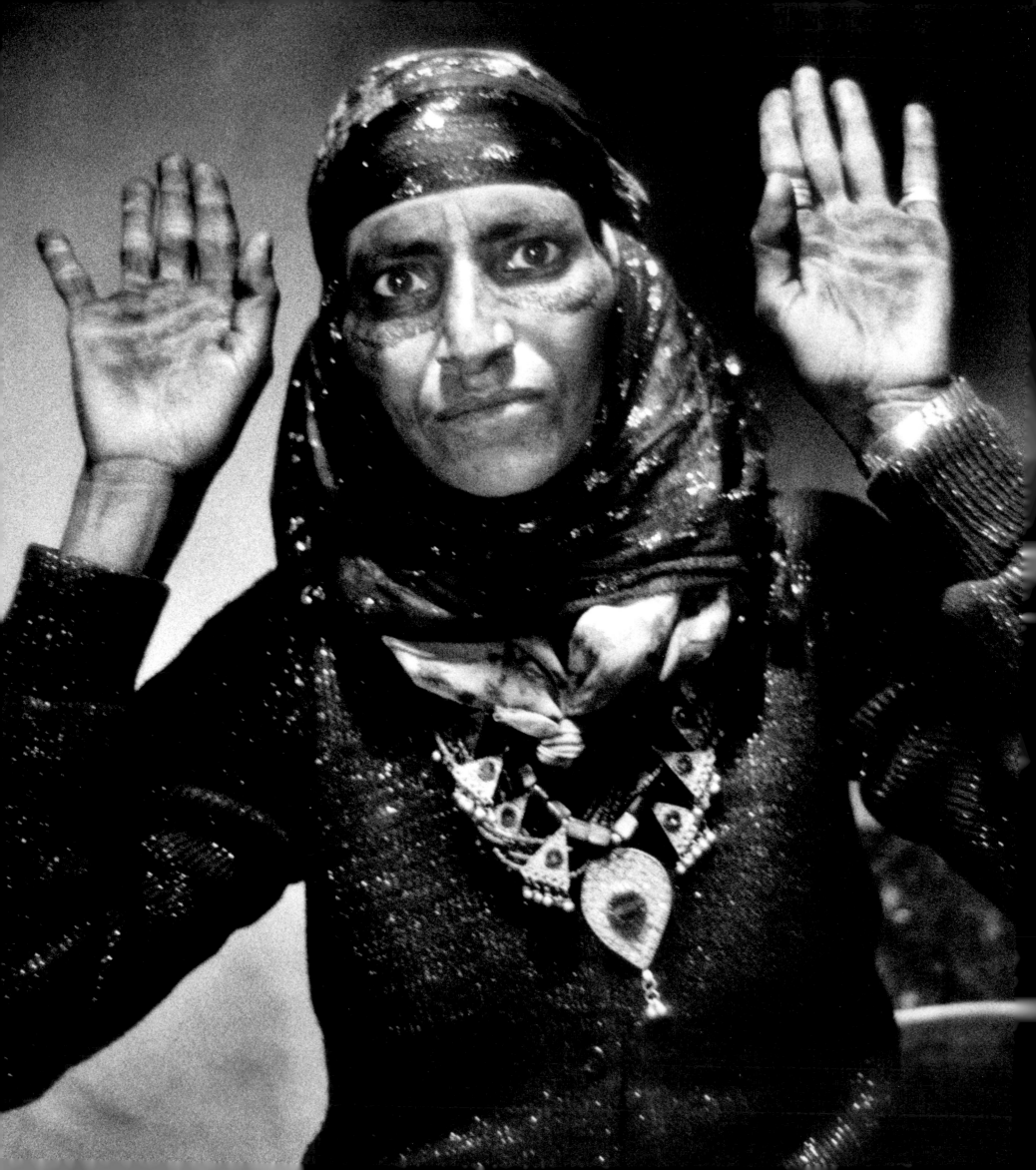

YEMEN

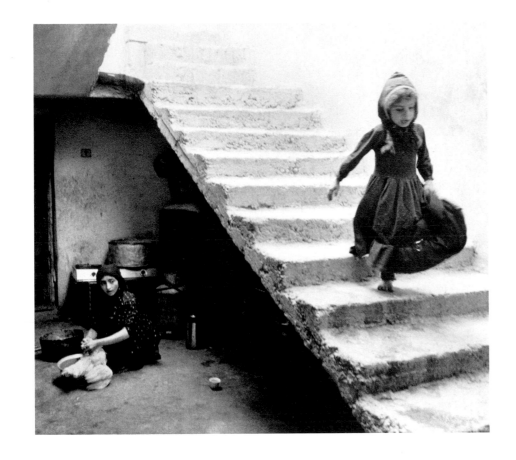

Beauty is prized in Yemen. Khaddab, a liquid extracted from leaves, is applied to magnify the eyes (facing page) and decorate the hands. A woman must stay attractive in order to entice her husband. Even though her wedding is the most important event in a Yemenite woman's life, and even though she may retain her beauty, the time will come when she hears that her husband has married another woman. According to Torah, a man is allowed more than one wife. So, when Rabbi Gershom, the leading authority among European Jews, banned polygamy over one thousand years ago, his decision was not binding in the Yemenite community.

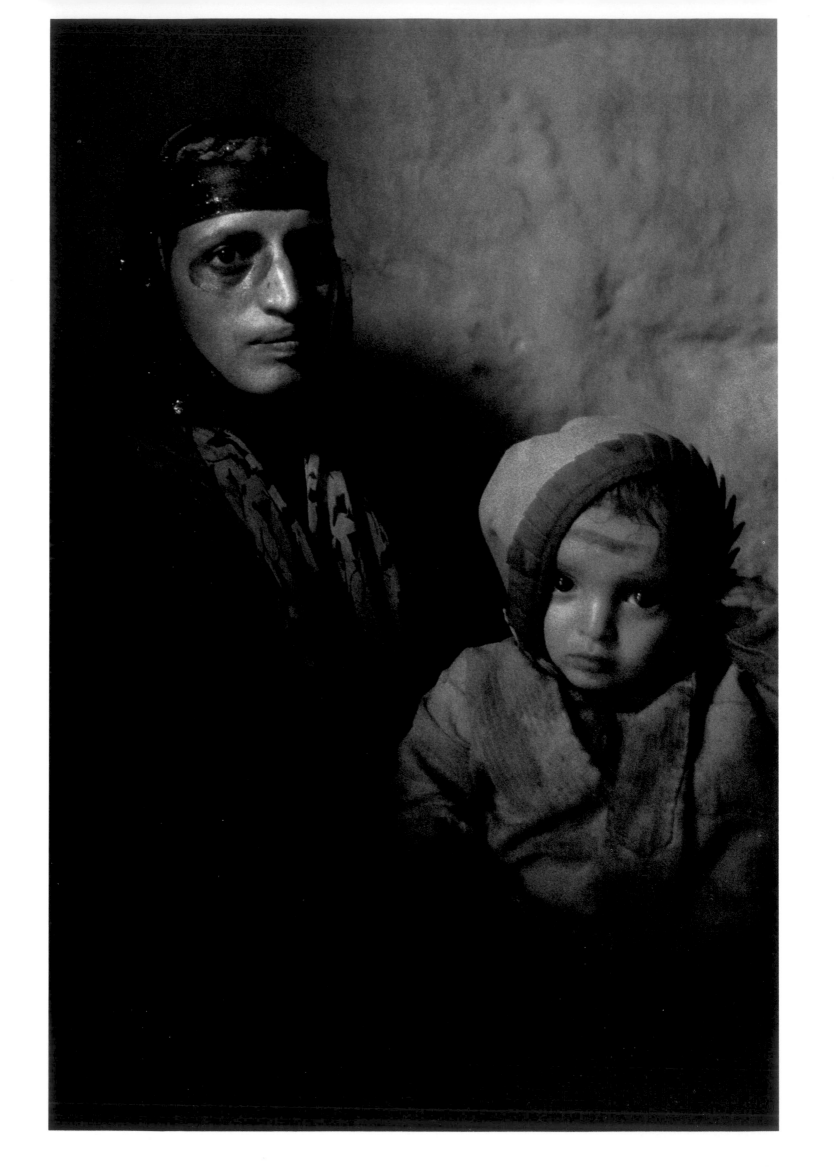

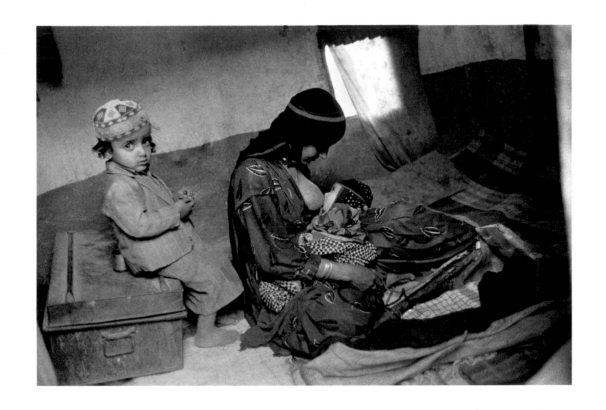

(previous page) A young wife plucks a chicken as her niece races down the stairs.

(above) A mother nurses her baby while her older son looks on.

(facing page) A mother and child wear *khaddab*.

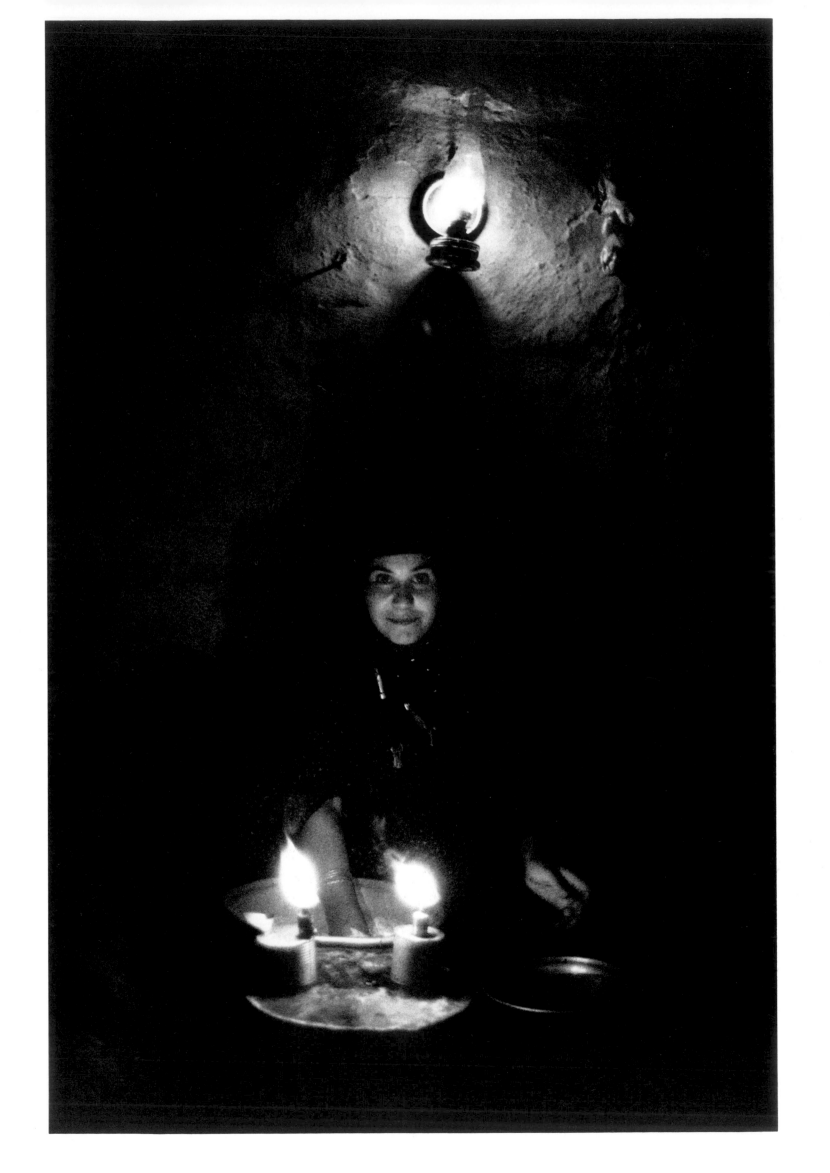

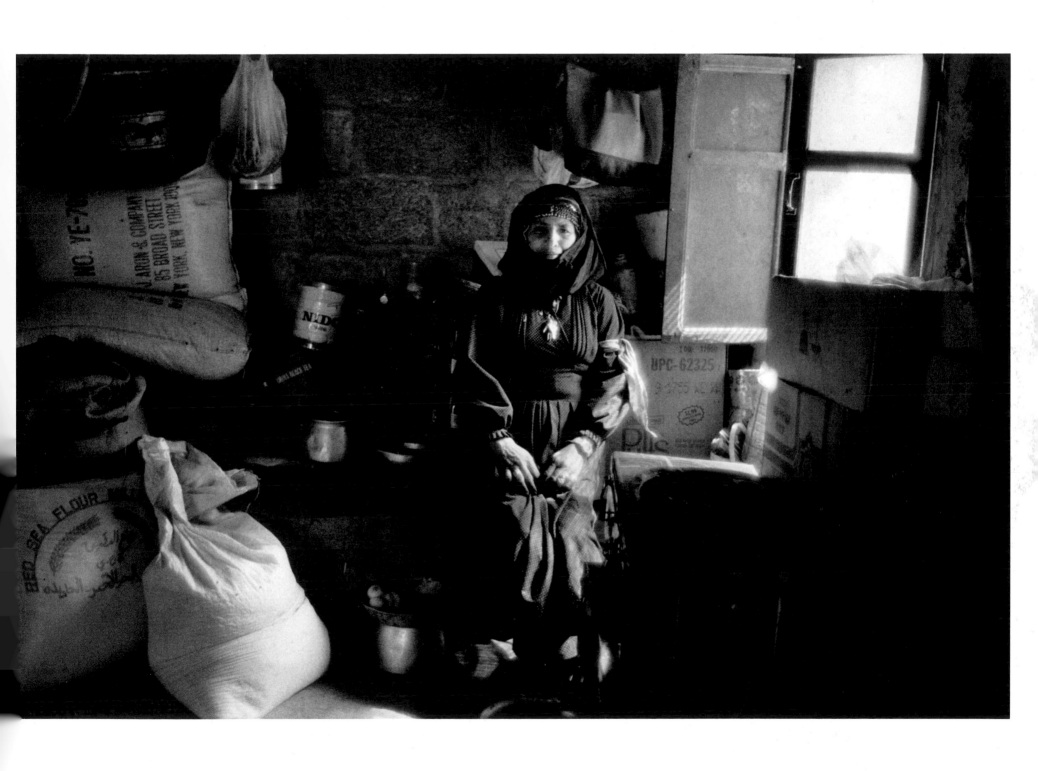

(above) In a storeroom, a woman guards her food supplies.

(facing page) Kneading *salufa* (pita dough) by candlelight in a *daima* (kitchen) in Wadi Amlah.

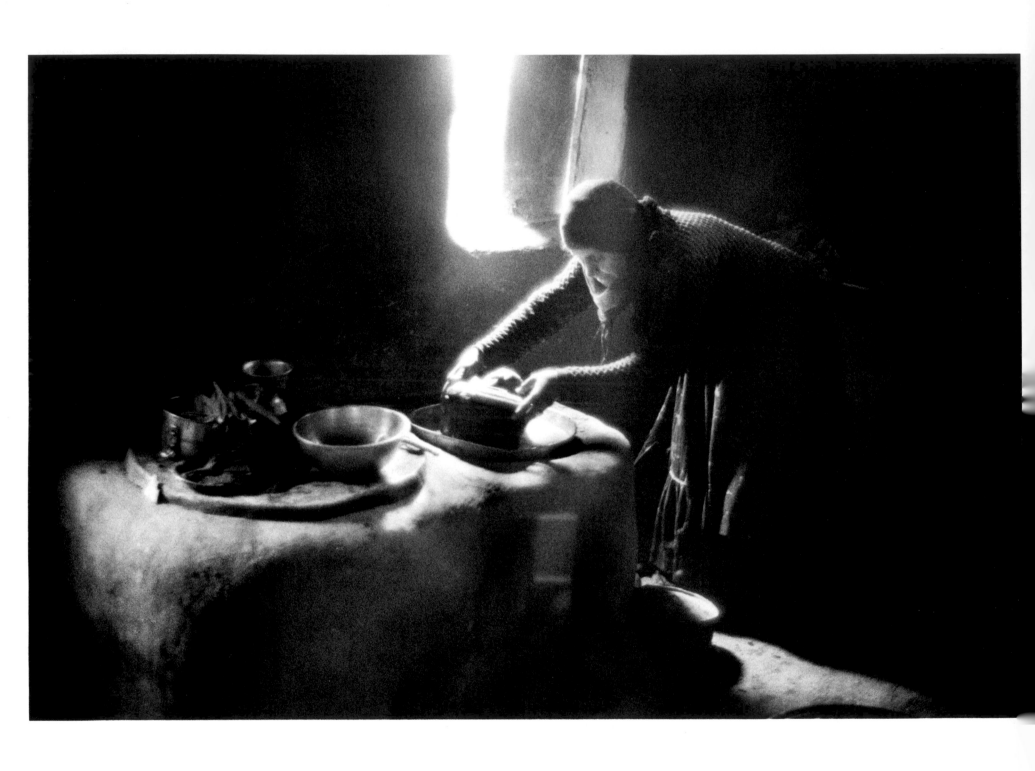

A woman bakes a special bread for the Sabbath.

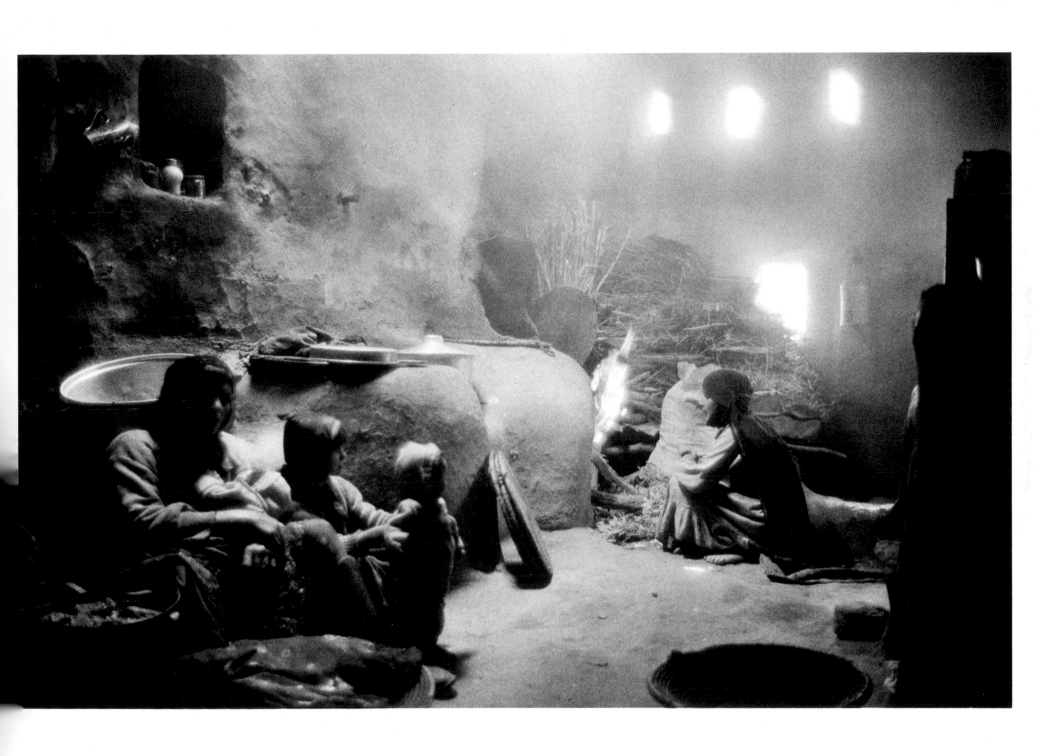

The *daima* is a communal gathering place for women. Firewood dragged from the hillside is used to build a fire in the *masaad* (clay oven).

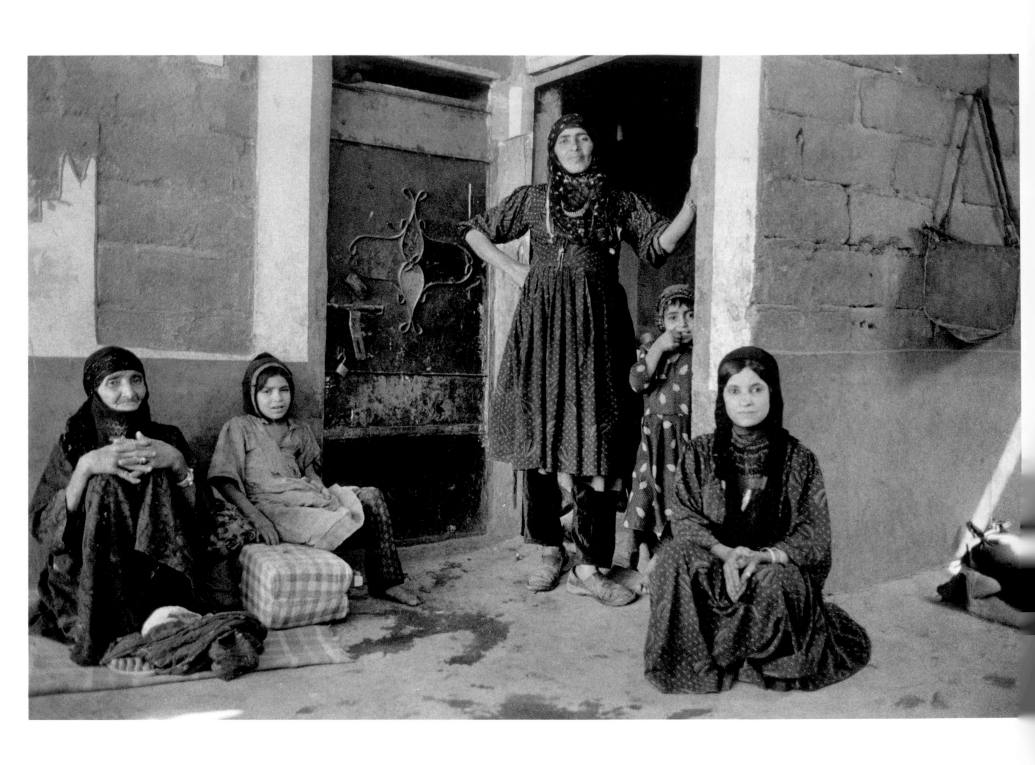

Several generations live together as part of an extended family.

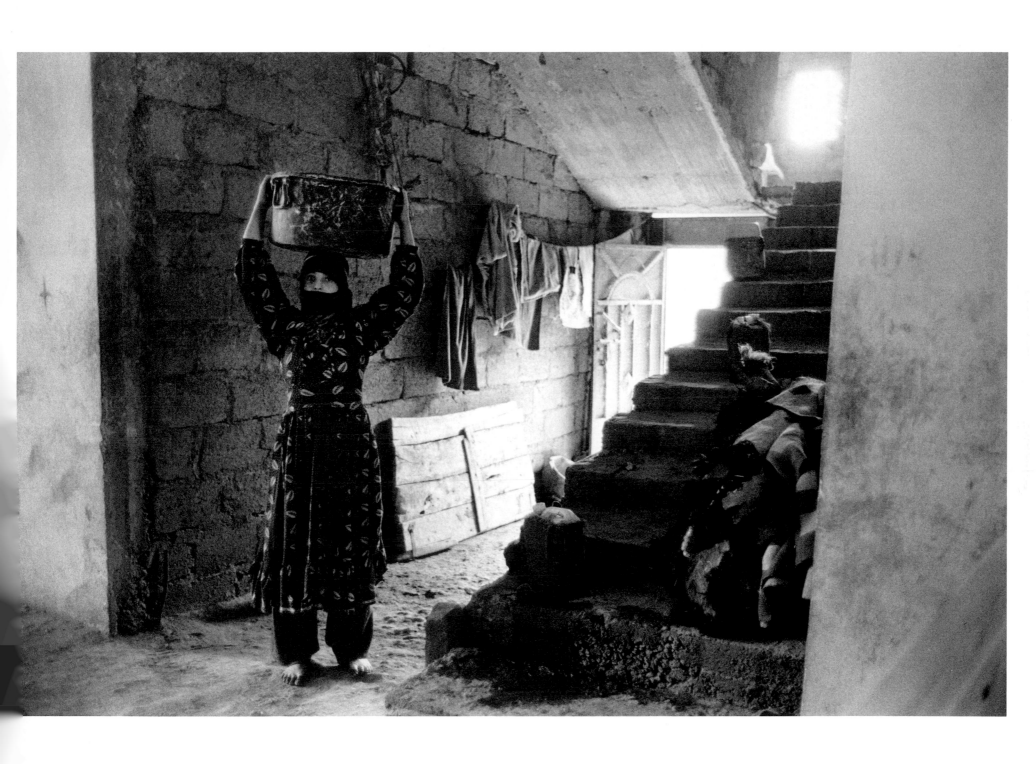

Water is brought into the home from an outside well by a young woman.

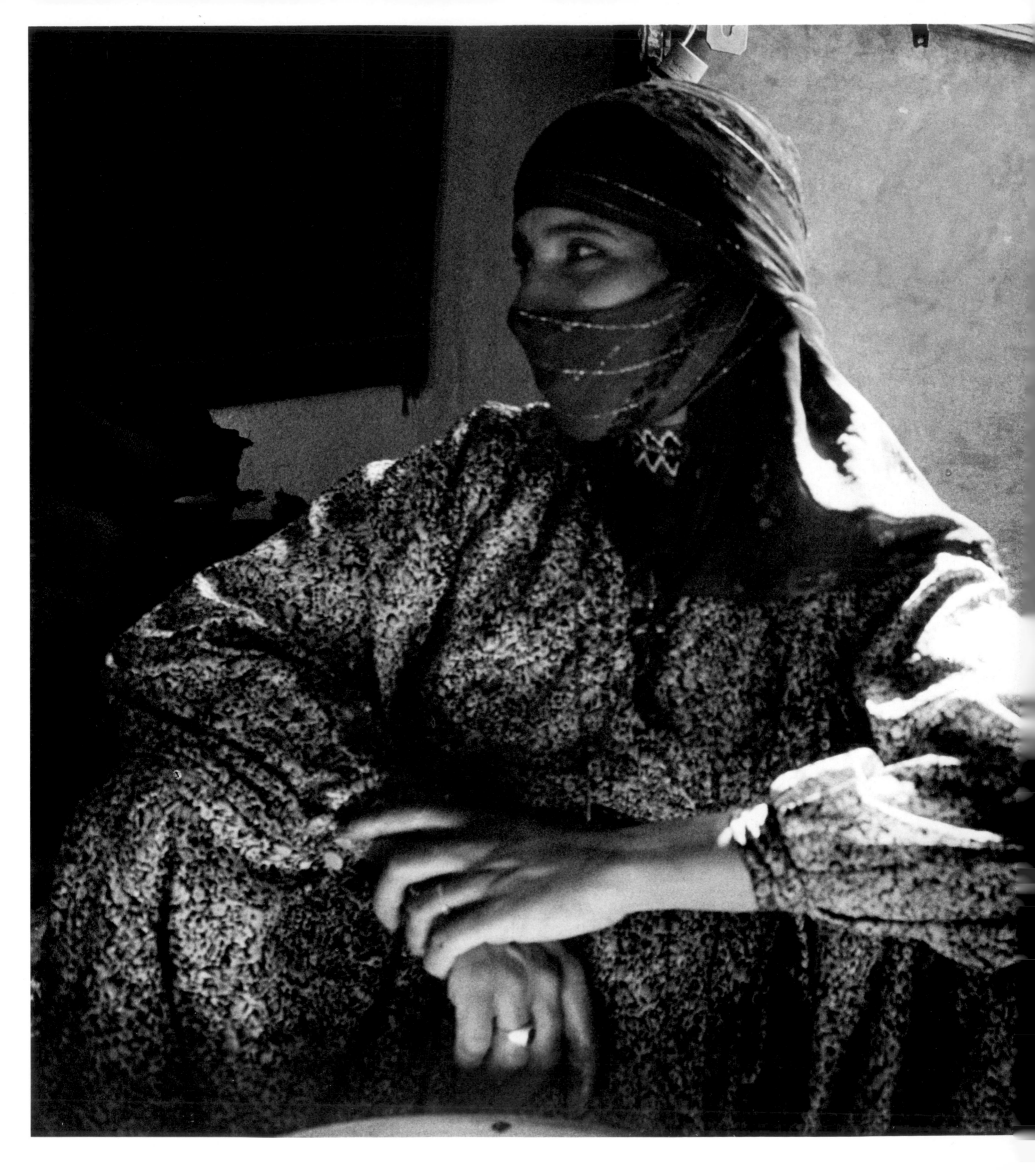

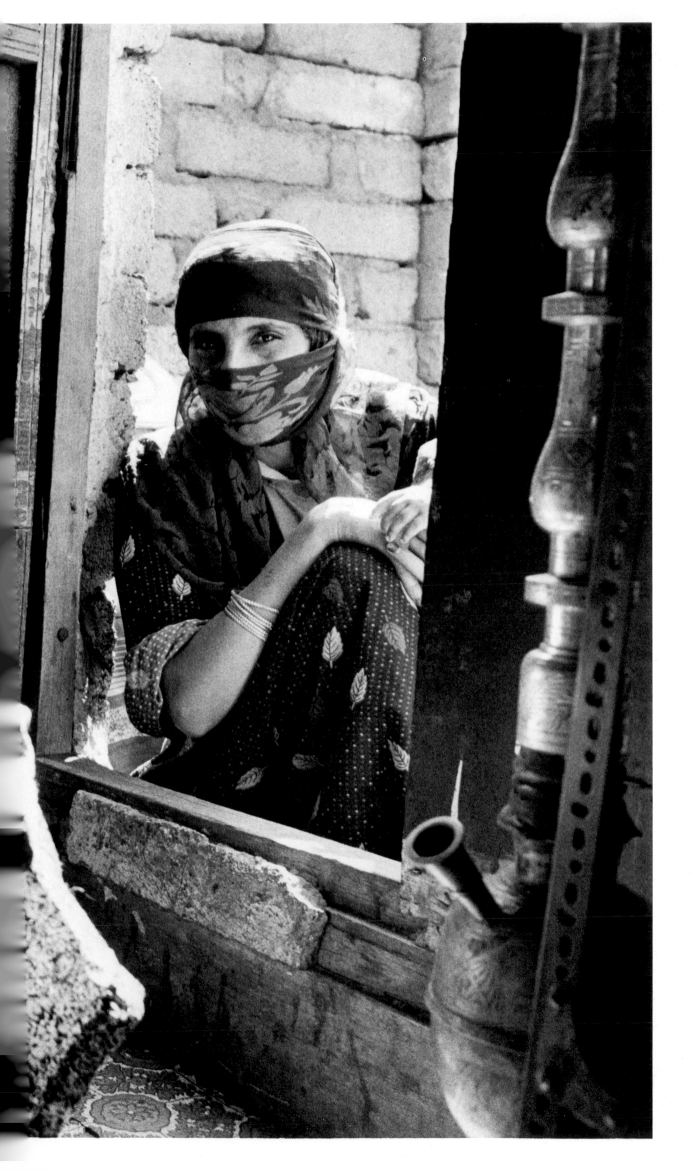

The two wives of the same husband
await his return.

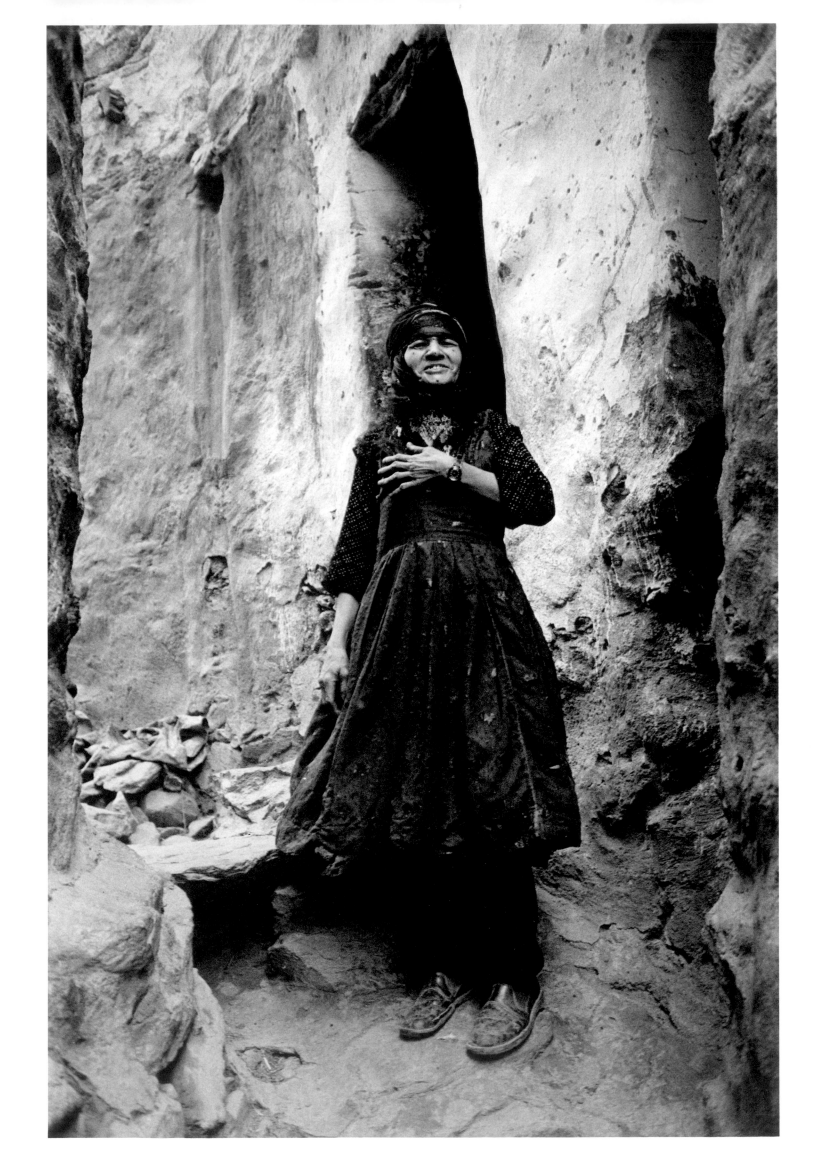

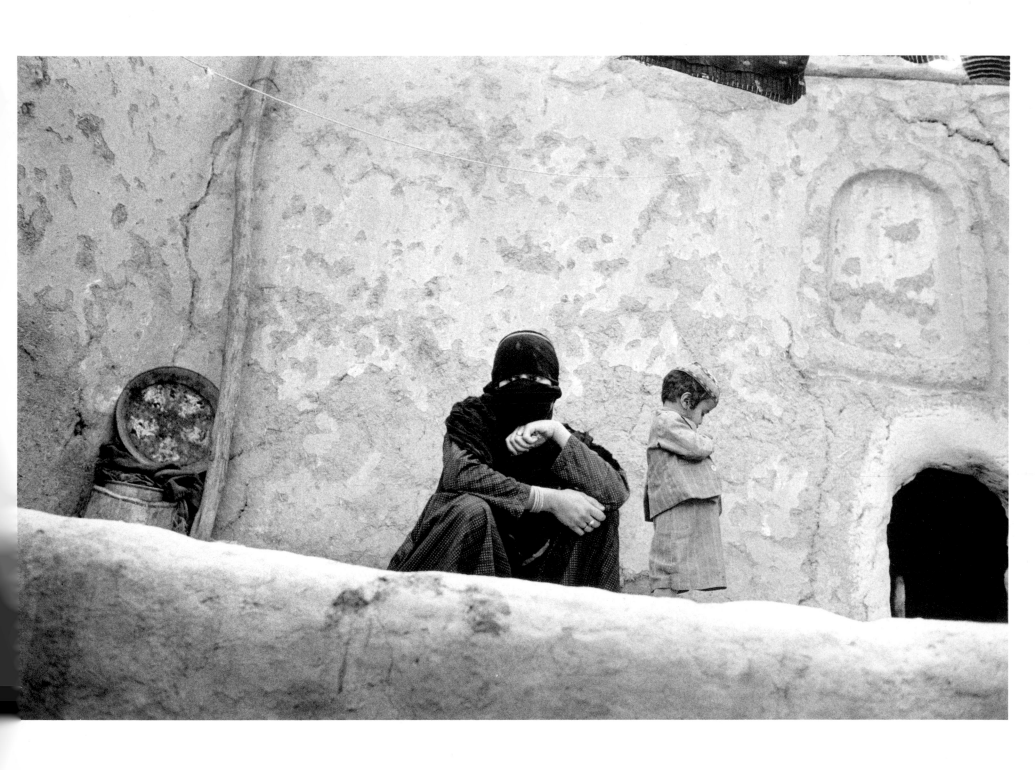

(above) In northern Yemen women wear a black *lithma* (half veil) in front of guests.

(facing page) A woman dressed for the Sabbath stands before the entrance to her home.

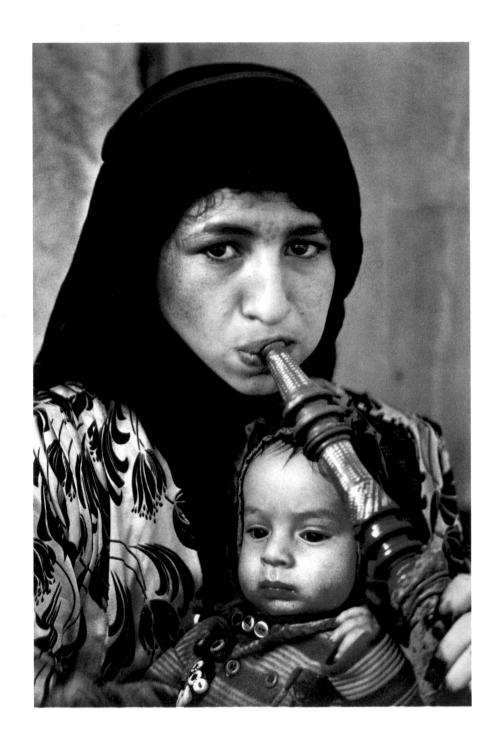

(above) A young mother smokes a water pipe.

(facing page) New mothers swaddle their babies and cradle them in a leather papoose, supported by ropes.

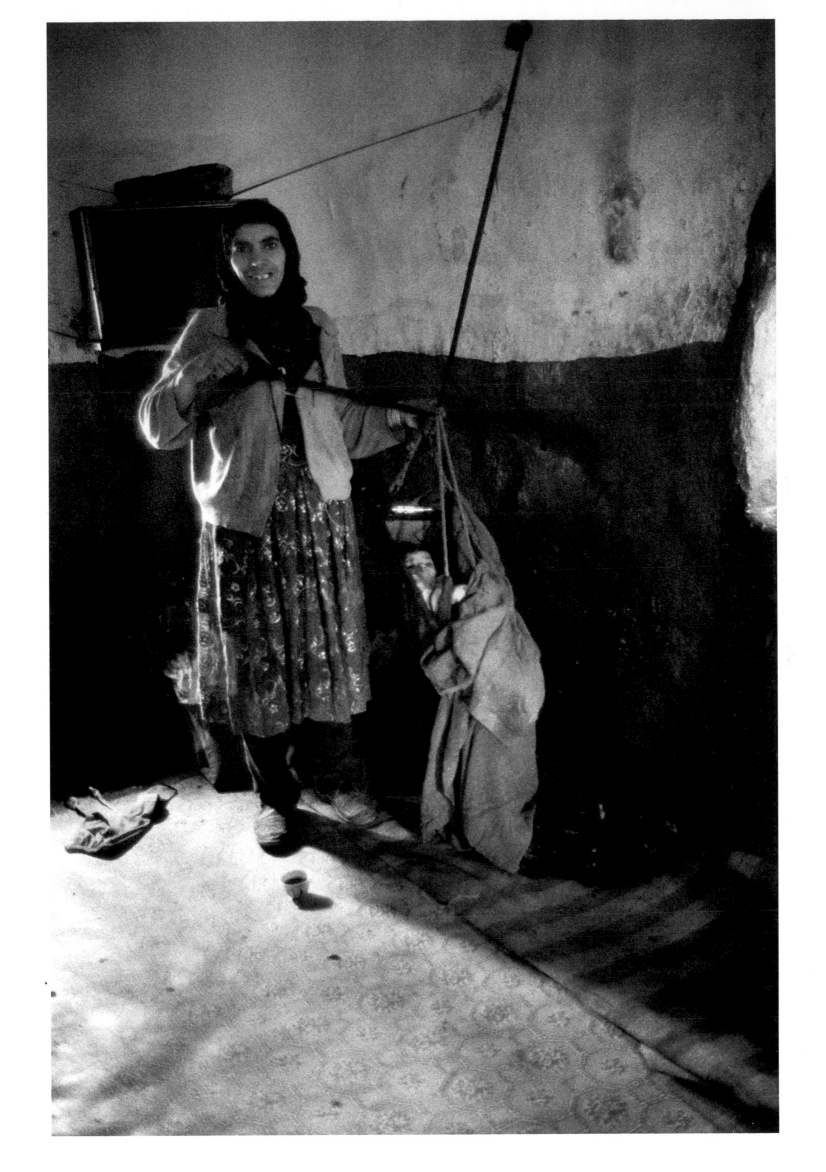

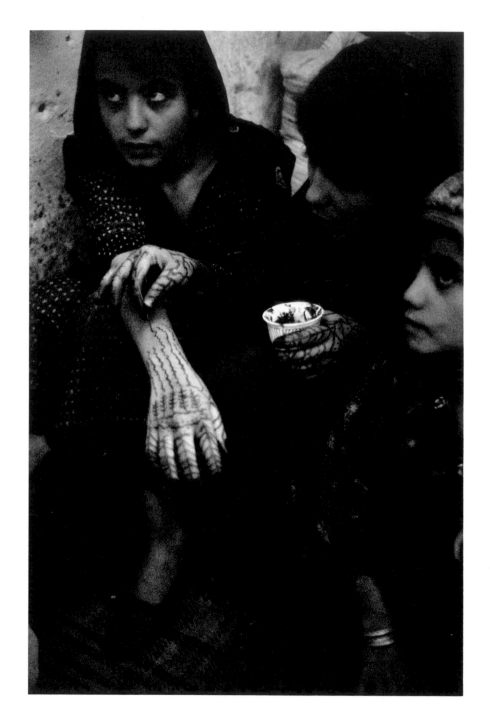

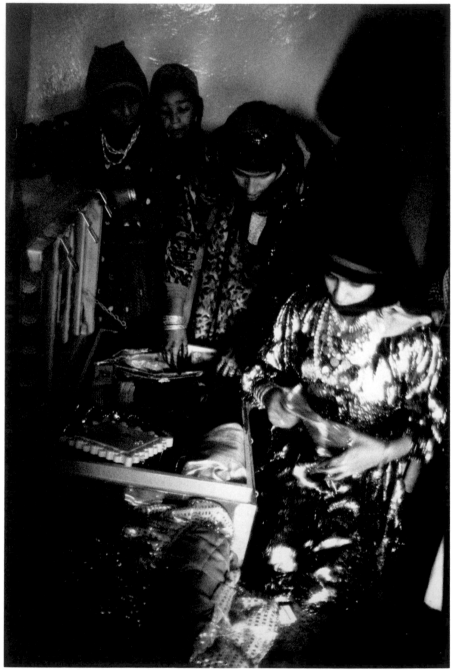

(left) An artist paints intricate patterns on a bride's arm with *henna*, a red dye ground into a paste from leaves. The design is applied for beauty.

(right) A trunk filled with jewels, clothes and other gifts, called a *sandook*, is given to a bride by her groom.

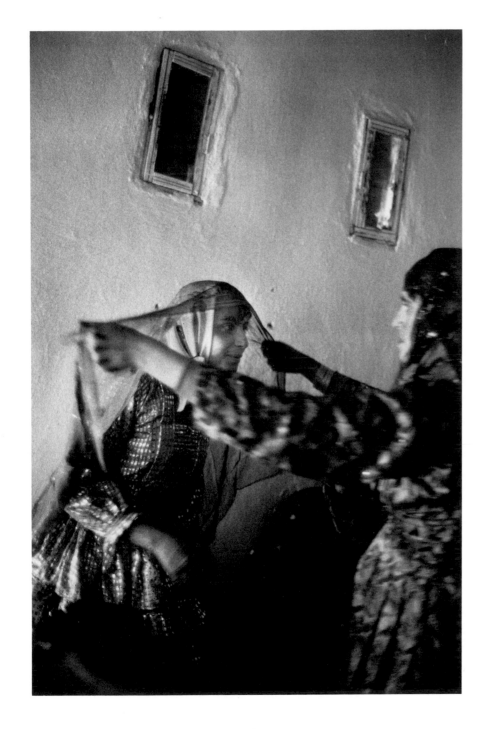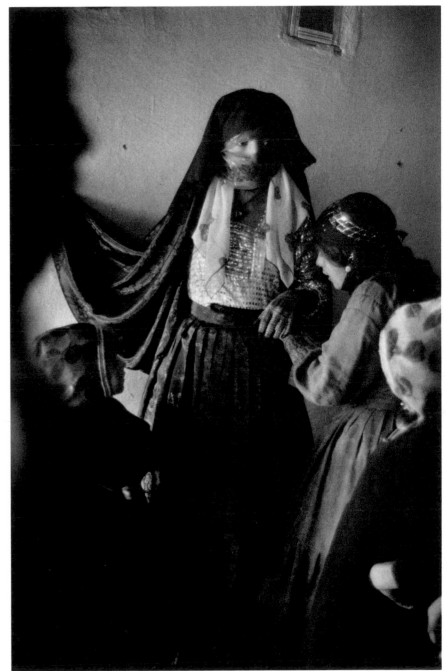

(left) A bride's head and face are wrapped in a chiffon scarf.

(right) Attendants dress a bride wearing her wedding gown in a *sharshaf* (outer covering). *Sharshaf* means shelter and is comprised of a long skirt, a head covering with an attached cape and a veil.

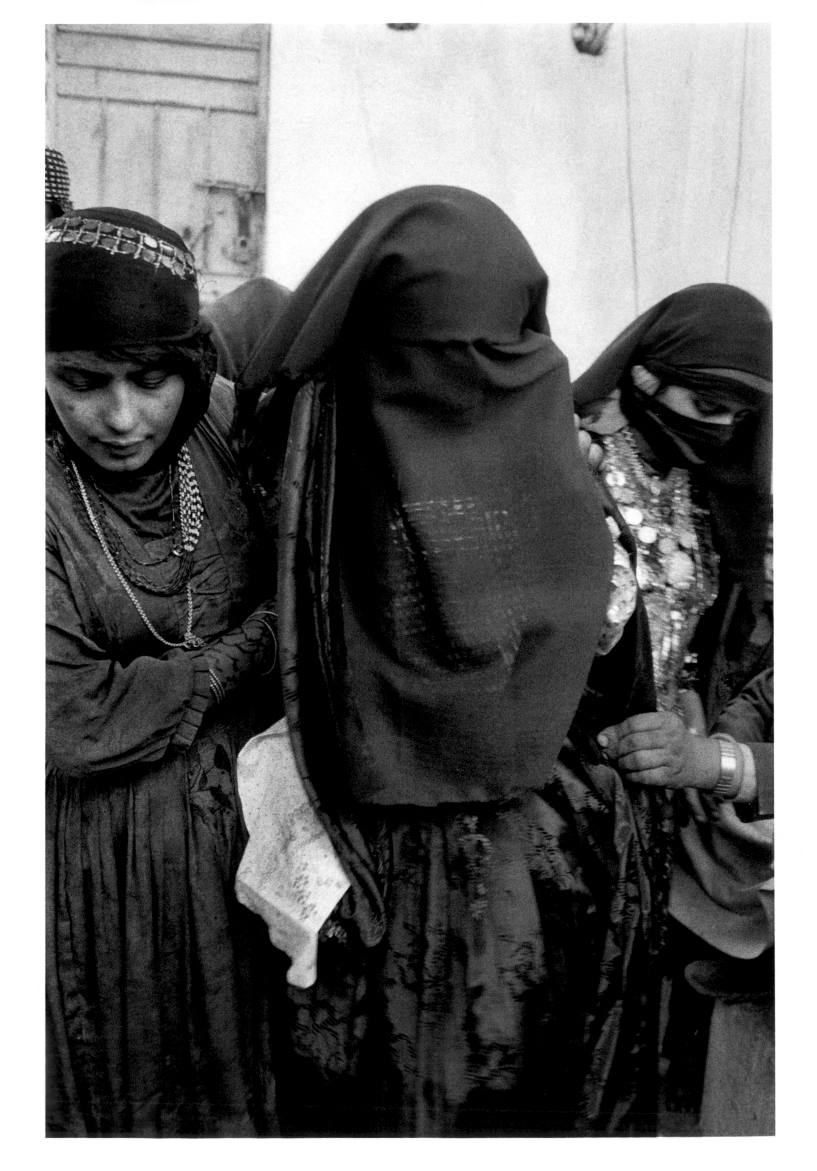

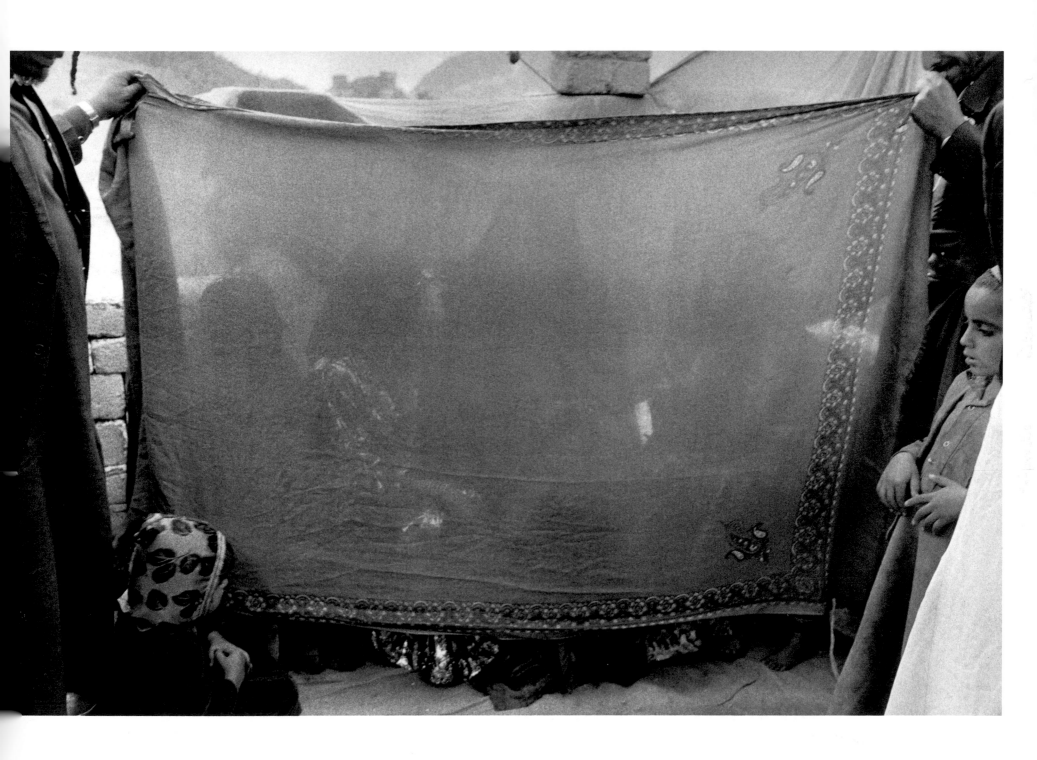

(facing page) A full black veil completes the covering of a bride as she walks down the aisle.

(above) During the marriage ceremony, a bride and her attendants sit behind a *mehitzah* (partition).

(overleaf) The *mehitzah* is lifted for the conclusion of the ceremony.

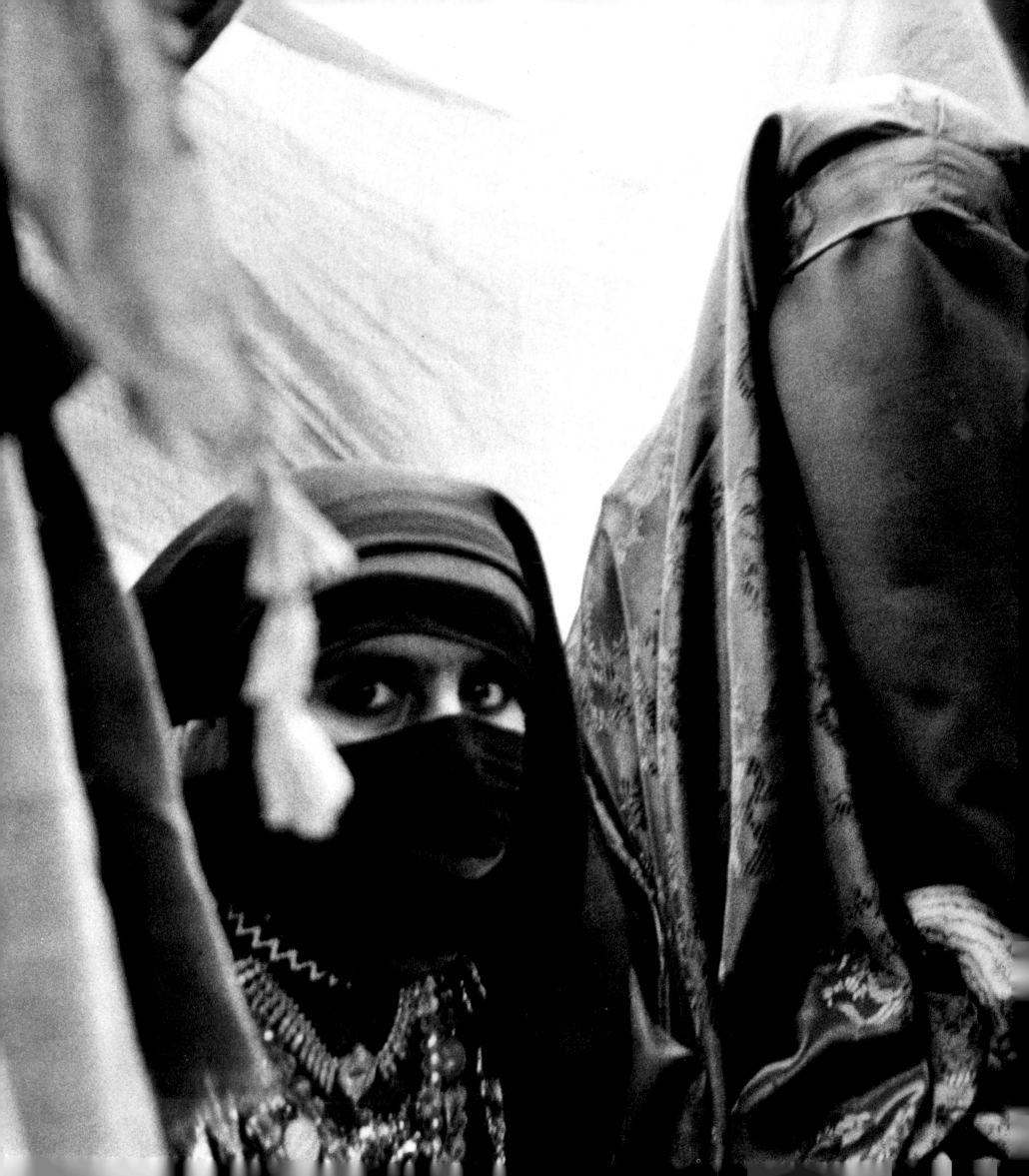

victories. Their prayers were recorded and saved as

models in Rabbinical Judaism," explains scholar Penina

Peli. ↷ The *Amidah* (silent prayer) originates from the

biblical Hannah's appeal to God for a son. Worshippers

mouth words of prayer in the same way Hannah

summoned God in the Temple. Her lips moved as if she

were speaking, but her voice could not be heard. The

Kohen Gadol (high priest) saw her, thought she was

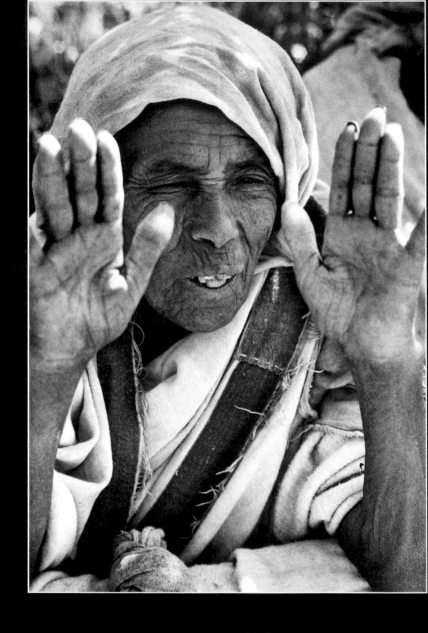

PRAYER

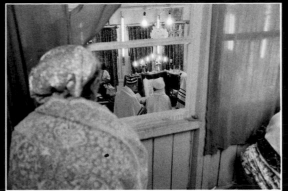

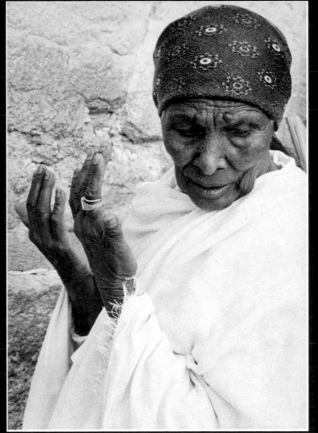

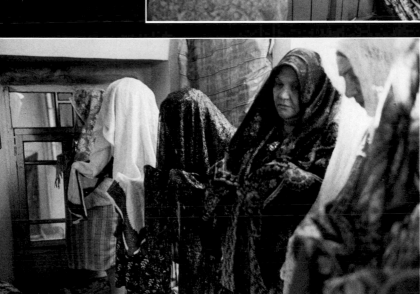

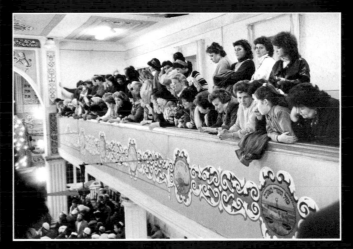

(clockwise from top left)
omen's gallery in a synagogue, Bukhara; The
Kotel (Western Wall), Jerusalem; Women's
allery, Kiev, Ukraine; *Davening* (praying) in a
ddik's tomb, Israel; Yemenite women pray at
Kotel, Jerusalem; "Women of the Wall" read
om the Torah in a prayer service in the Old
, Jerusalem; Women cover their heads with
shawls during the blessing of the *Kohanim*
(Priestly Blessing), Bukhara.

(facing page) Ambober, Ethiopia.

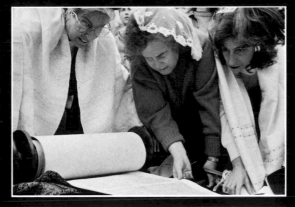

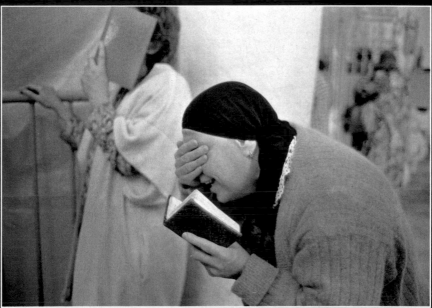

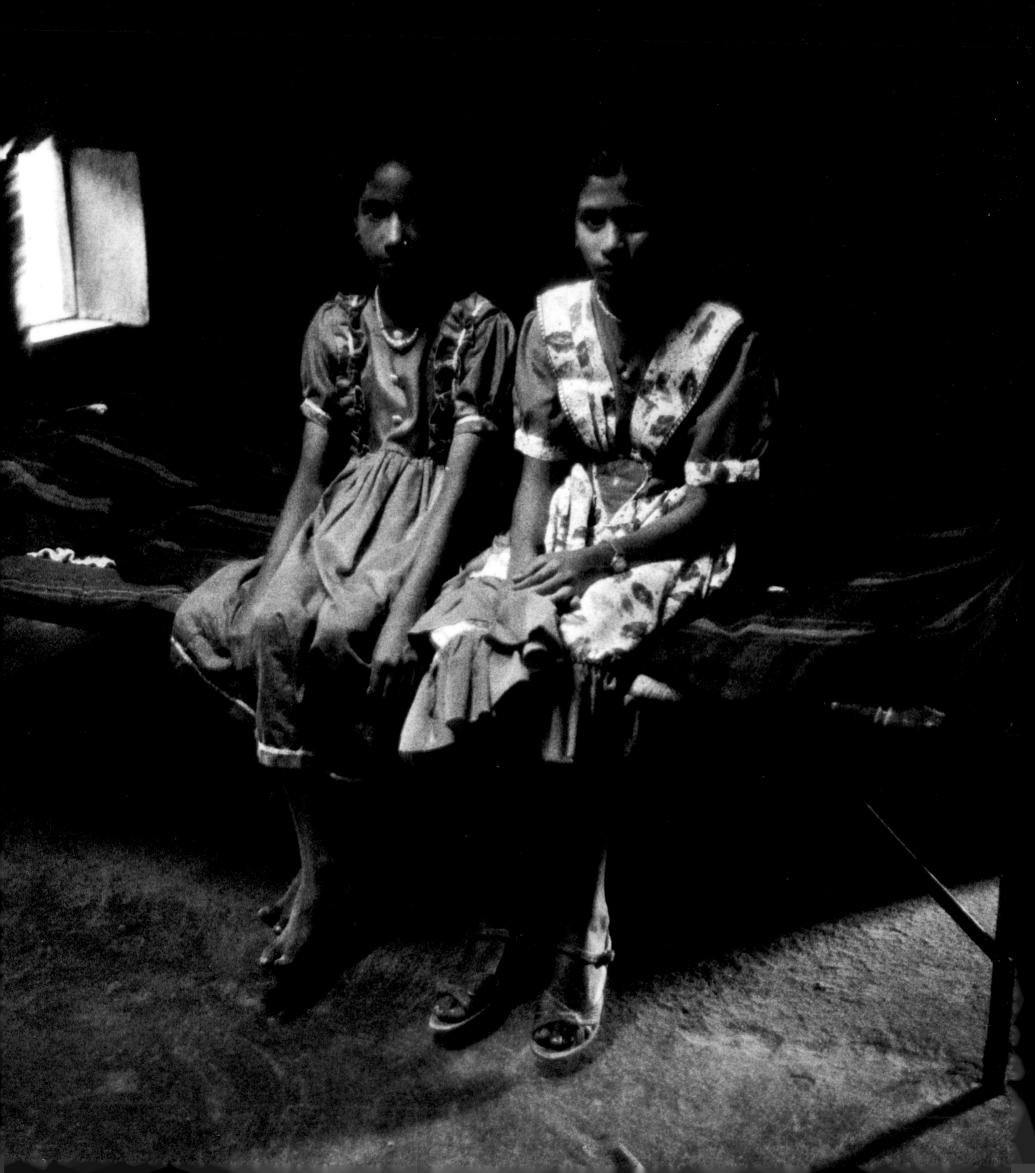

INDIA

The highest social position for an Indian woman is as a wife devoted to home and family. Historically, marriage overruled everything else, until Protestant missionaries opened schools and encouraged Jews to become educated. Oddly, women attended school while men pursued army careers. Mothers who'd never been out of the house worked as cooks and maids to pay for their daughters' education. At first it was revolutionary for girls to read books. Then in the early 20th century, Dr. Jerusha Jhirad, a Jew and India's first woman doctor, gave respectability and importance to the role of educated women — even those who selected a career over a husband.

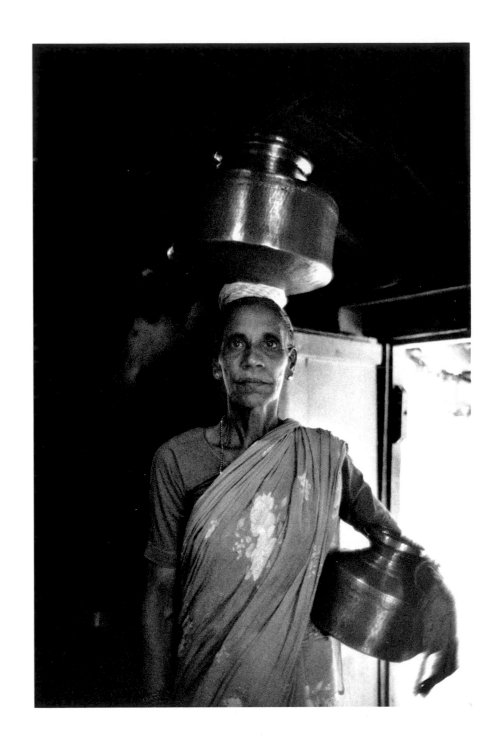

(above) A woman prepares to gather water from the community well in Alibag.

(facing page) Ruth Varsulkar returned from Israel to be with her grandmother, Elizabeth Abraham. "Granny's the root of our family," explains Ruth.

(previous page) Sisters Flora, Sarah and Elana (pictured with their mother) benefit from Dr. Jhirad's legacy.
Unmarried and financially independent, they contribute to the community through their work as educators.

(previous page) Two girls, a Buddhist and Jew, have become close friends.

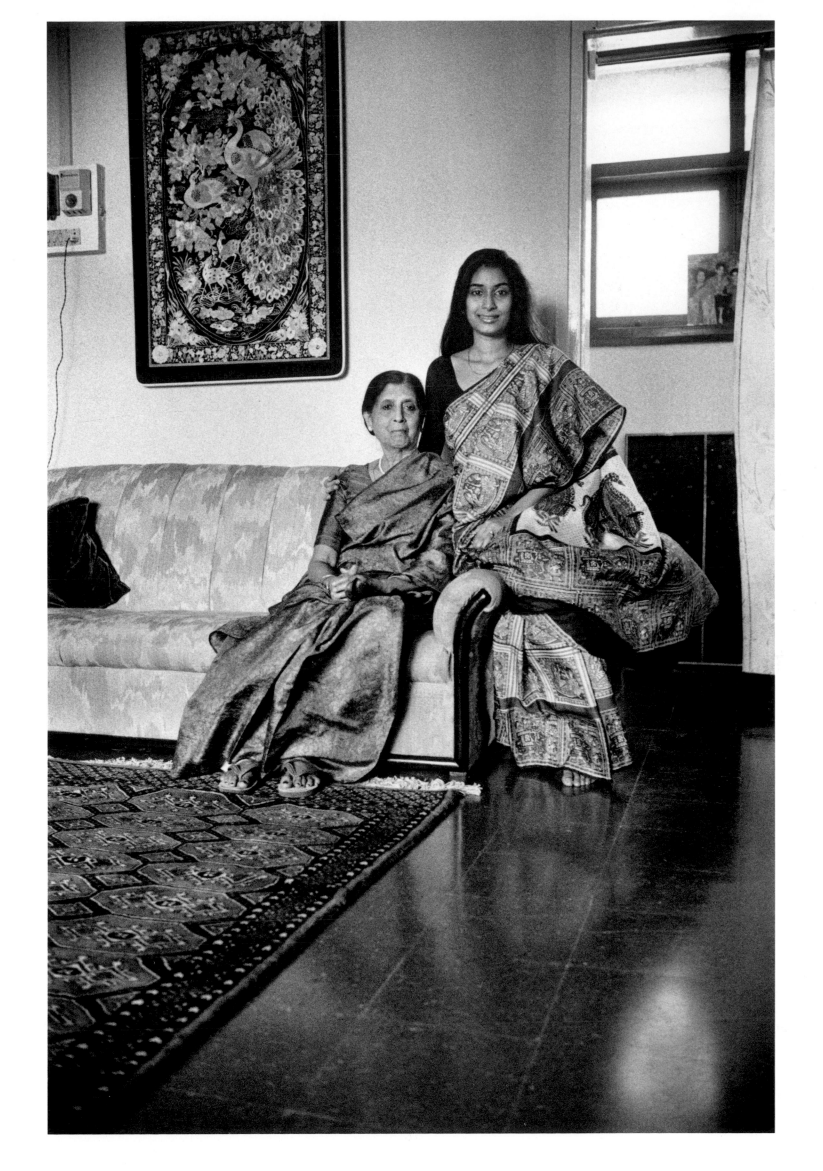

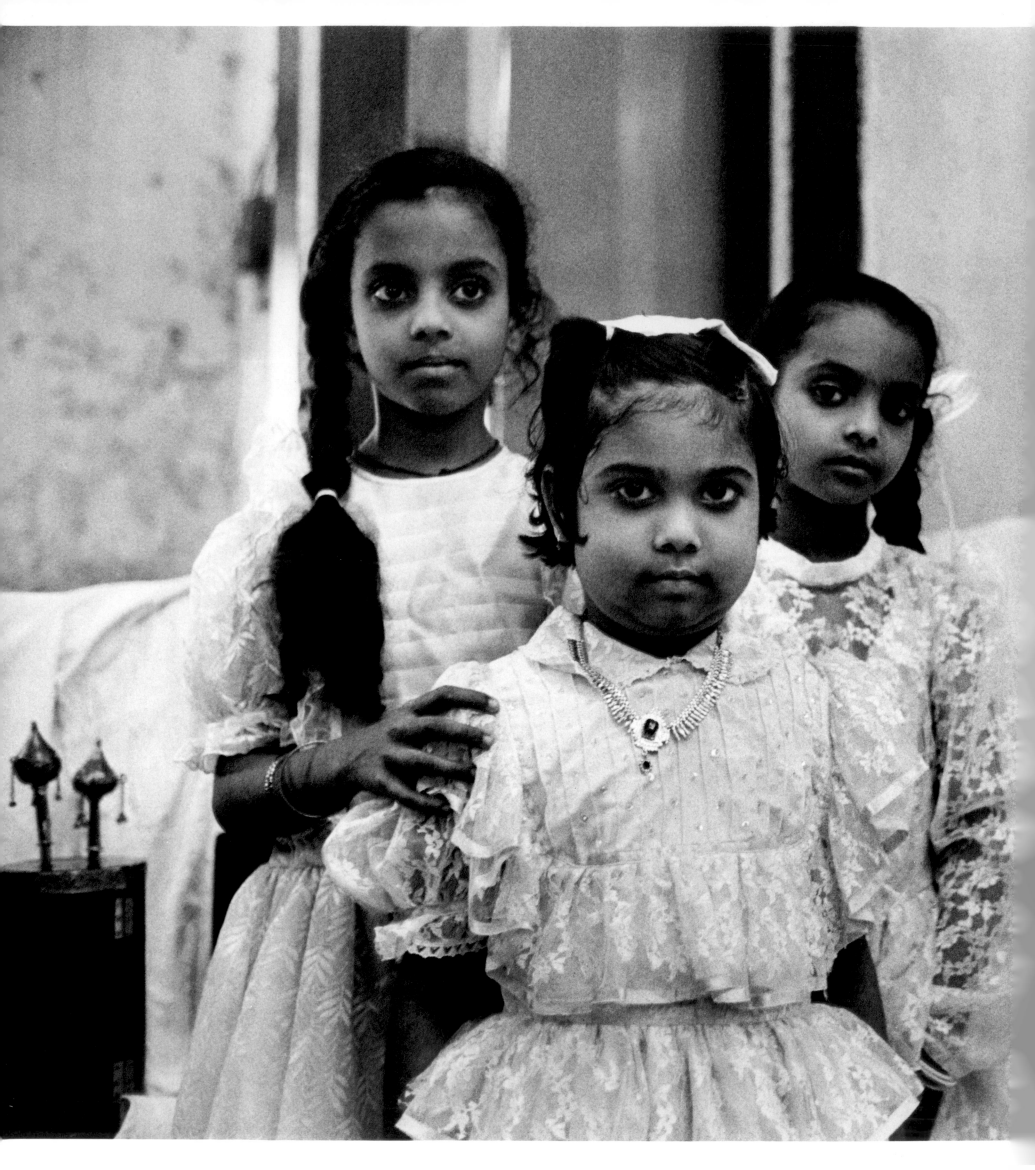

Three girls celebrate the holiday of *Simchat Torah* in the Magen Hassidim Synagogue in Bombay.

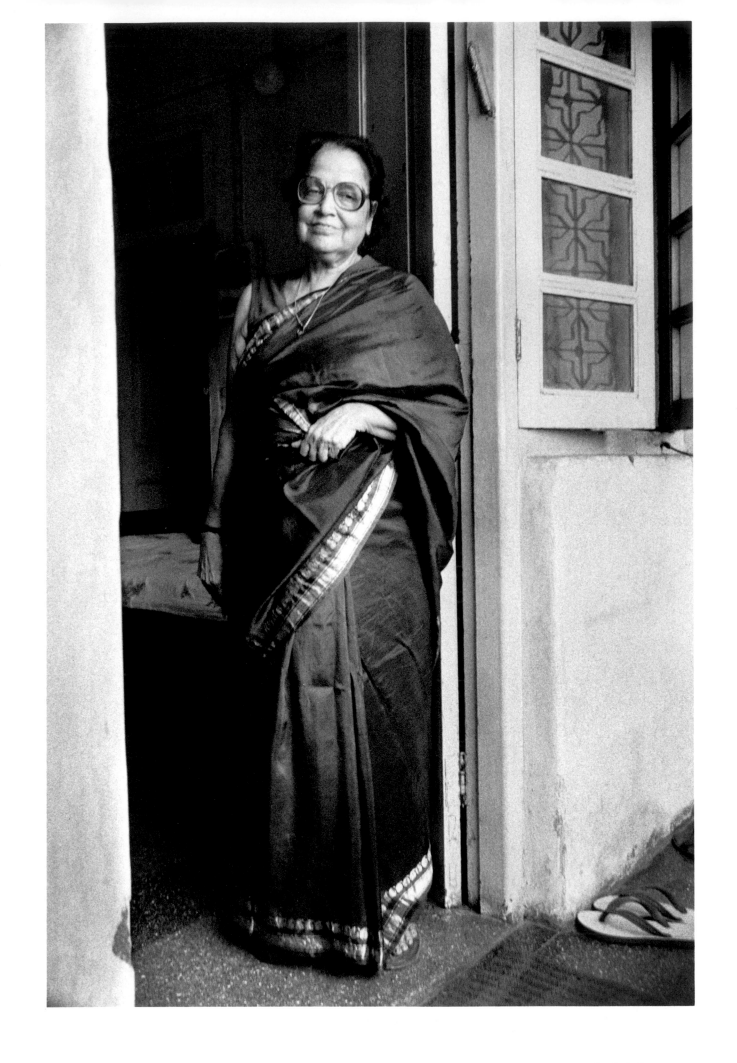

Esther Talkar, one of the first women to serve in the government in the 1950s, was scheduled to be Indira Gandhi's private secretary prior to the prime minister's assassination.

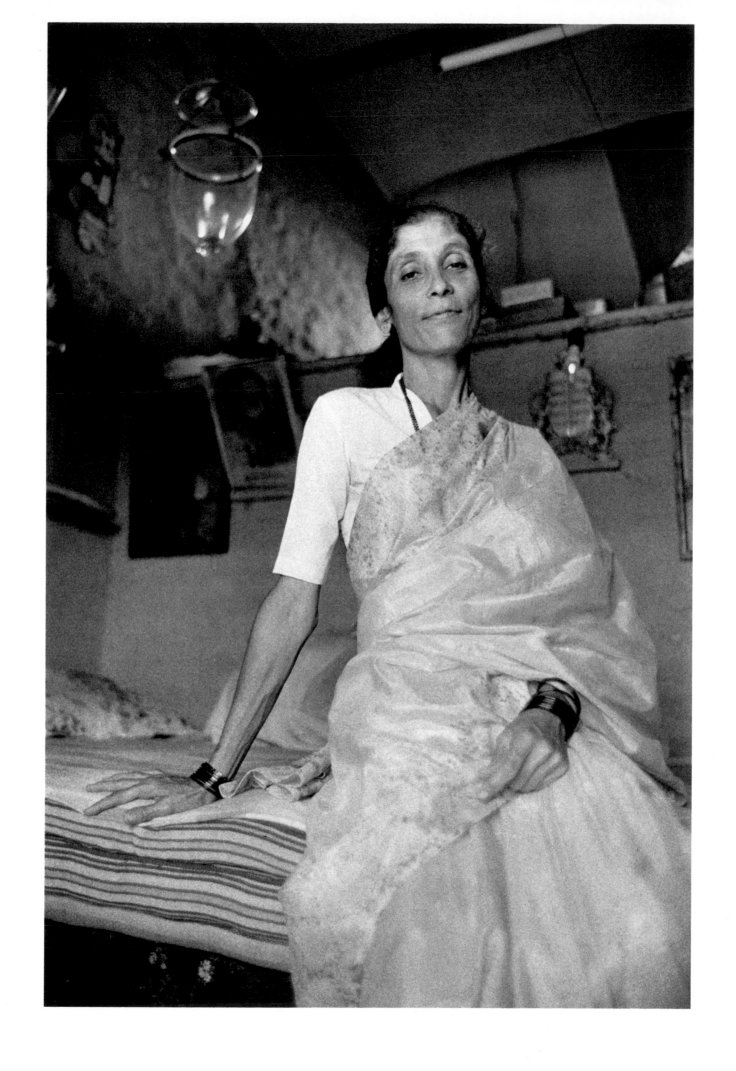

A woman who works in a rice mill in Penn sits in a bedroom that is also her living room.

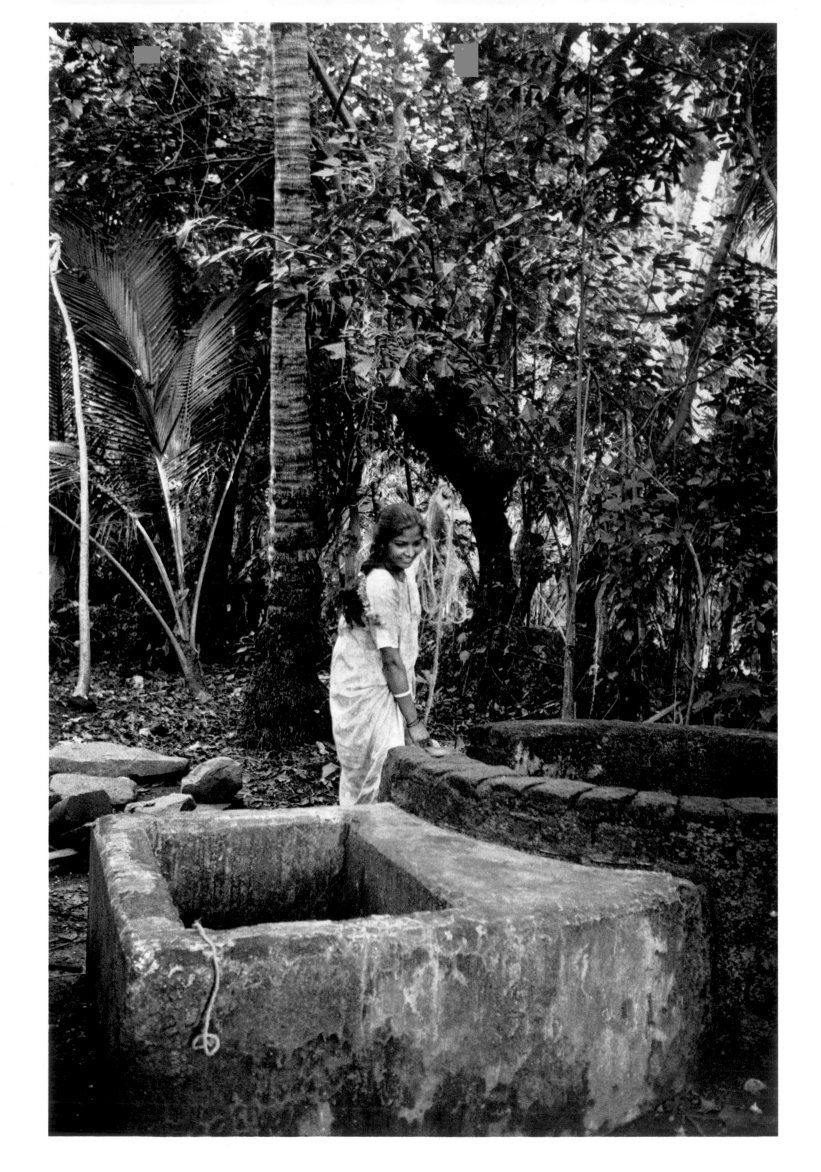

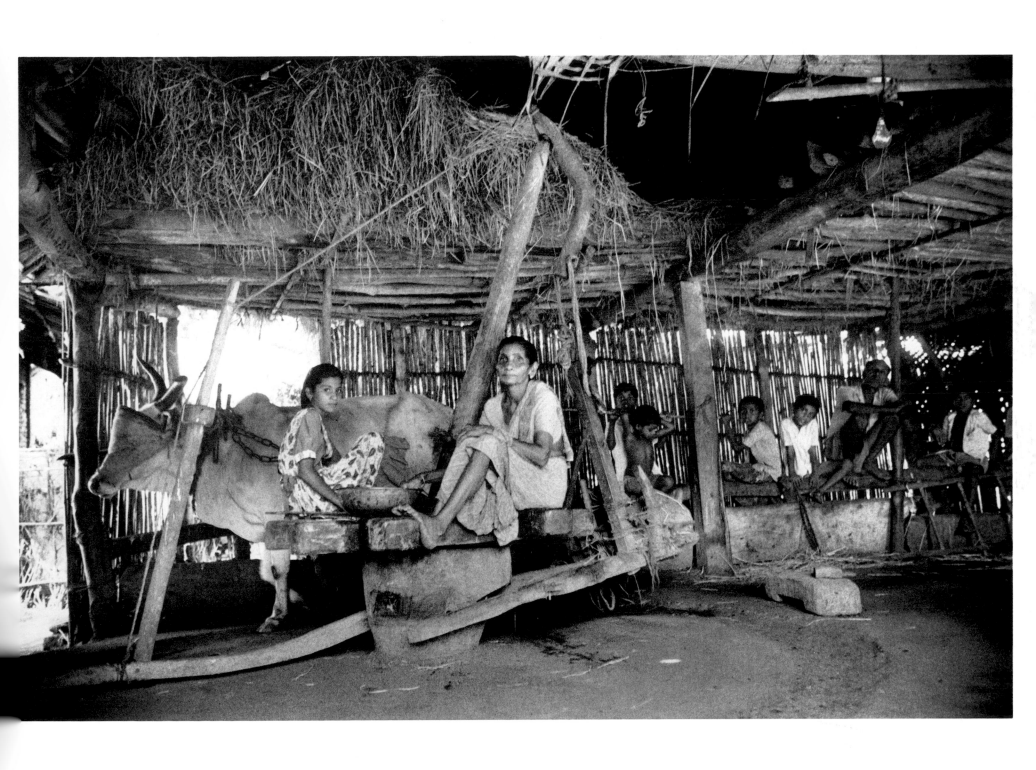

(above) A grandmother teaches her granddaughter the ancient skill of pressing oil from coconuts.
Women usually didn't work outside the home, but wives of the *Shanwar Telis* (oilmen who keep the Sabbath) always assisted their husbands.

(facing page) A woman gathers water from a private well.

(above) An artist paints the hands and feet of a bride-to-be with *henna* as a child entertains them.

(facing page) Detail of the intricate design on the hands of a bride. A portion of the right index finger is left bare for women to apply the remaining dye in the *henna* ceremony, which they believe will bring good luck.

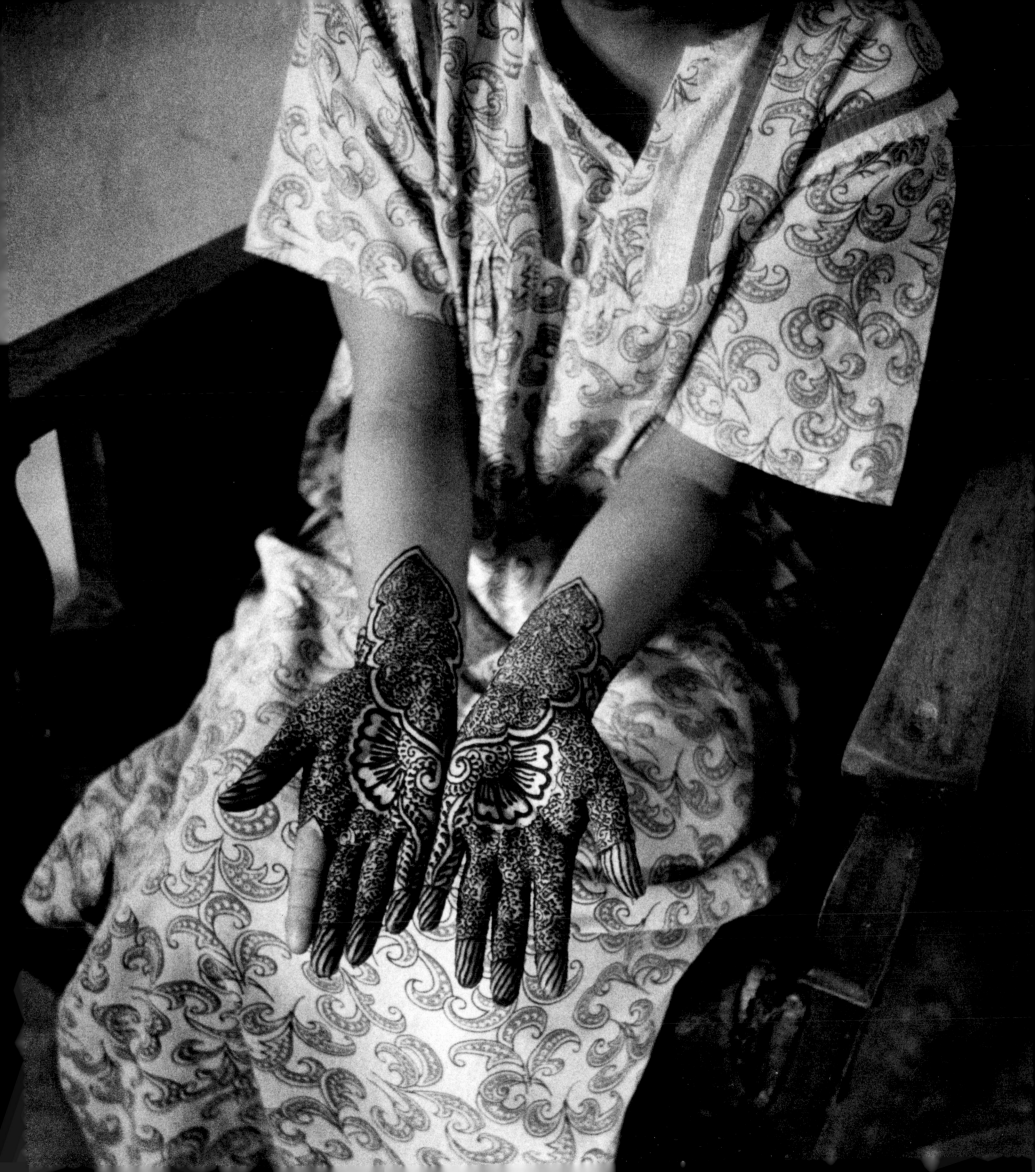

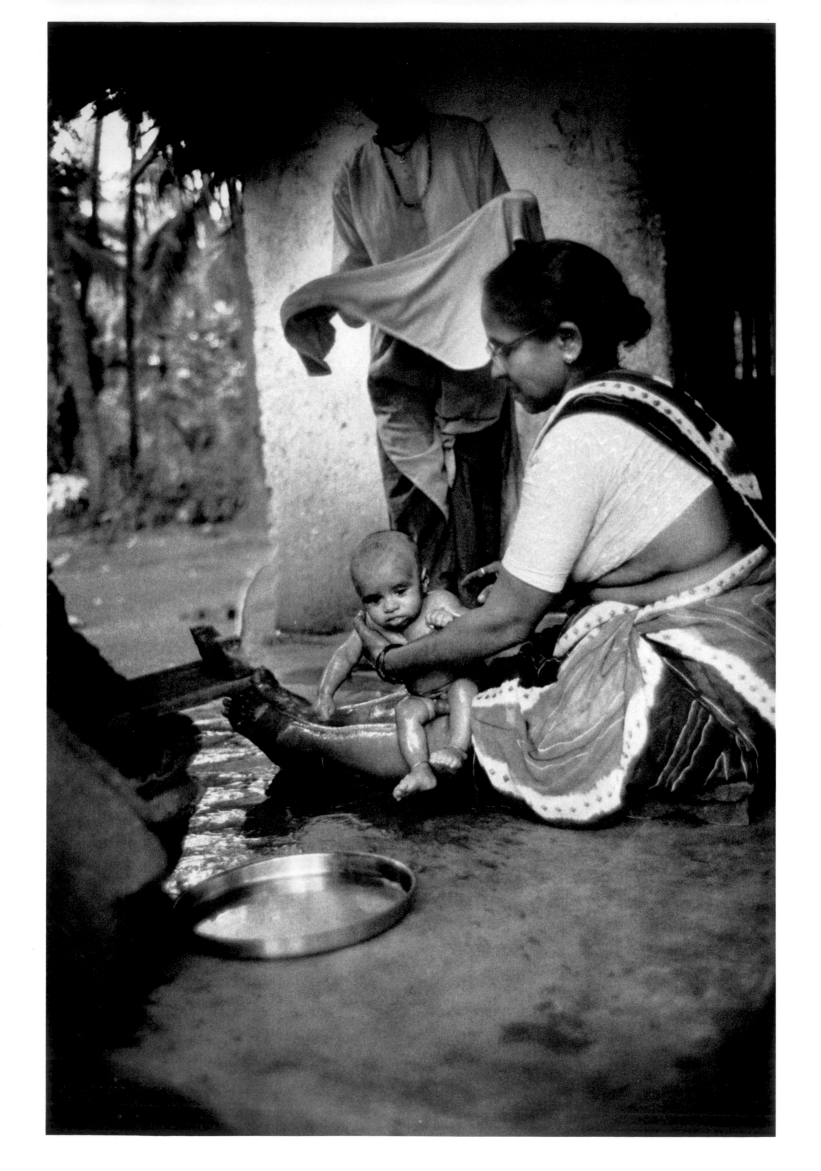

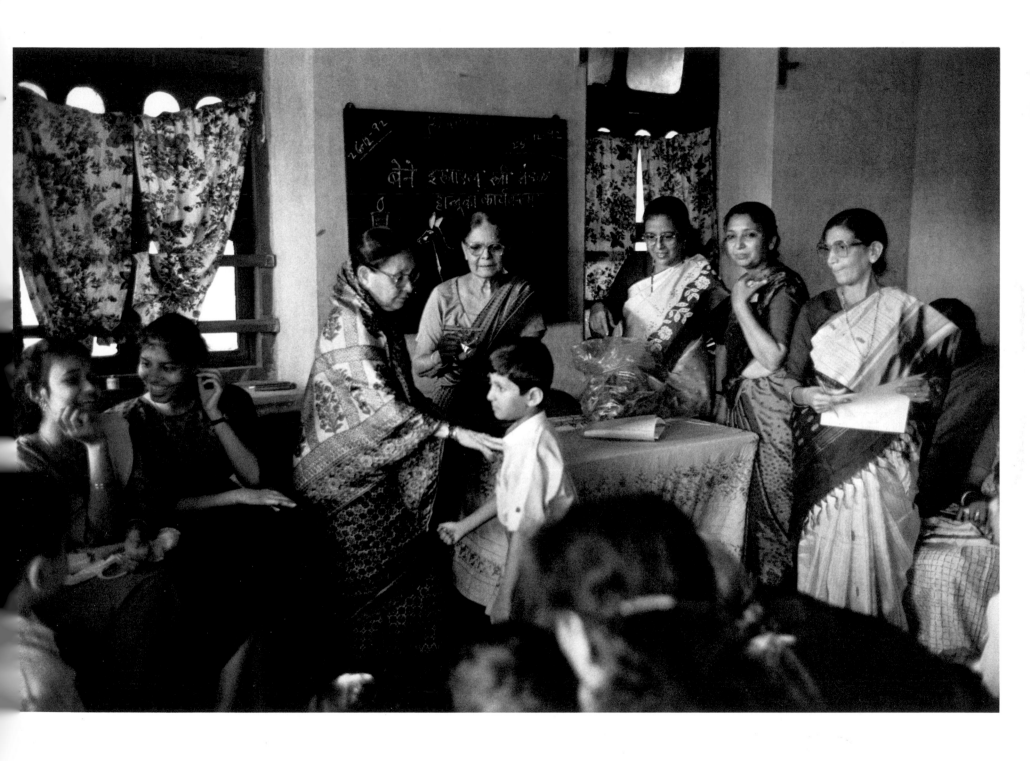

(above) Shri Mandal, a women's volunteer organization, was founded in 1913 by Dr. Jerusha Jhirad to help other women and the entire community. Today women in Bombay continue her tradition of charity by hosting a Hanukkah party.

(facing page) A grandmother bathes her grandchild in Alibag.

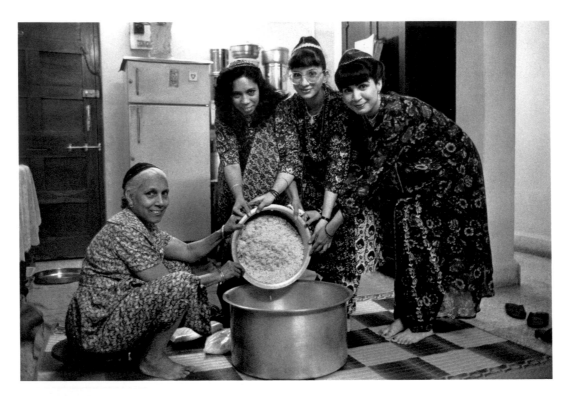

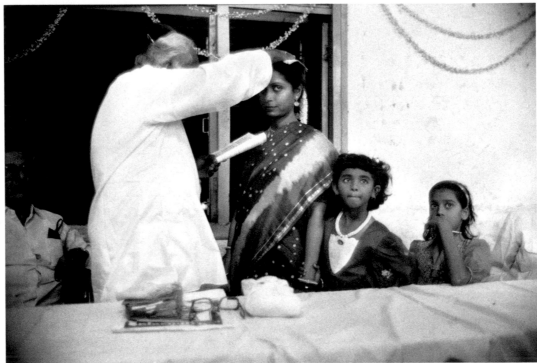

(top) Pressed rice, fruit and coconut milk are prepared in a big pot and served in the *malida* ceremony — an offering to the prophet Elijah.

(bottom) A father blesses his daughter using her maiden name for the last time before her marriage as part of the *mehndi* (henna) ceremony.

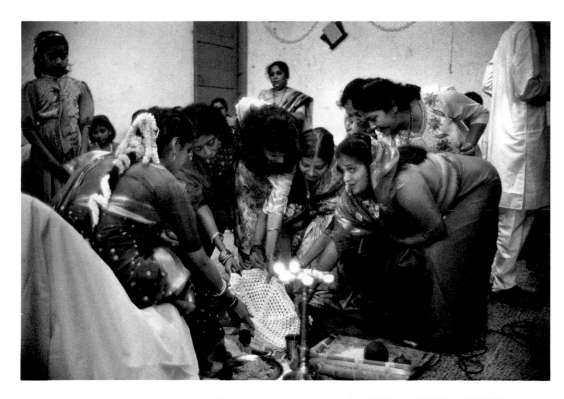

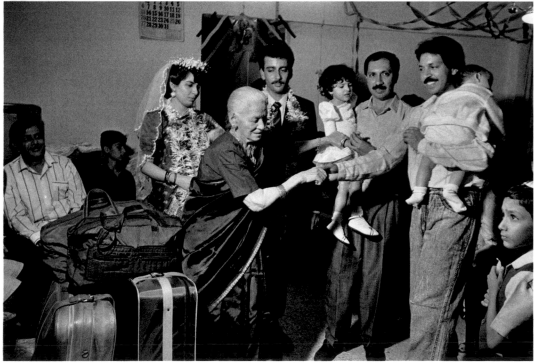

(top) Seven unmarried women apply *henna* to a bride's finger during the *mehndi* ceremony, hoping they too will marry.

(bottom) The day after the wedding, the family gathers for the *doli* ceremony — a tearful farewell for a bride leaving home to live with her new husband and his family.

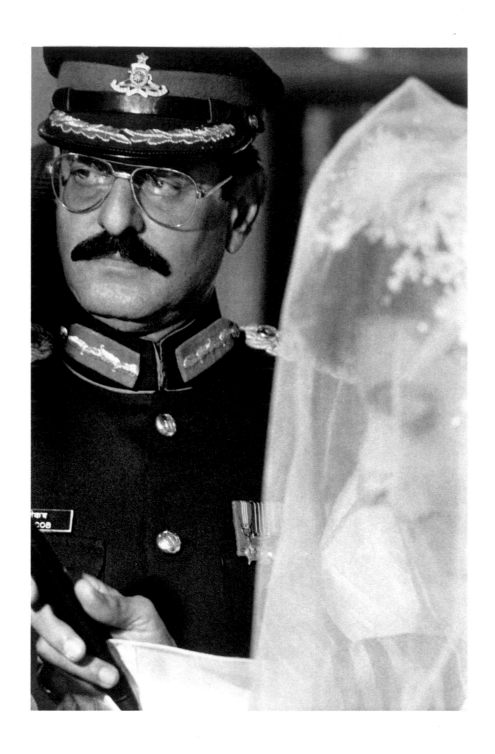

(above) Regina's father, a colonel in the Indian army, listens as the *ketubah* (marriage contract) is read under the *chuppah* (canopy).

(facing page) The grandparents of Regina's groom, Ruby and Samuel Solomon, based their fifty-year marriage on equality. Both doctors, they supported each other in their careers and shared the raising of their children.

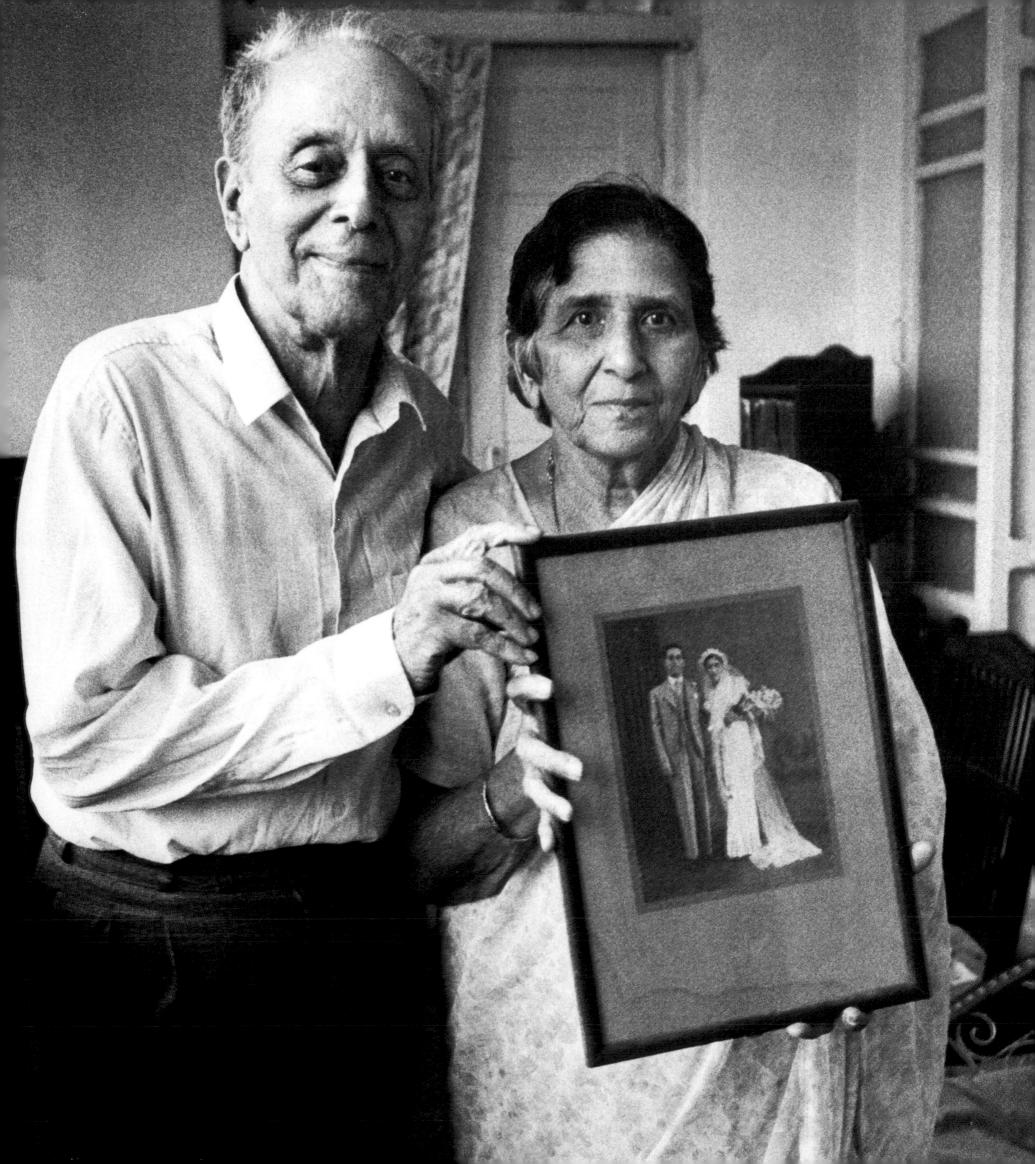

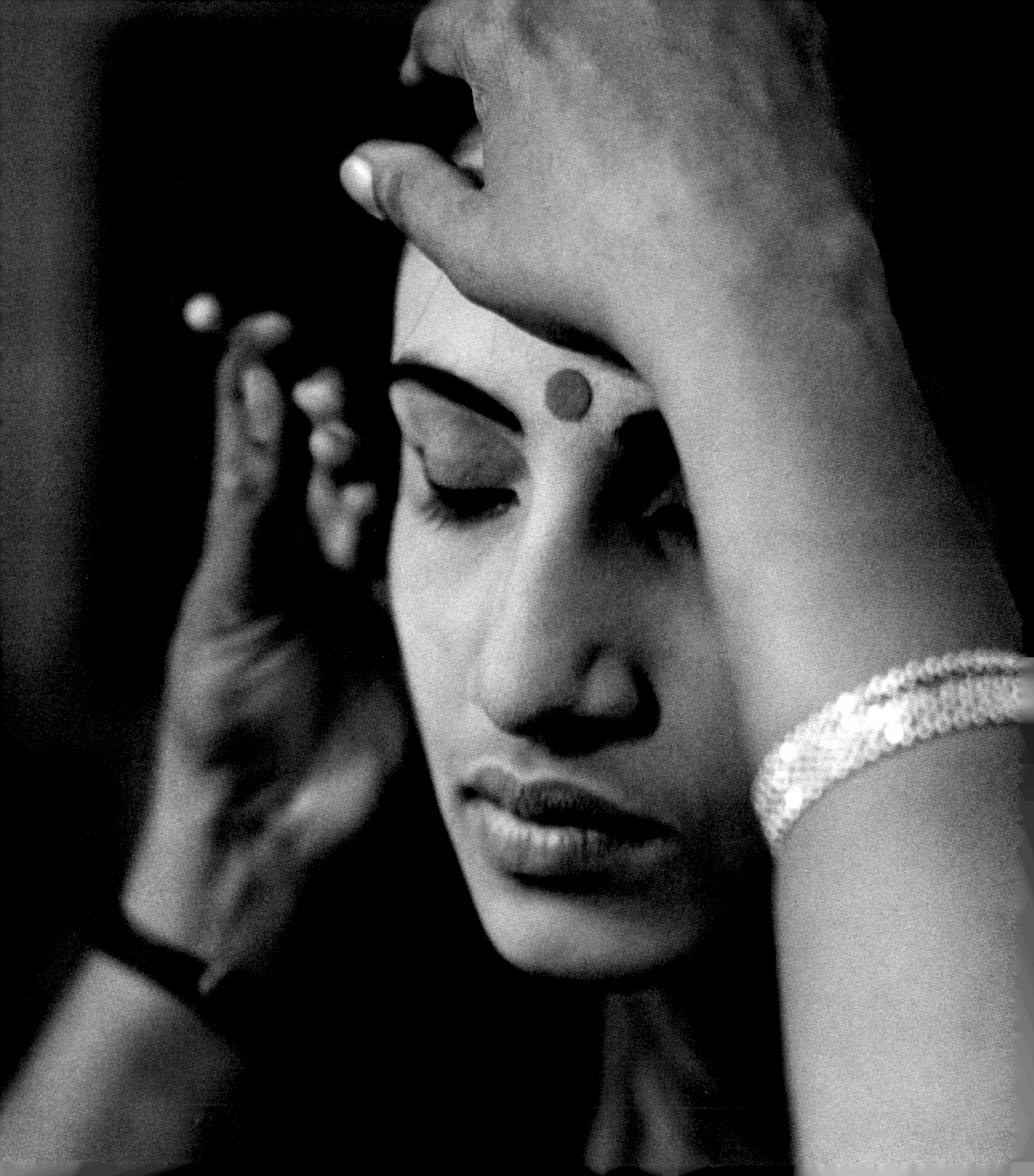

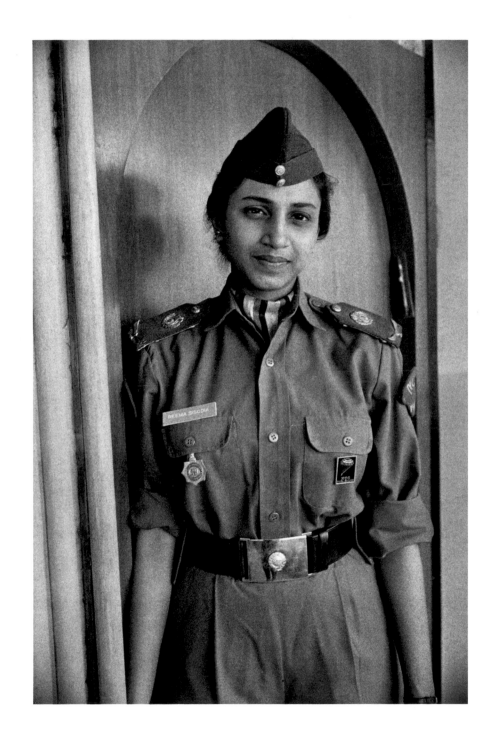

(above) Reema Sisodia ranks first in the National Cadet Corps Air Wing Division. Even though she is highly accomplished and well integrated into Indian society, she dreams of making *aliyah* (going to Israel).

(facing page) A Baghdadi-Indian Jew and political science student, Reema is being made up in traditional fashion for a performance of *kathak* (classical) dance.

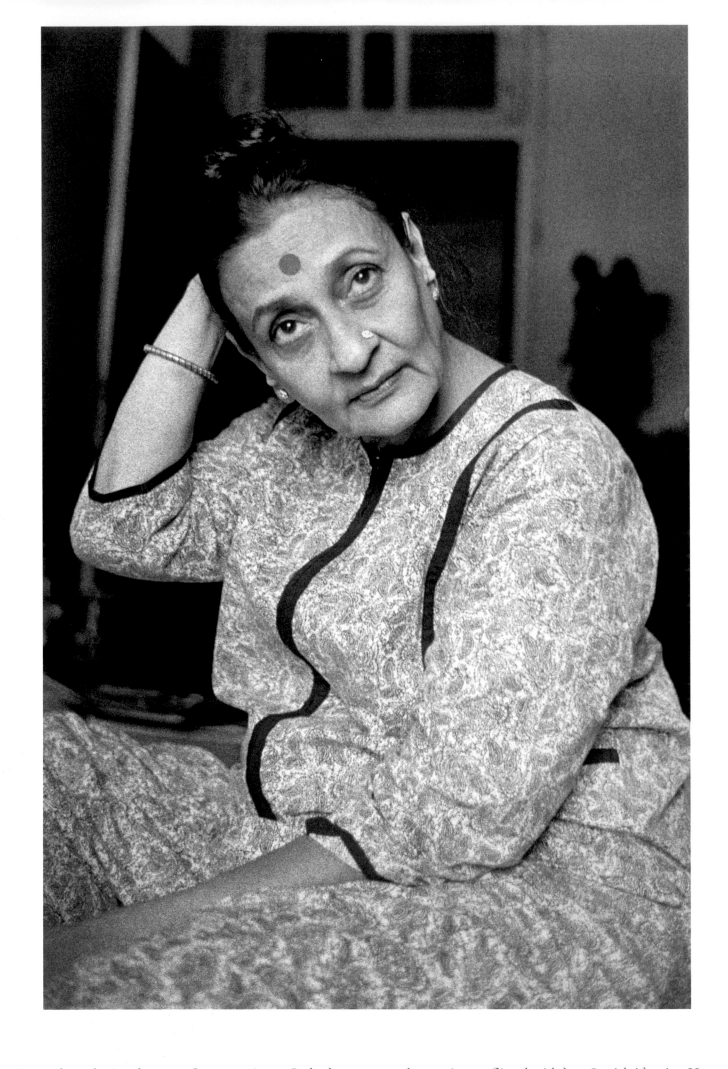

Nadira rose to movie stardom playing the part of a vamp. As an Orthodox woman, the movies conflicted with her Jewish identity. Her mother warned her that if she acted in risqué roles and wore a *tikka* on her forehead, no Jewish man would marry her. None did.

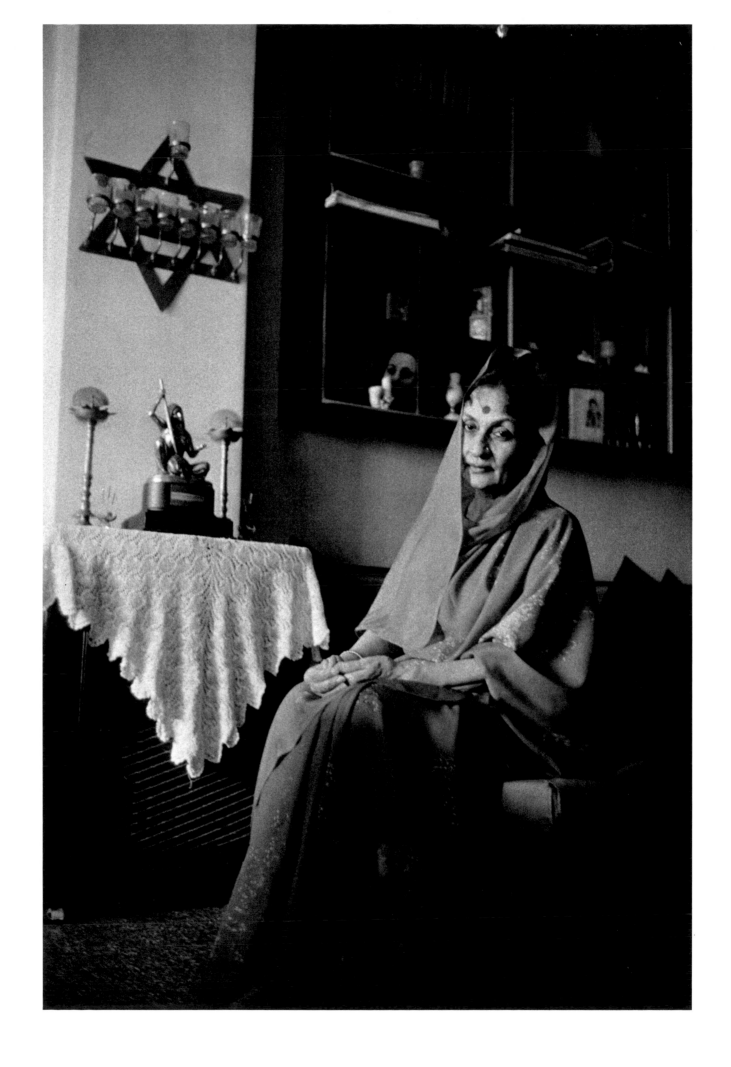

Left with a sense of longing, Nadira struggles between her Jewishness and fame. When asked what she would choose to be if she were given a chance to live again, she replied, "I'd have to come back as twins: one to marry a Jewish man; one to be a star."

Deborah the prophet is also known as the woman with

lapidot (torches) because she used torches to ignite the

Temple lamps. Like Deborah, a Bukharan woman

(right) uses her torch to lighten the spirit by healing the

body. "My wisdom comes from the highest sources —

God and my mother," she says. ✺ According to

Susan Starr Sered, author of "Women as Ritual

Experts" and noted anthropologist, women experience

religion as a caring and interpersonal relationship with

history and cosmology. Because women are responsible

for the spiritual, physical and psychological well-being

of the family, they use rituals to celebrate feminine

energy and to add piety to rites of passage.

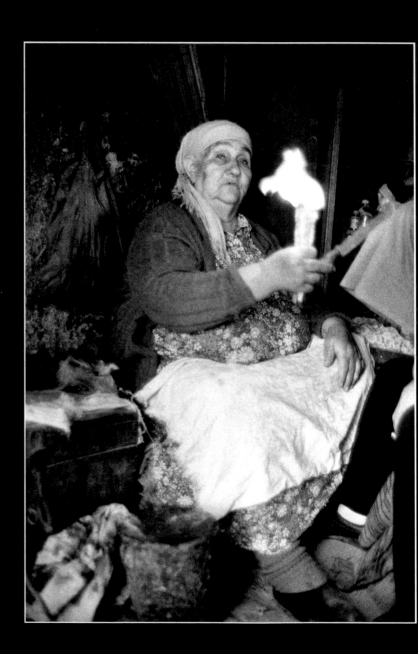

R I T U A L

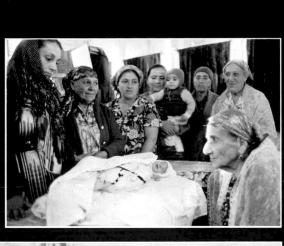

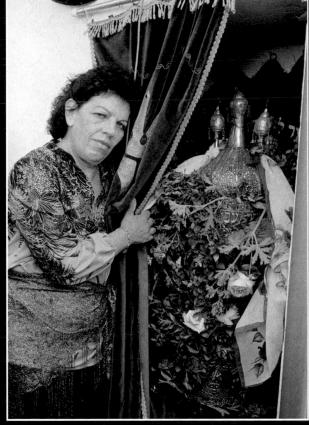

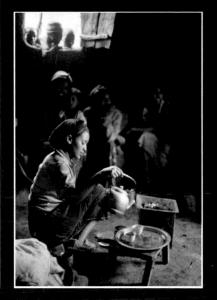

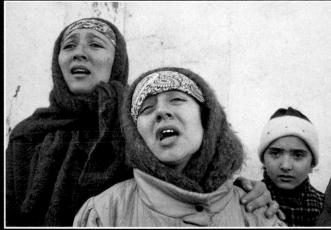

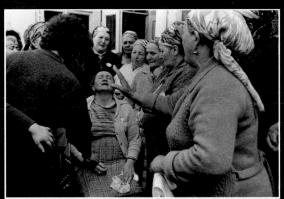

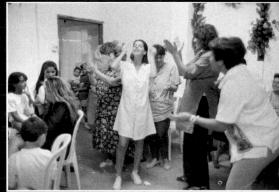

(clockwise from top left) Women prepare a newborn boy for his *bris milah* (circumcision), Bukhara; Opening the ark on Lag B'Omer, Safed, Israel; Coffee ceremony, Waleka, Ethiopia; *Mikveh* celebration, Jerusalem; A *Sukkah*, Bukhara; Queenie shakes a *lulav* (palm) and *etrog* (citron) in a *Sukkah*, Cochin, India; Two sisters mourn the loss of their mother, Bukhara; (center) Bukharan women sing and lay on hands to heal while in mourning.

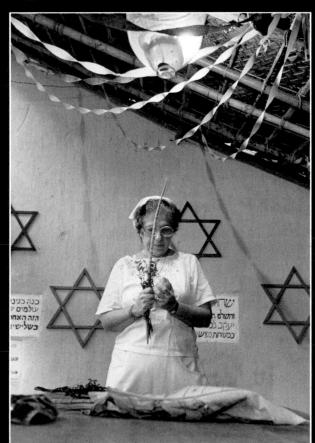

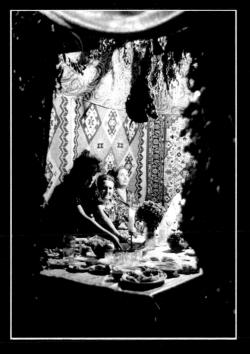

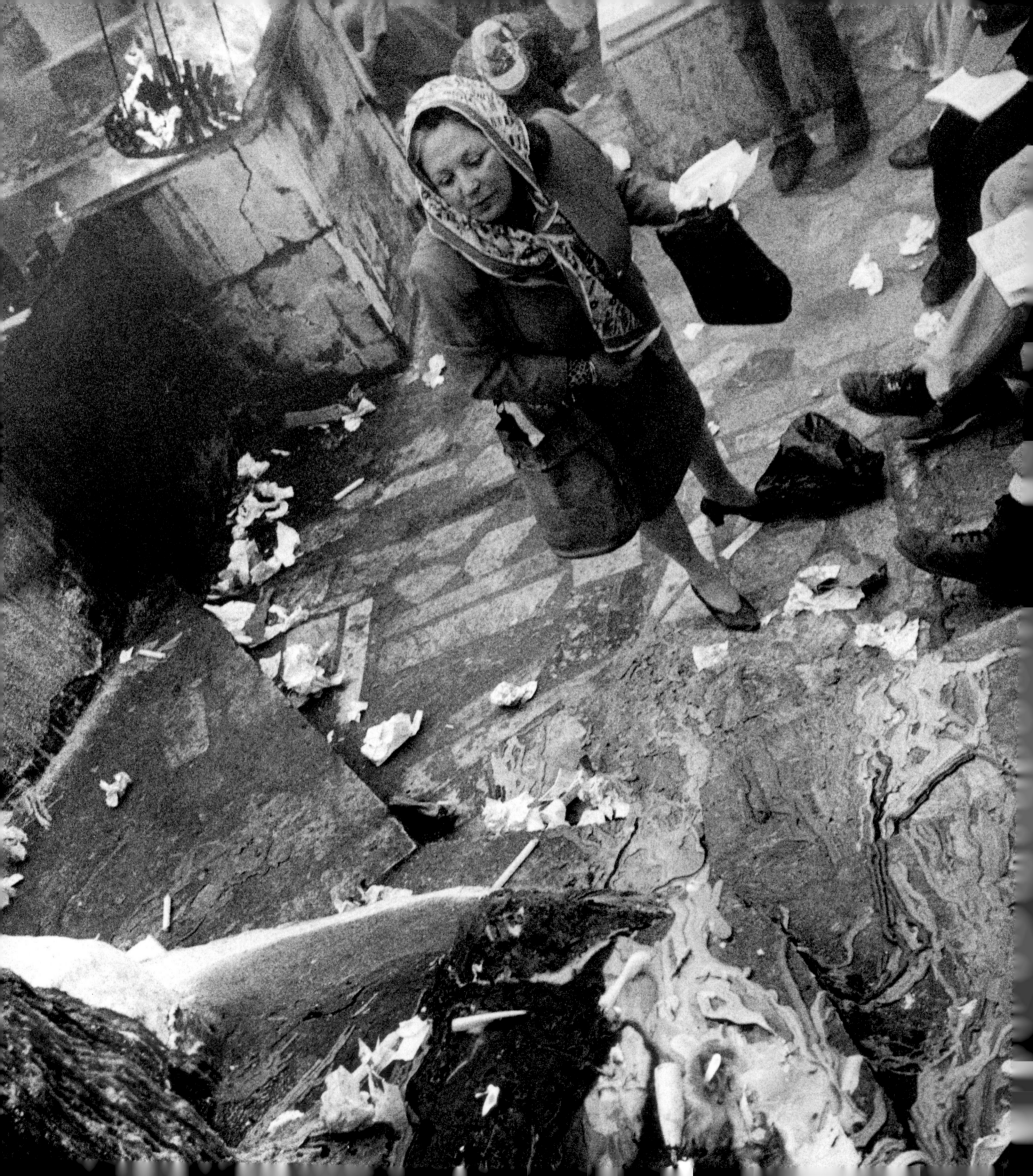

MOROCCO

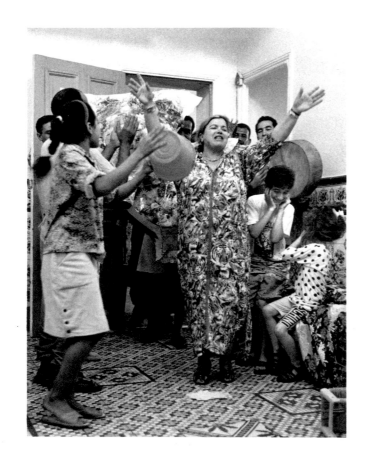

Illness is cured and problems solved through mysticism, magic and superstition. Every grandmother tells stories of saints who appear in dreams and of miraculous cures at their shrines. ⁊ Seeking divine intervention, this woman (facing page) throws candles into the flame at the tomb of Rabbi Amram Ben Diwan, the most popular tzaddik (righteous soul) in Morocco. She throws the candles in order to light the inside of his grave and awaken his soul before asking for a blessing on behalf of her children. "I can't get through this world without a little help to ease life's struggles," she explains.

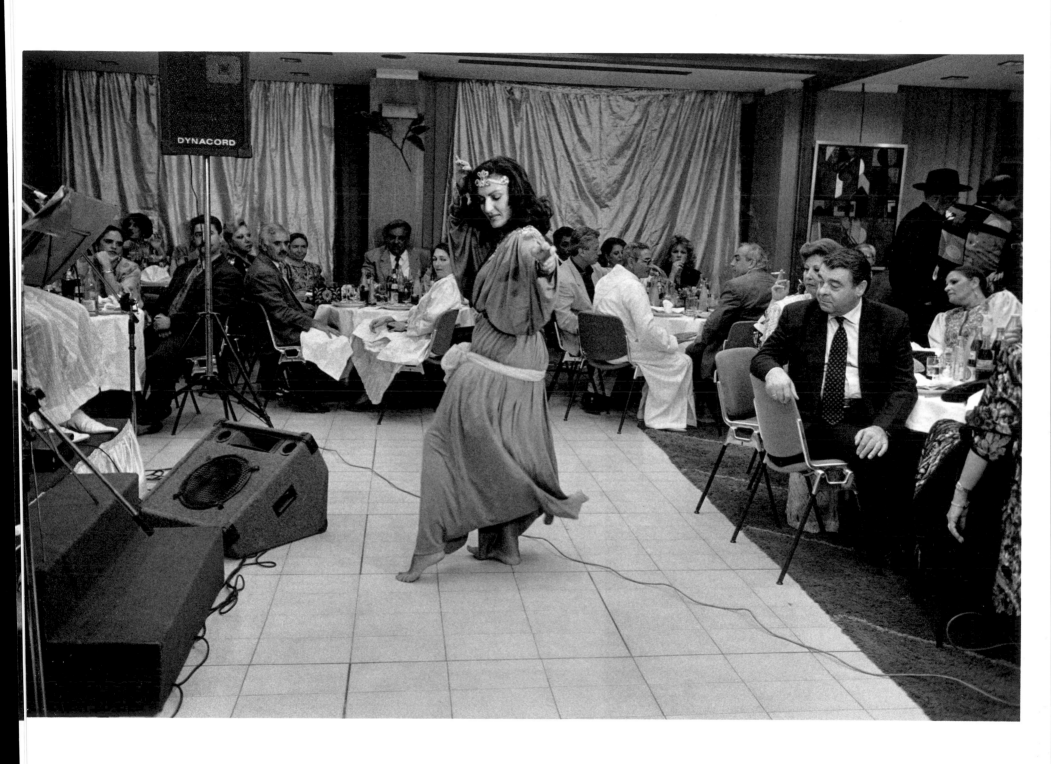

(above) Belly dancing is an important tradition in which the women try to outdo each other.

(facing page) Arlette on the morning of her daughter's wedding.

Madame Oinounou, the founder and CEO of Impricolor
Printing Inc., bought her first printing press in 1972. In 1980,
a brain tumor paralyzed her right leg, but didn't stop her. In
1981, she and Mr. Tagmouti, an independent contractor,
merged their companies. She says, "Tagmouti is a gentle sage."
He says, "Oinounou is intelligent and wise."

A Budapest pensioner *bentsht likht* (blesses candles)

using her grandmother's century-old candlesticks. Every

Friday evening as the flames flicker, she is reminded of

the miracle of her son's birth. ℘ She'd finally

conceived after ten years of marriage, just before her

husband was taken to a labor camp. "Perhaps we shouldn't

bring a baby into this world after all," he wrote. "I must

give birth to this baby," she answered. "I've waited

so long, and without you I will never have another

opportunity. Let the world be blessed with our baby!"

℘ After the birth, she left the hospital on an impulse

three days earlier than planned — three days before

fascists ransacked the hospital and killed all the patients.

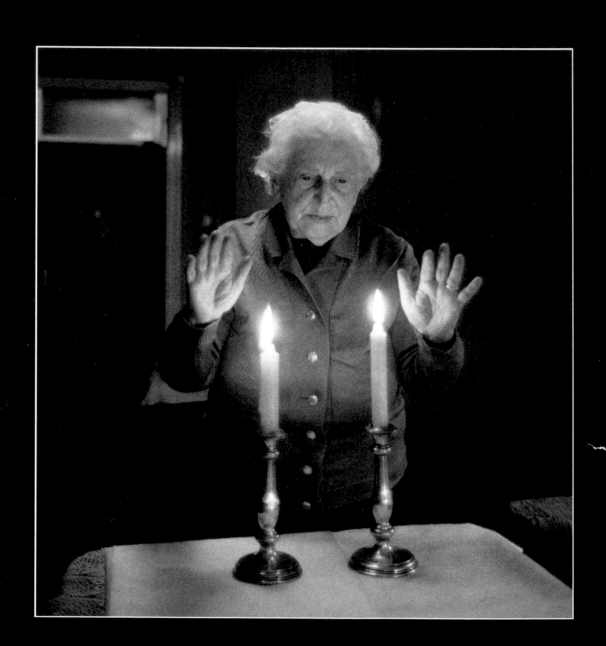

CANDLES

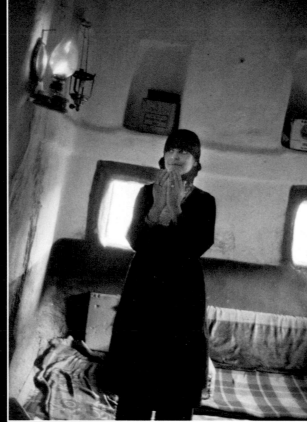

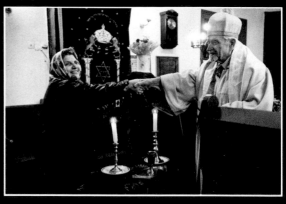

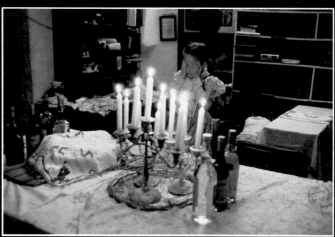

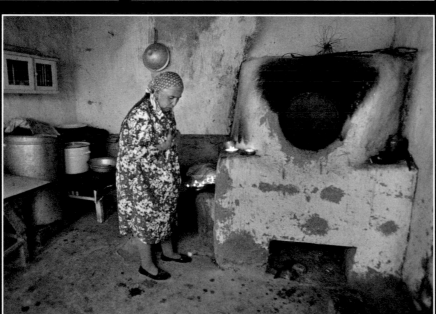

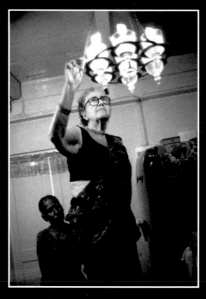

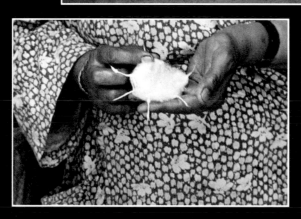

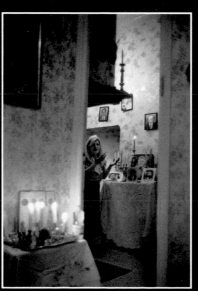

(clockwise from top left)

Yarzeit candles in a *tzaddik's* tomb, Israel; A wall lamp
is lit for the Sabbath, Saadah, Yemen; A woman is
congratulated by her cantor after kindling Sabbath
candles on behalf of the community, Sofia, Bulgaria;
Jerusalem; Esther Cohen lights seven lamps in a
chandelier on the Sabbath, Cochin, India; Madame
Oinounou follows the mystical tradition of lighting
Sabbath candles in every room of the house, Casablanca,
Morocco; Wicks are made of fresh spun cotton
wrapped around a thin piece of wood, Bukhara;
Lighting Sabbath candles, Bukhara.

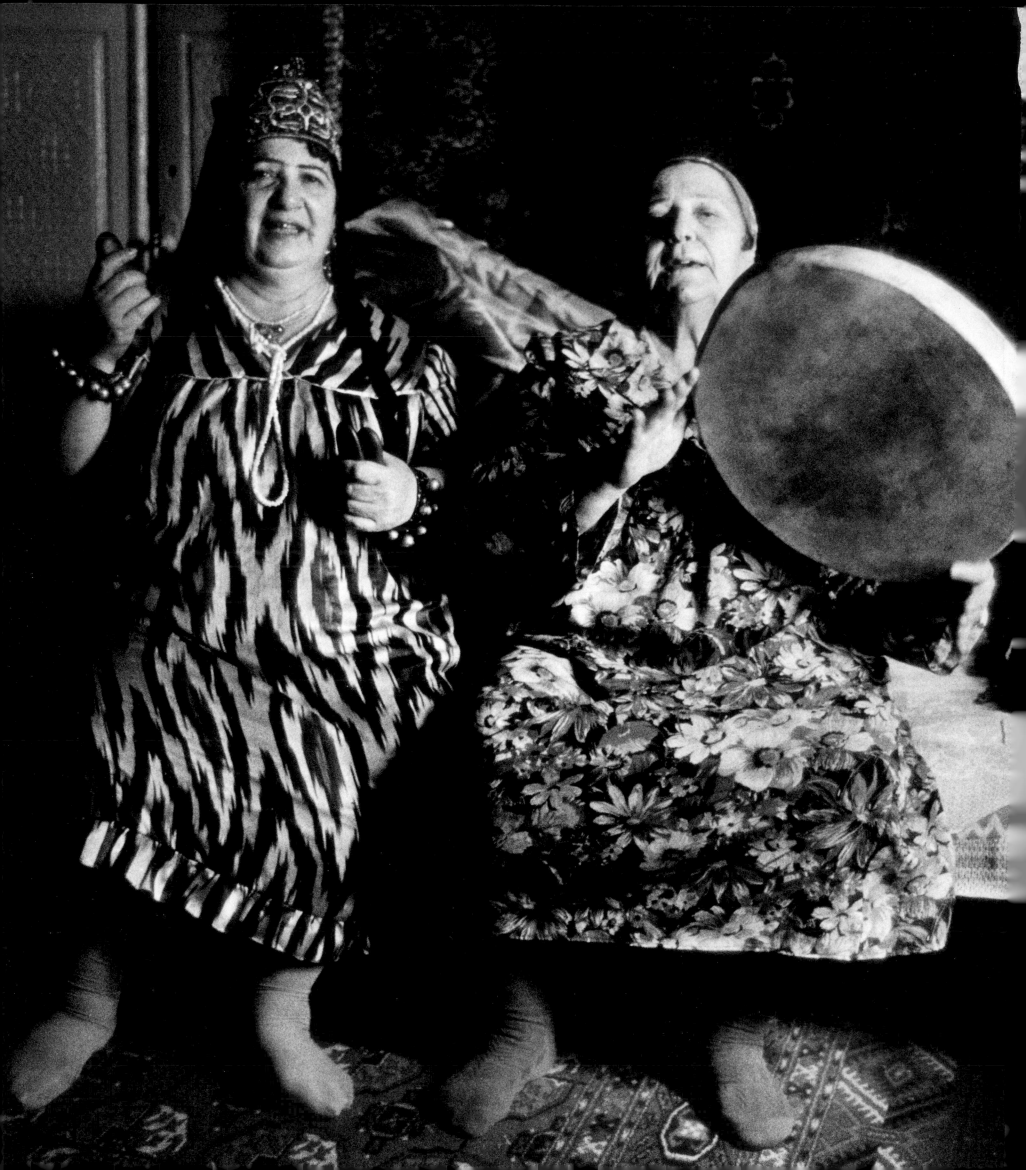

BUKHARA

Every Bukharan woman is a born musician and dancer. Jewish women performed in the courts of the Emirs (rulers) and to this day women like Shura Kariyeva (facing page, left) and Azebo Negazovna (right) play the bells and the doira (drum) to celebrate Jewish life. ॐ In this high-spirited community, dating back to the 8th century, cooking is a religious activity. Though religious practices were forbidden under Communist rule, women continued to follow dietary regulations from memory, koshering their homes, cooking for the Sabbath, holidays and endless celebrations. "We do it the way our grandmothers did and because tradition must be passed on," explains one woman.

Mazel Zolup, a naturopathic healer, waves a burning rag
on a stick as an all-purpose remedy.

(previous page) An abandoned women's gallery in
a synagogue closed by Stalin is now reopened.

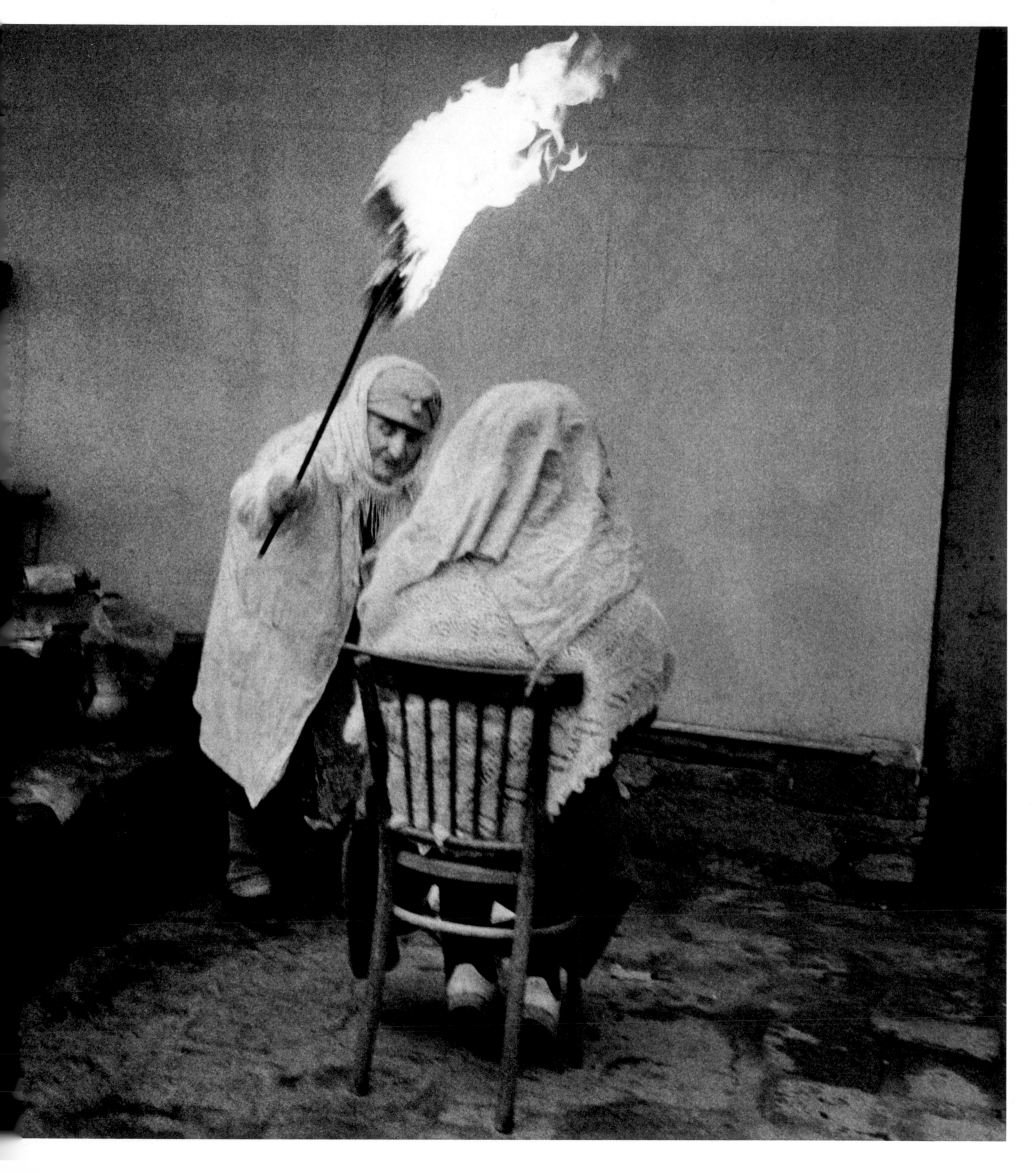

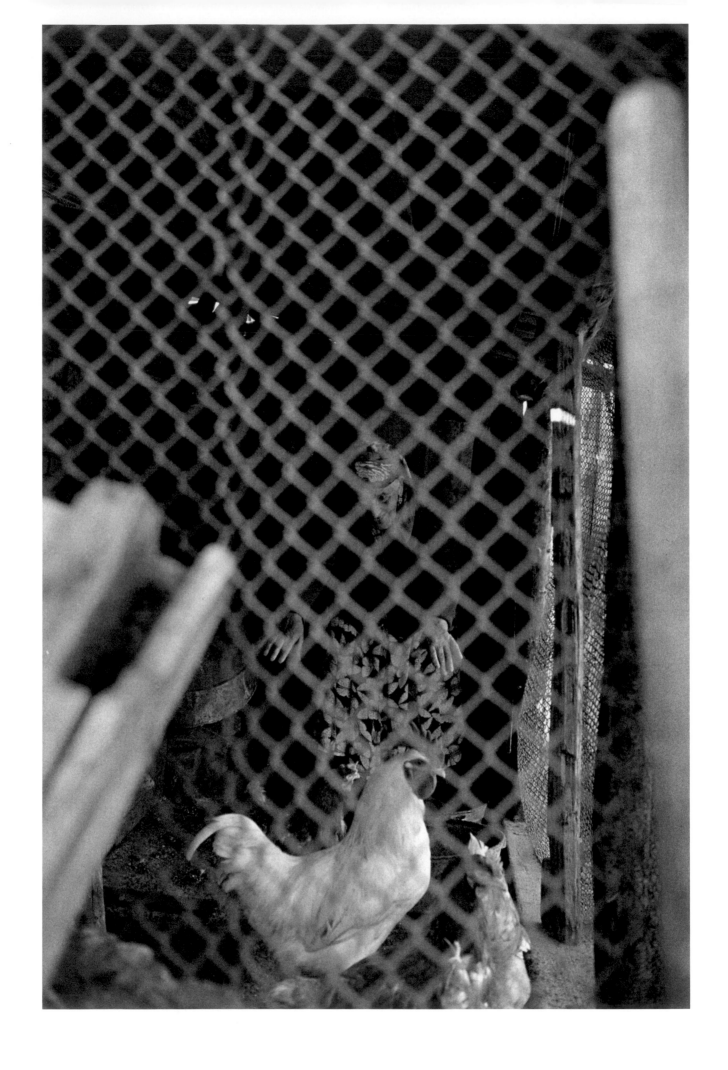

Waving her hands, this woman blesses the chickens before she feeds them.

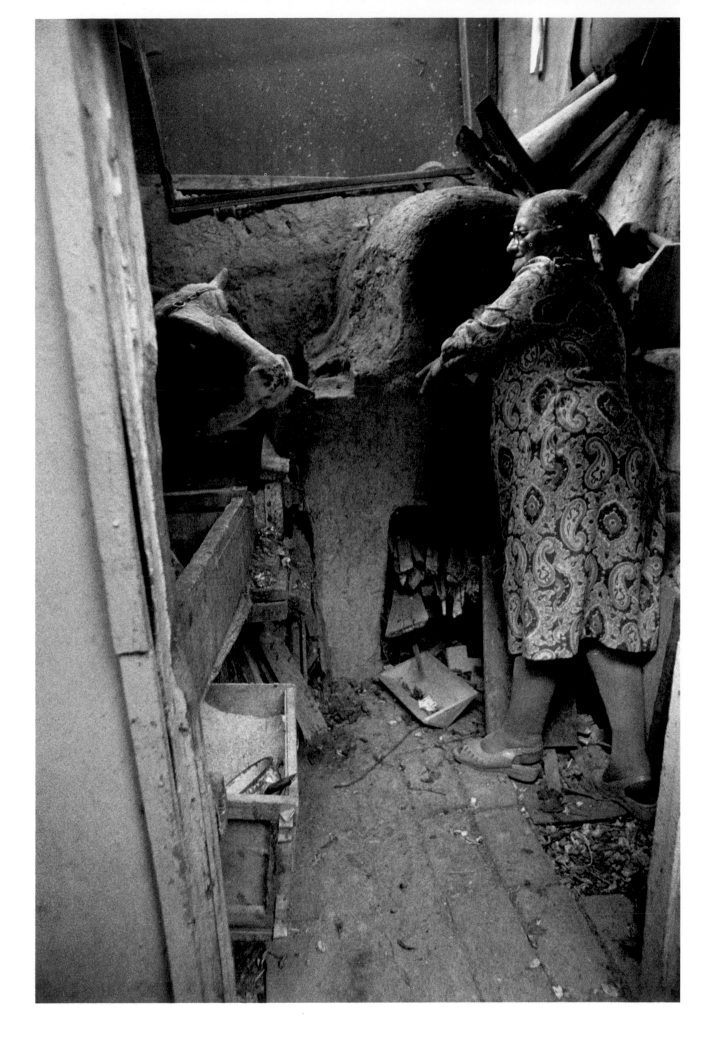

A woman bakes bread as a cow waits to be slaughtered.

(overleaf) After a loved one dies, women cook enough chicken to serve hundreds of mourners.

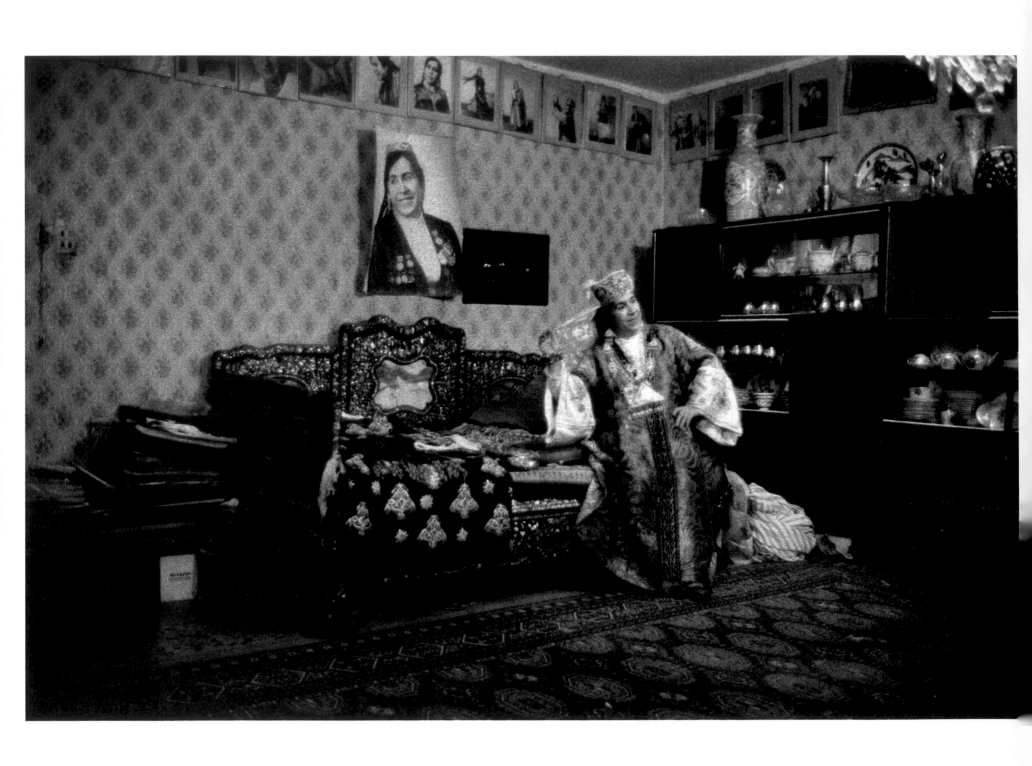

Dressed in distinctive ethnic attire, famed folk dancer Margarita Akilova sits on a mother-of-pearl sofa in her living room.

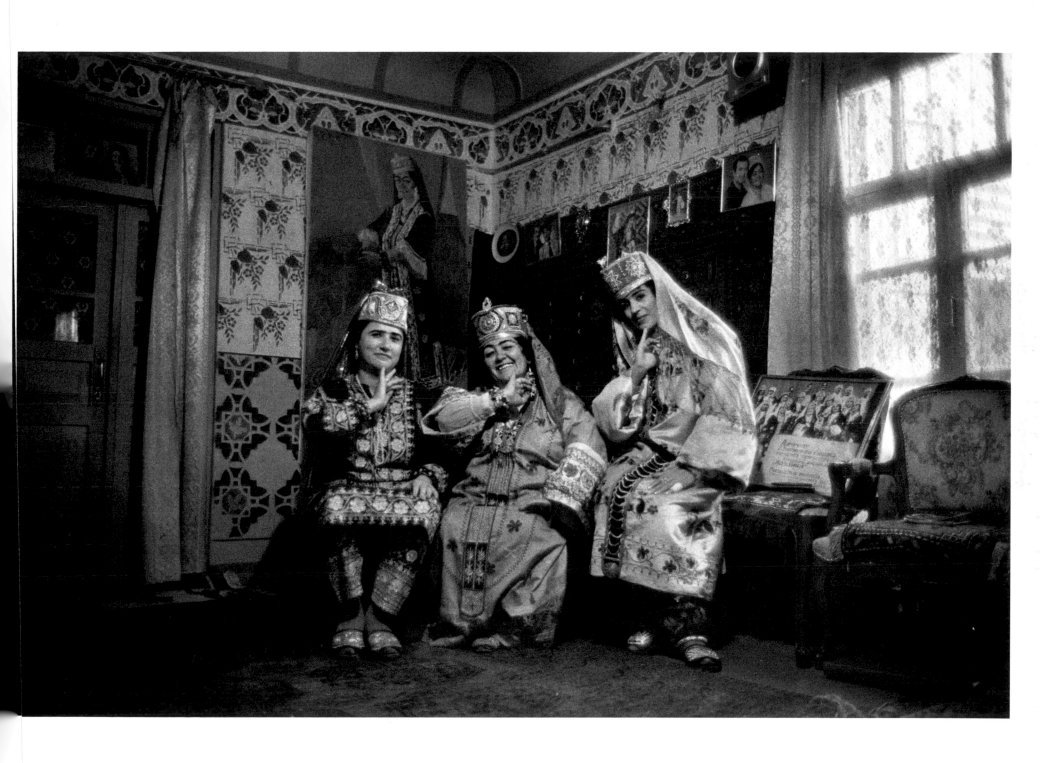

Legendary folksinger and dancer Yafa Pinkhasova (center) rehearses with two members of her ensemble.

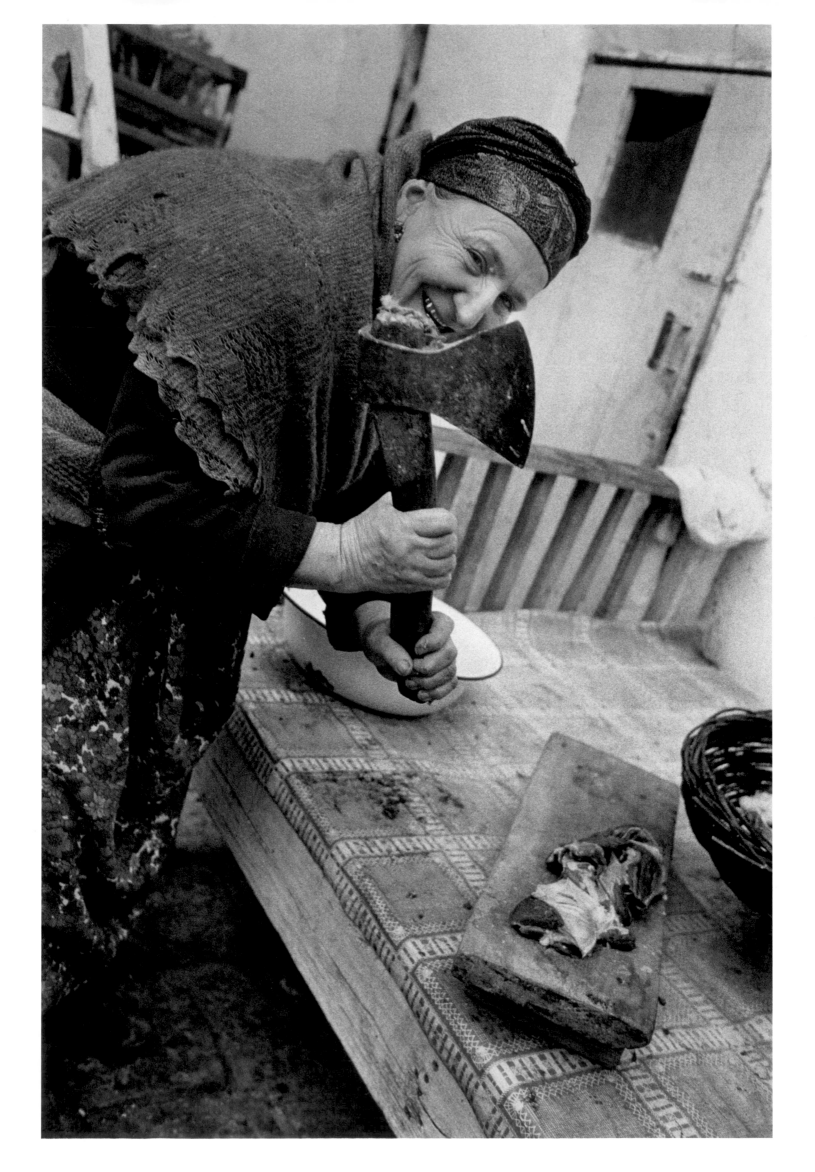

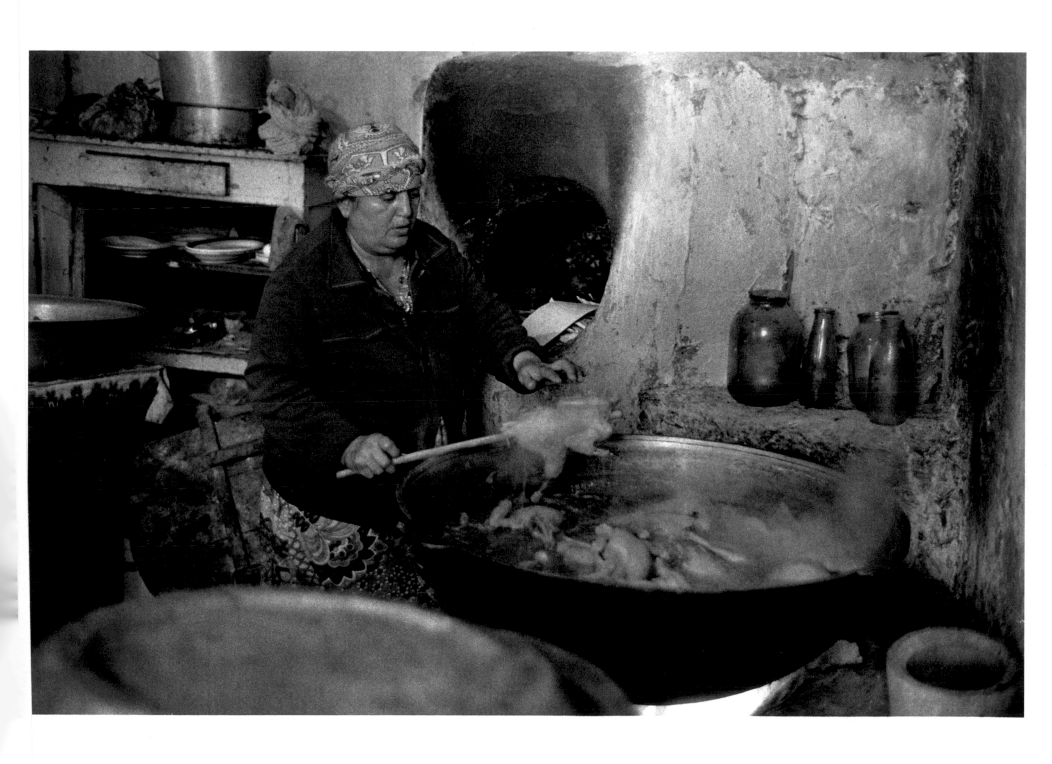

(above) Approximately one hundred fifty chickens will be boiled for a celebration.

(facing page) Zoli Kivono Simkevoah, the best caterer in Bukhara, takes an axe to what's left of a side of beef.

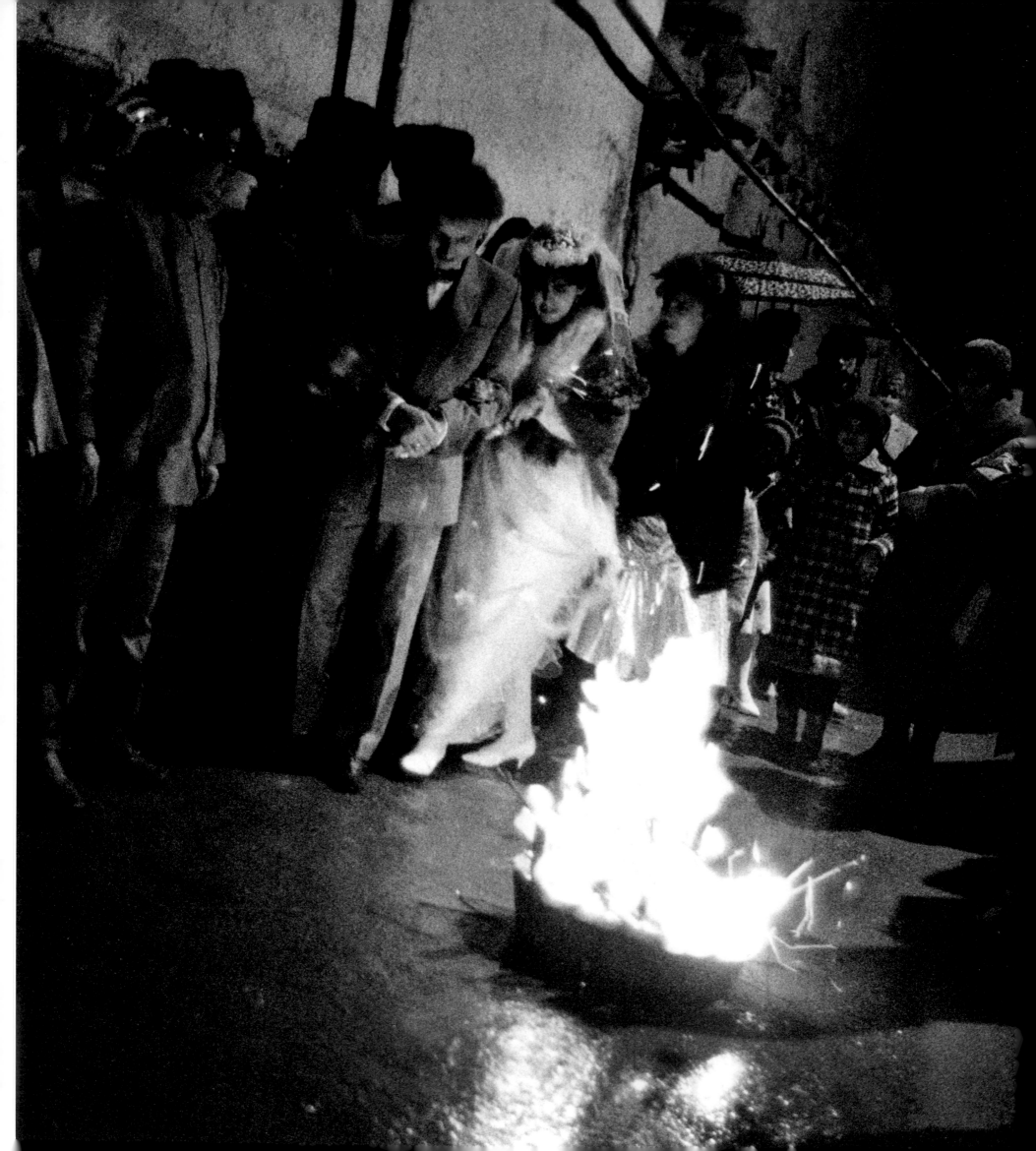

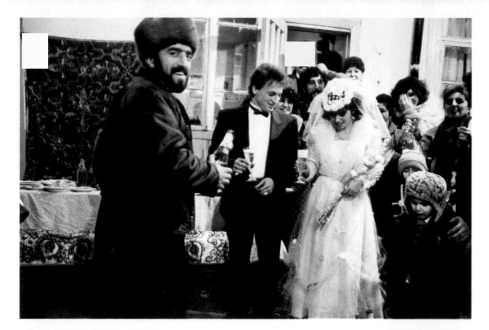

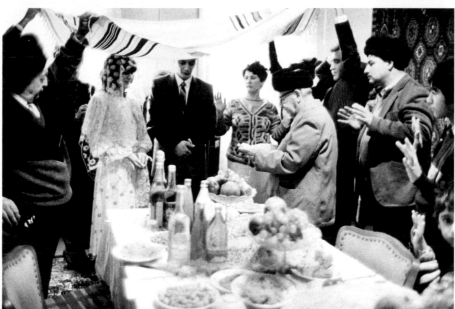

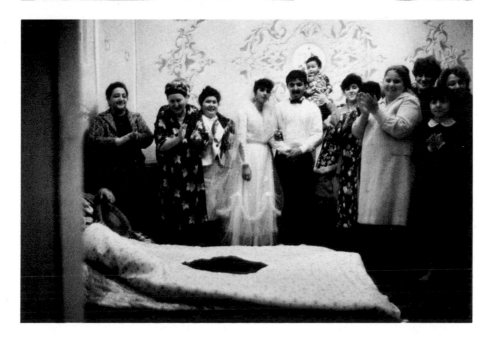

The wedding festivities last for several days and include:
(top) a champagne toast on the day the bride registers her marriage with the state;
(center) a religious ceremony under the *chuppah* in the bride's living room.
(bottom) Guests accompany the bride and groom to their nuptial chambers to bless their union.
(facing page) A fire ceremony — an Uzbek custom incorporated into the Jewish tradition.

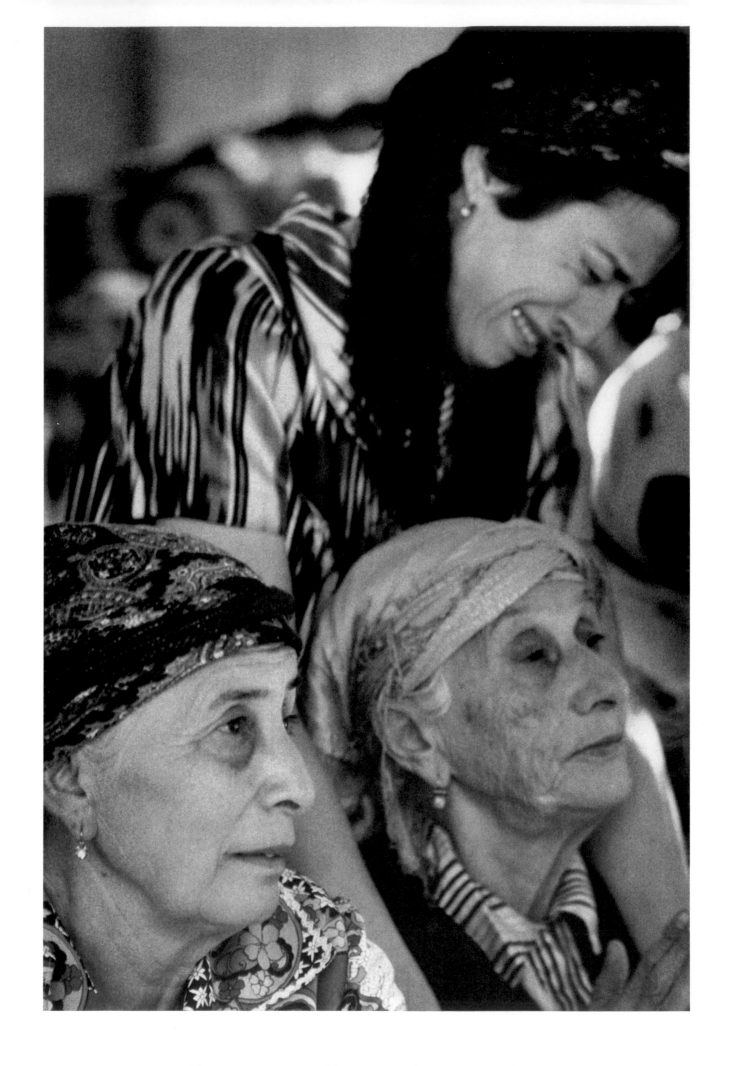

(above) Women cry and lament over the loss of a loved one.

(previous page) Women cover their heads with woolen shawls for the blessing of the *Kohanim* (Priestly Blessing).

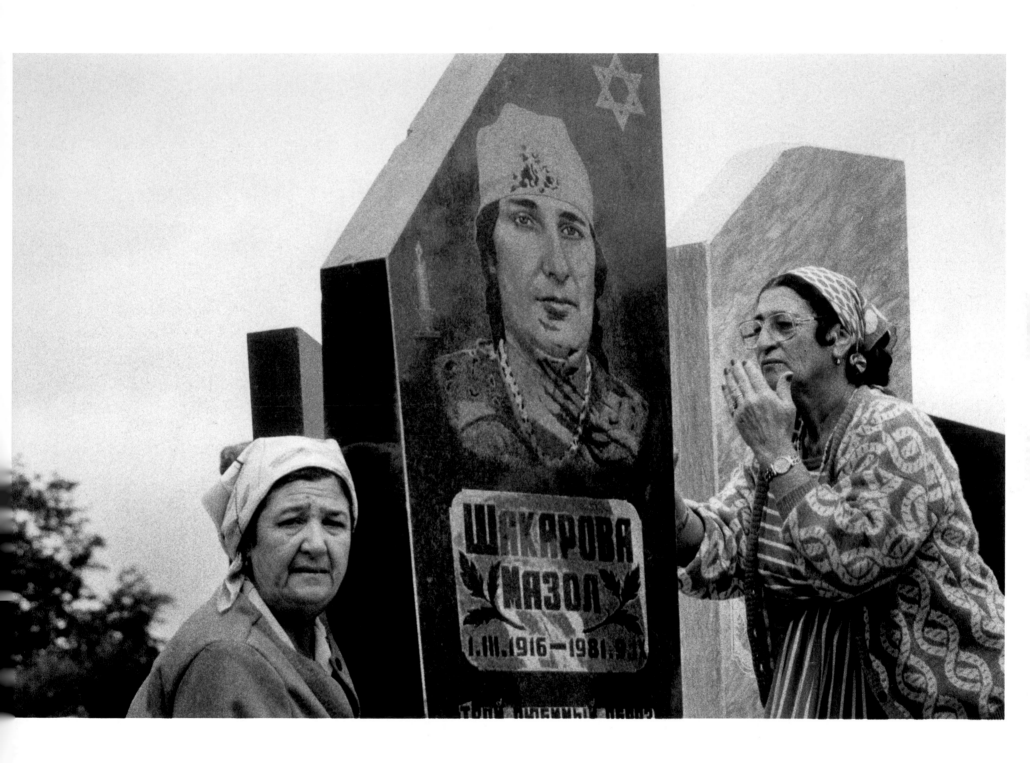

(above) Two sisters pray at their mother's grave. "You are gone, but you remain with us," they sing. "As long as we live, we will tell our children about you."

(overleaf) Women gather separately for a *yarzeit* (memorial) ceremony.

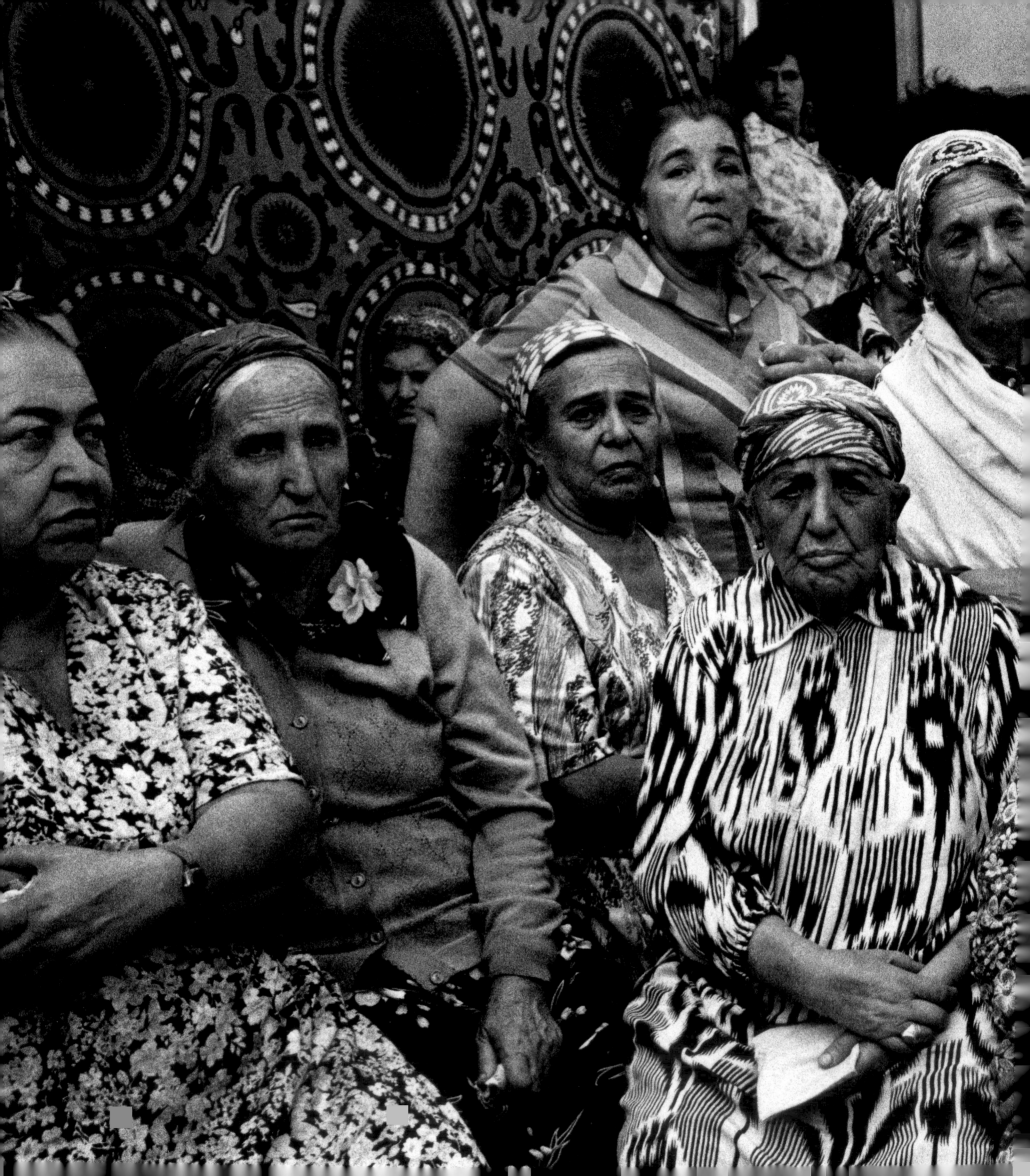

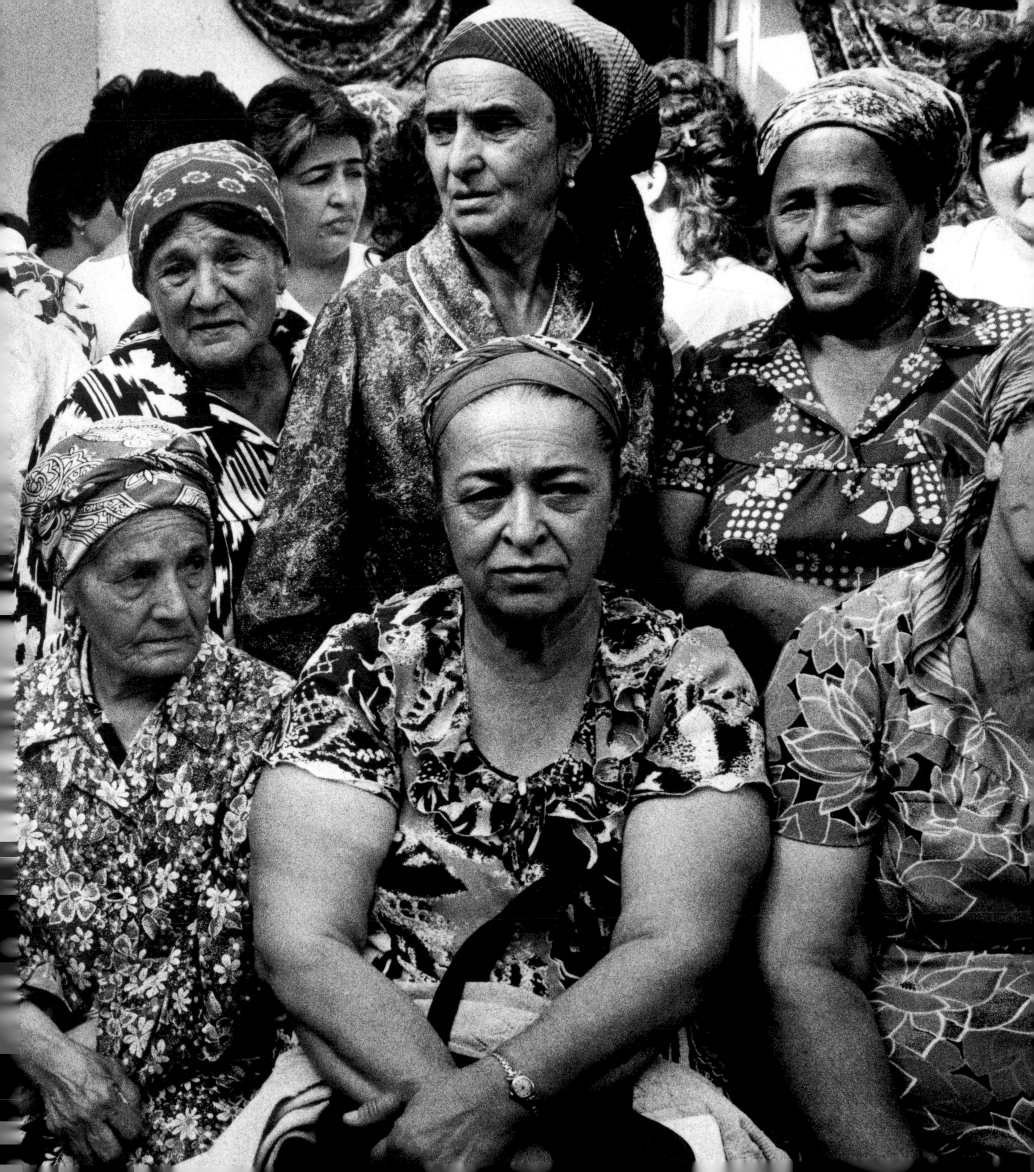

brations. Guests eat, dance, apply *henna* to the palm of

a bride's hand for good luck, and breathlessly view

jewelry given by her fiancé and his family on the night

before the wedding. ॐ A bride's wedding day is

likened to *Yom Kippur* (the Day of Atonement). She

fasts, is absolved of any wrongdoing and all her

prayers are answered. Her union with her soul mate

is considered among the holiest of holy events and

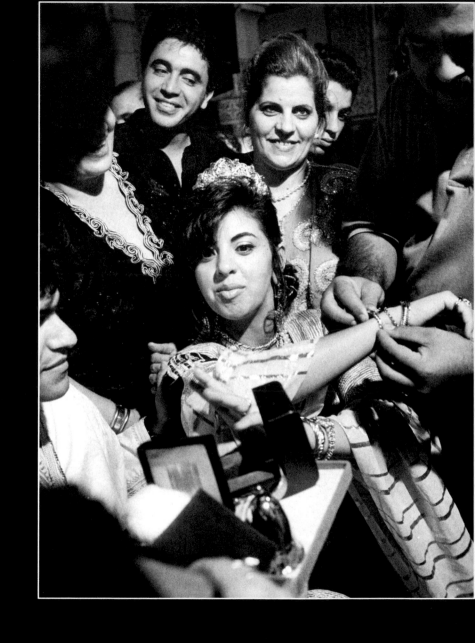

WEDDINGS

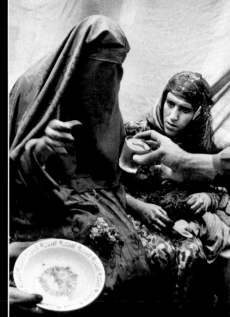

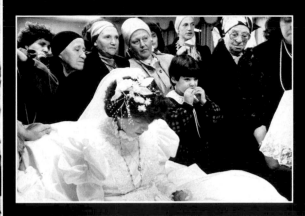

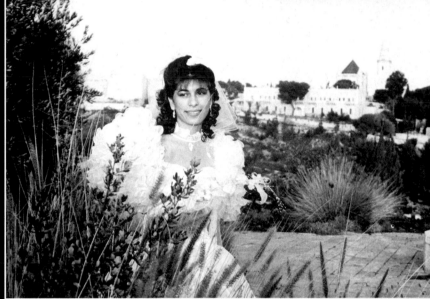

(clockwise from top left) Sanctification of the marriage betrothal, Hayden, Yemen; *Bedeken* ceremony, a bride waits for the groom to cover her face with a veil, Israel; Bride with the Old City in the background, Jerusalem; Casablanca, Morocco; On the way to the *chuppah* at the Belz wedding, Jerusalem; Ahmedabad, India; *Henna* ceremony, Bombay, India; Ahmedabad, India; Engagement ceremony, Bukhara.

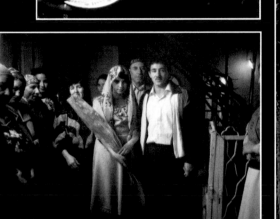

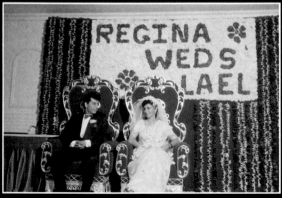

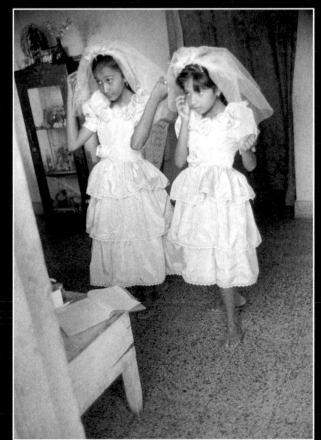

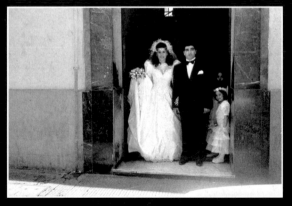

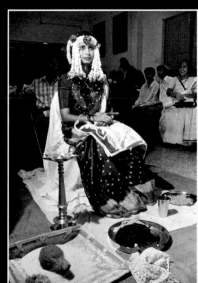

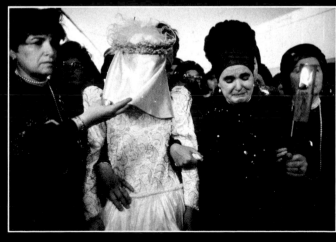

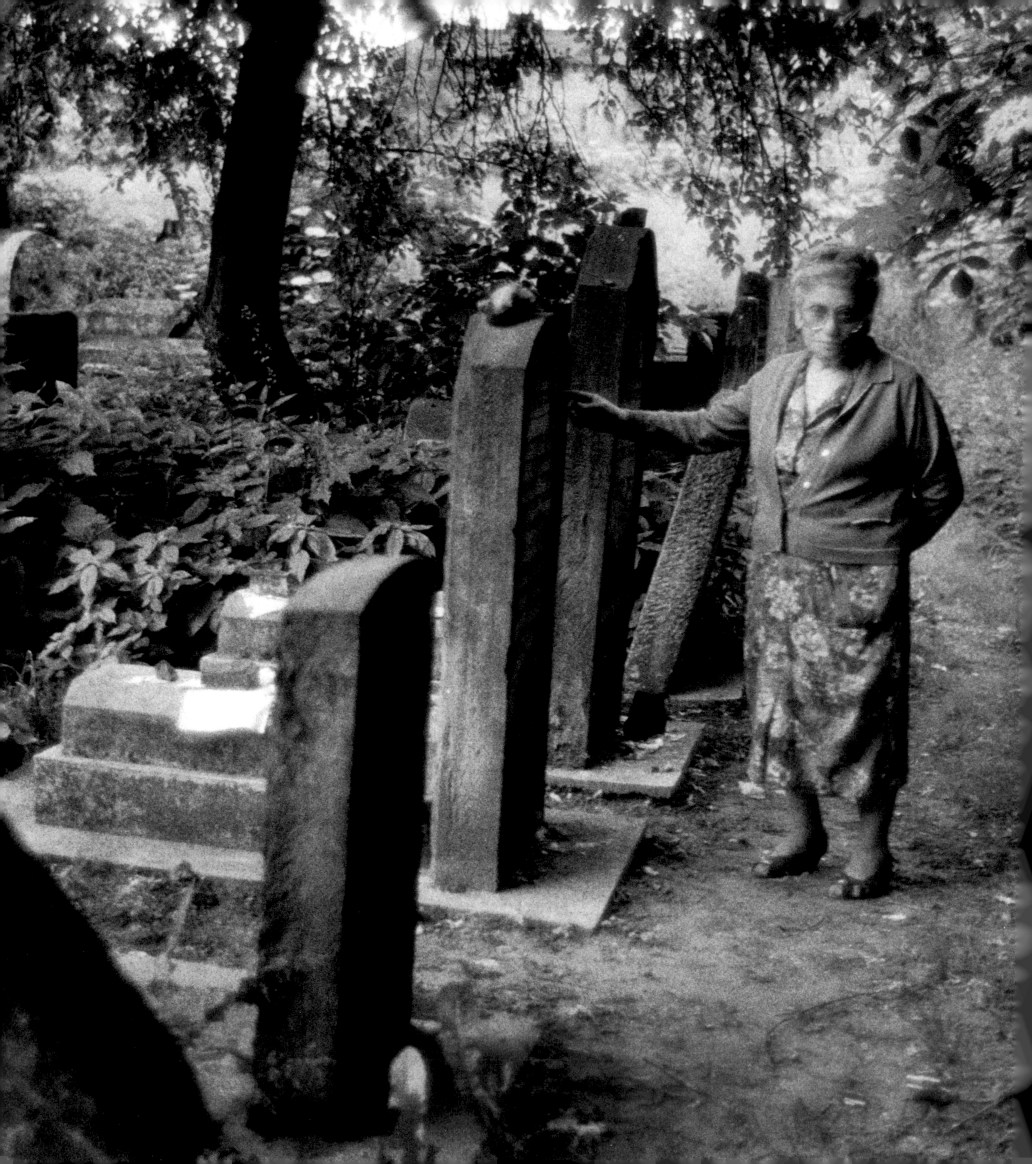

EASTERN EUROPE

Chana (facing page) is the caretaker of the historic Remuh Synagogue and Cemetery in Cracow. Like other Holocaust survivors who returned to the cities, she rebuilt her life. Many drew a line around the past and never spoke of it again. For years, the children of survivors did not know their parents were Jewish. "My grandmother was always afraid for her daughter," explains a young woman, "just as my mother suffers over me. My mother is a typical girl of her generation, divorced, afraid to be a Jew and can't explain why. I say to her, Don't put your fear in me. I am not afraid."

The women's gallery in the Altneuschul in Prague.
(previous page) Loretta Bergher, a dentist in Iasi, Romania.

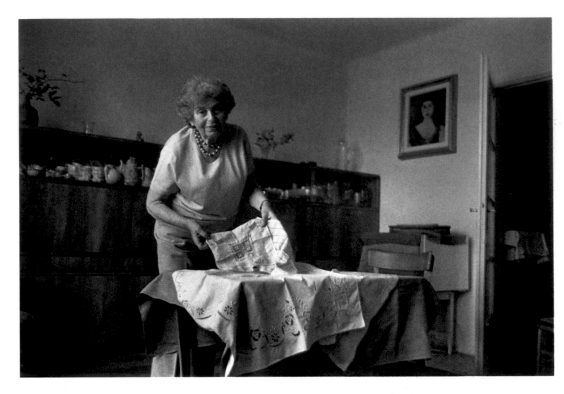

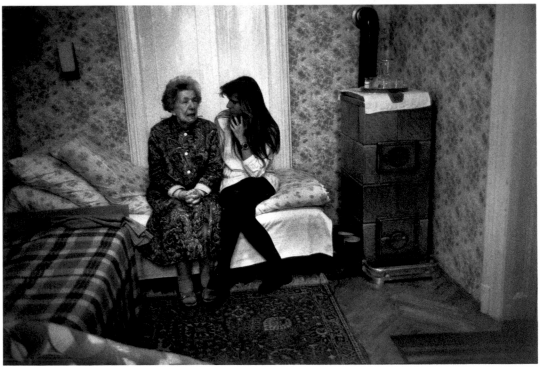

(top) "These are my relics," says Eliska. Her Prague apartment is filled with crystal, china and tablecloths she retrieved after the war. She holds a handkerchief with an inscription, "To my golden mother," embroidered by her sister.

(bottom) Yoli's granddaughter calls her the "Golda of Auschwitz" because she had the courage to steal bread and potatoes for starving friends when she worked in the camp kitchen.

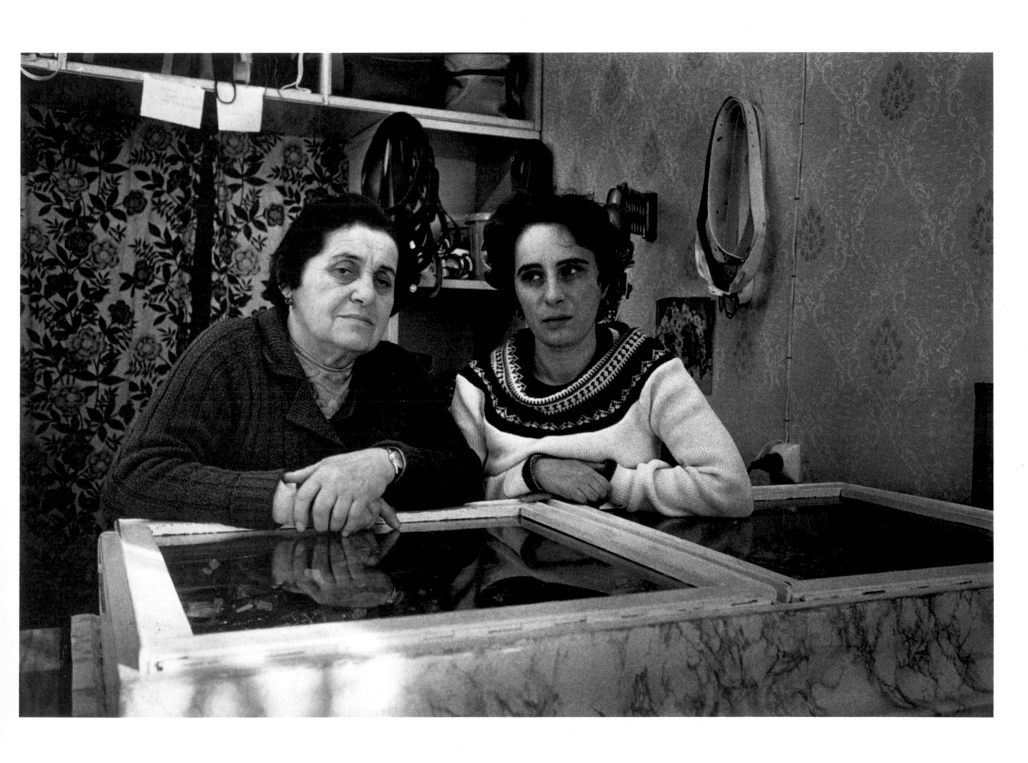

A mother and daughter sell jewelry, belts and other trinkets in Debrecen, Hungary. "This was a great Jewish community," the mother remembers. "Then they gassed the old people and sent the young men to work. I was taken to Auschwitz. Memories brought my husband and me back to a life we imagined was here. But there is no future for my daughter. No Jewish men for her to marry."

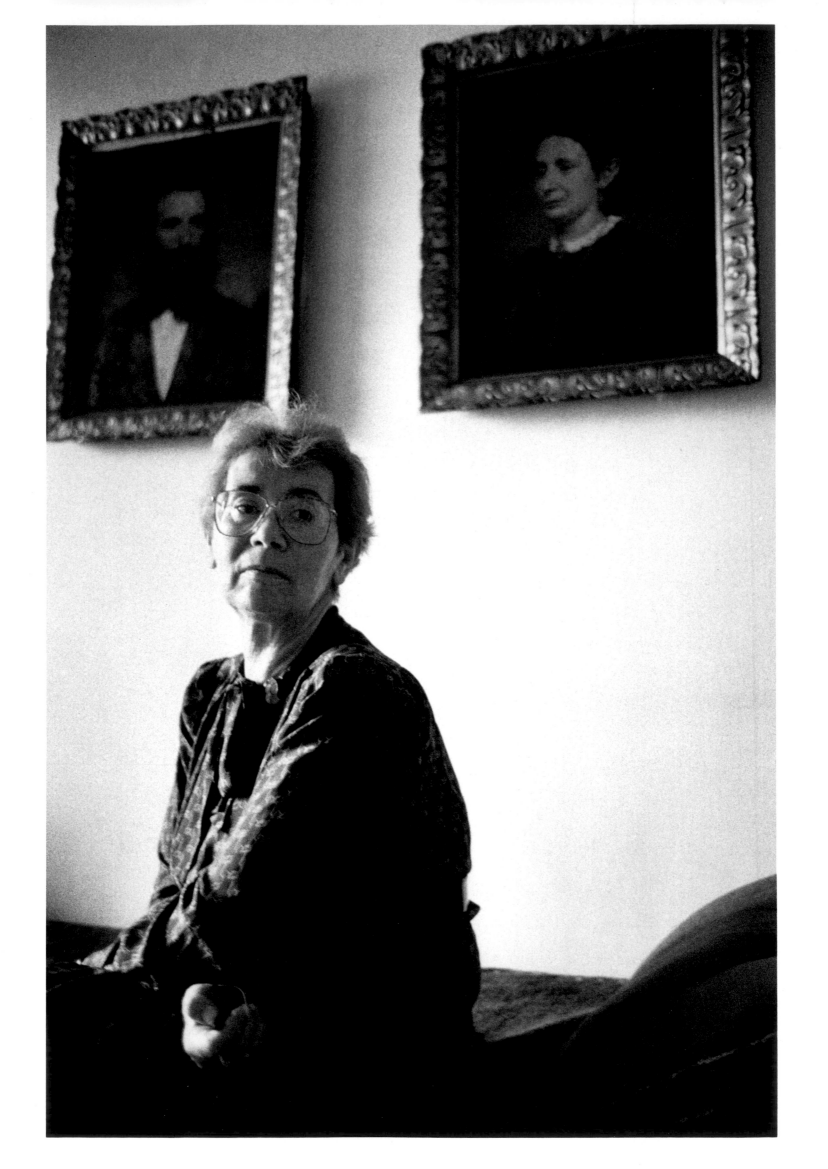

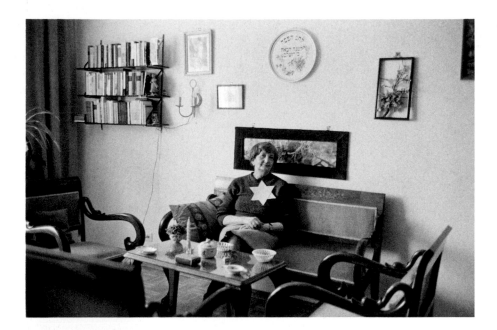

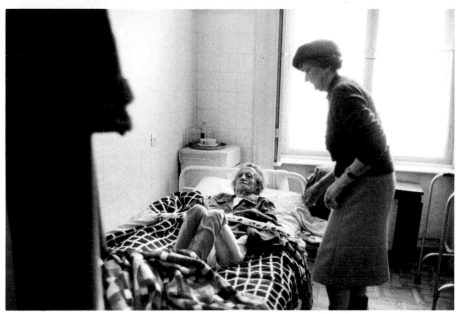

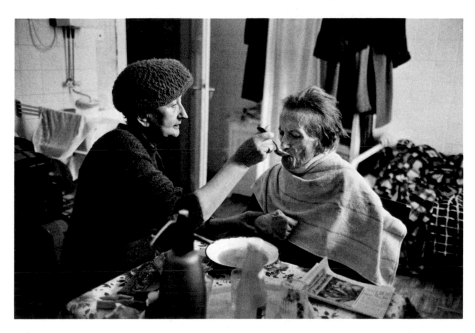

(facing page) Terez Virig is a psychoanalyst in Budapest who specializes in the psychic problems of Holocaust survivors. Before her mother was taken to Buchenwald, she managed to stitch a note into her blanket. "Dear Mother, this blanket will be good and warm because your child's heart is pulsing in it."

(above) Lilly, a patient of Dr. Virig, wore a yellow star and attempted to set herself on fire outside the Hungarian parliament. She wanted to punish herself because she survived the gas chamber and her mother didn't. To heal this loss, she tends an elderly woman.

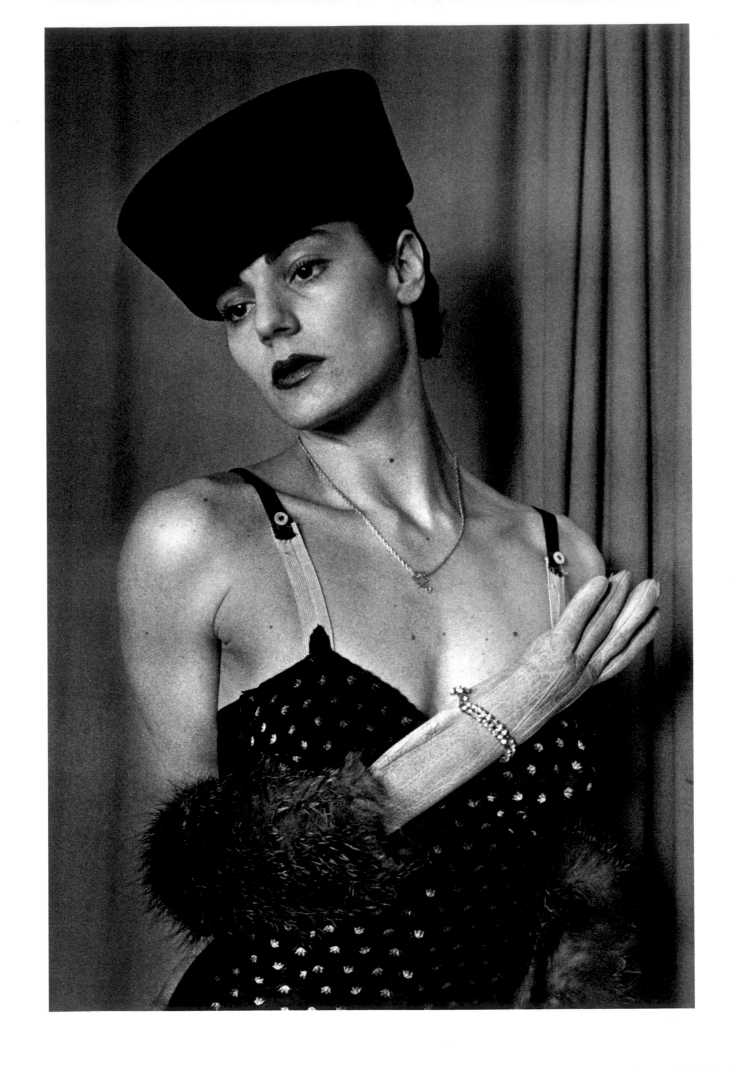

Maia once believed Jewish theater was propaganda. Now proud to be a Romanian Jew and the star of a play about a performer killed by the Nazis, she adds an illusion of glamour to those horrible days with a costume made from a ratty fur stole and fake arm.

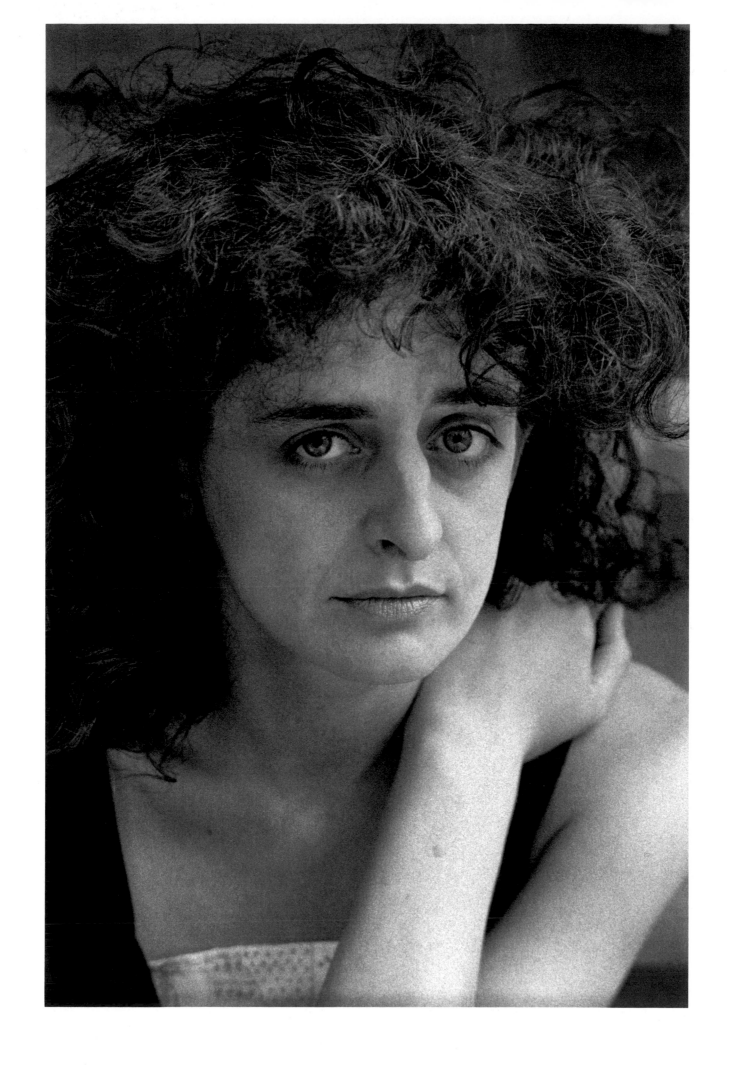

This Warsaw actress once sang a love song at a friend's wedding in a church in Cracow. The priest invited her to sing every Sunday. "I'm Jewish," she said. "Ah, you're welcome here," replied the priest.

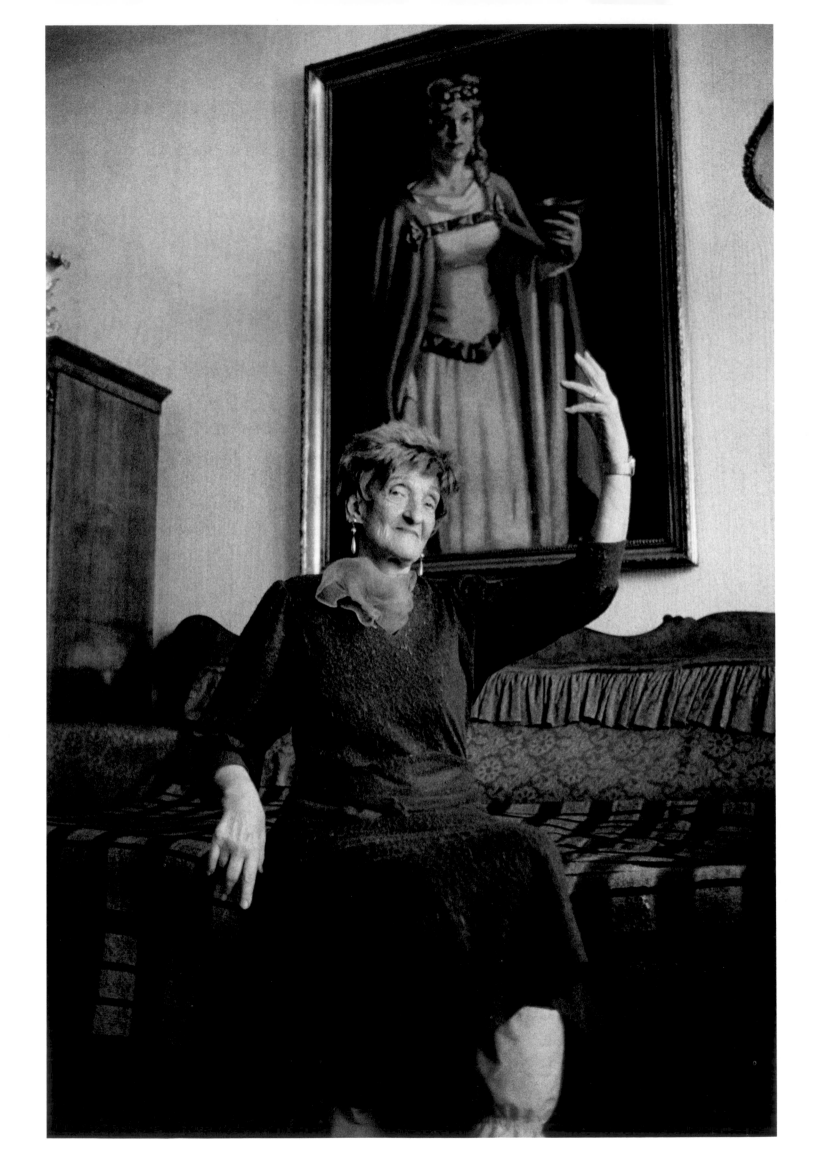

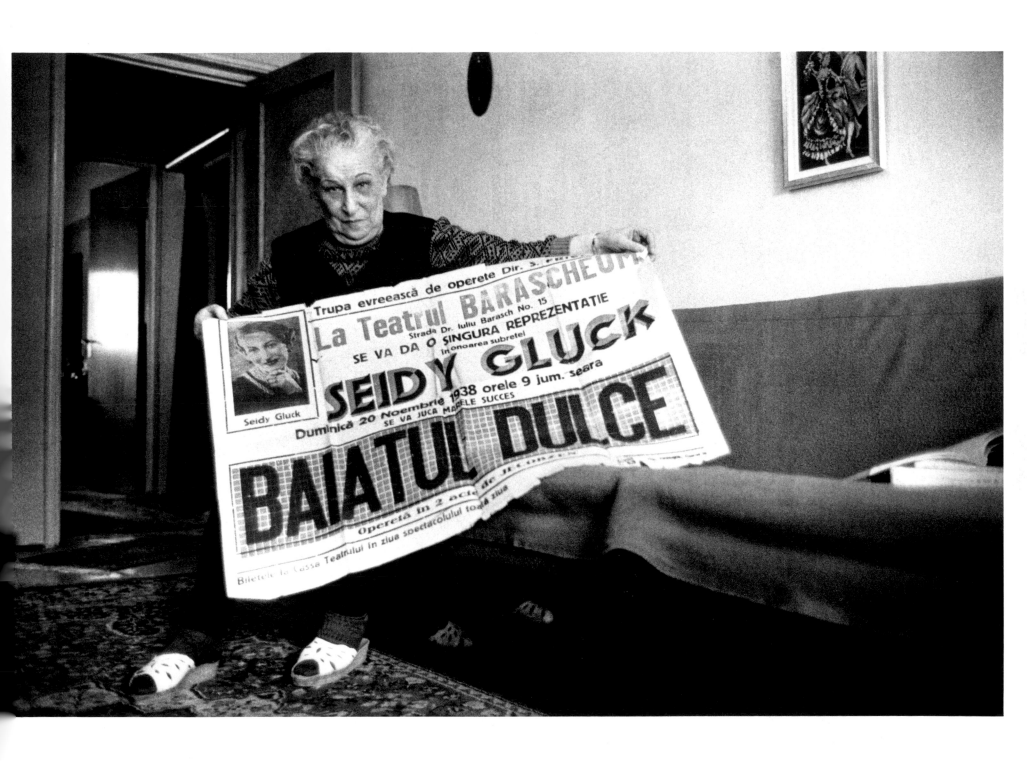

(above) As the major star of the Yiddish theater for fifty years, Seidy Gluck created many memorable roles.

(facing page) Having lost her mother and sisters in Bergen Belsen, Hungarian mezzo soprano Rosa Delly refused to sing Wagner. Then a minister of state pleaded with her to sing Venus in "Tannhäuser." Now, Delly's name, engraved in gold inside the National Opera House, and the portrait in her living room, immortalize her career.

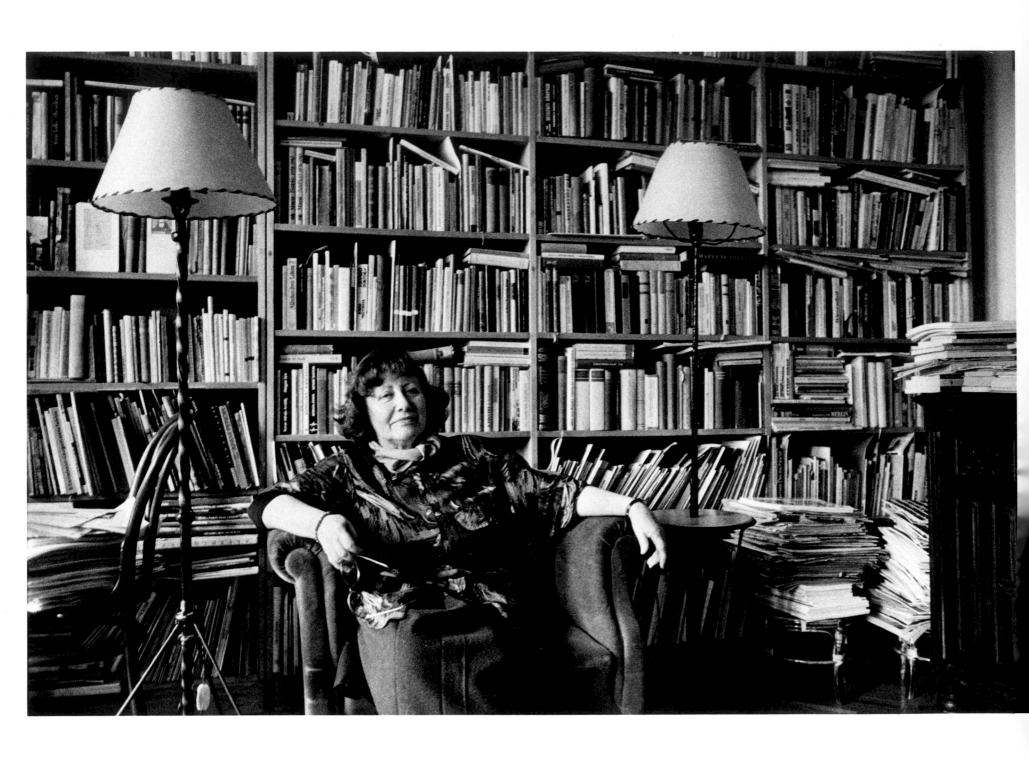

Maria Ember, deported to Austria during the war, was a figure in the 1956 Hungarian uprising.
She now writes the stories she once lived, and is the author of twenty-five books.

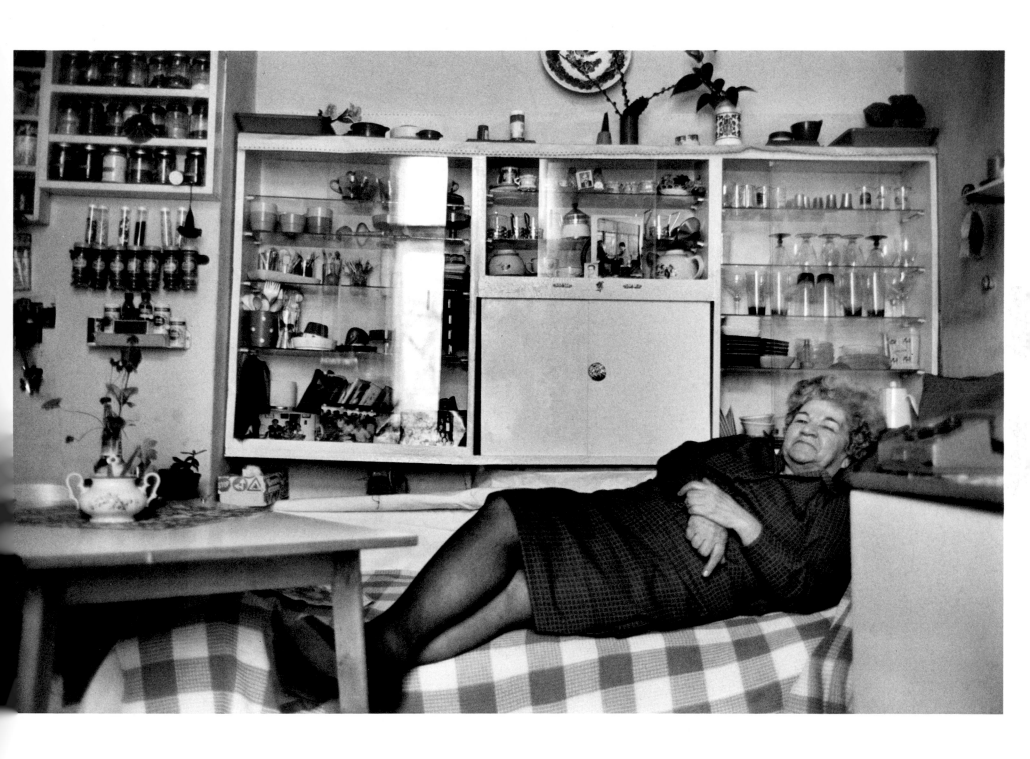

Bella Astrug, the one-time secretary of the Mayor of Sofia, lounges in her kitchen.

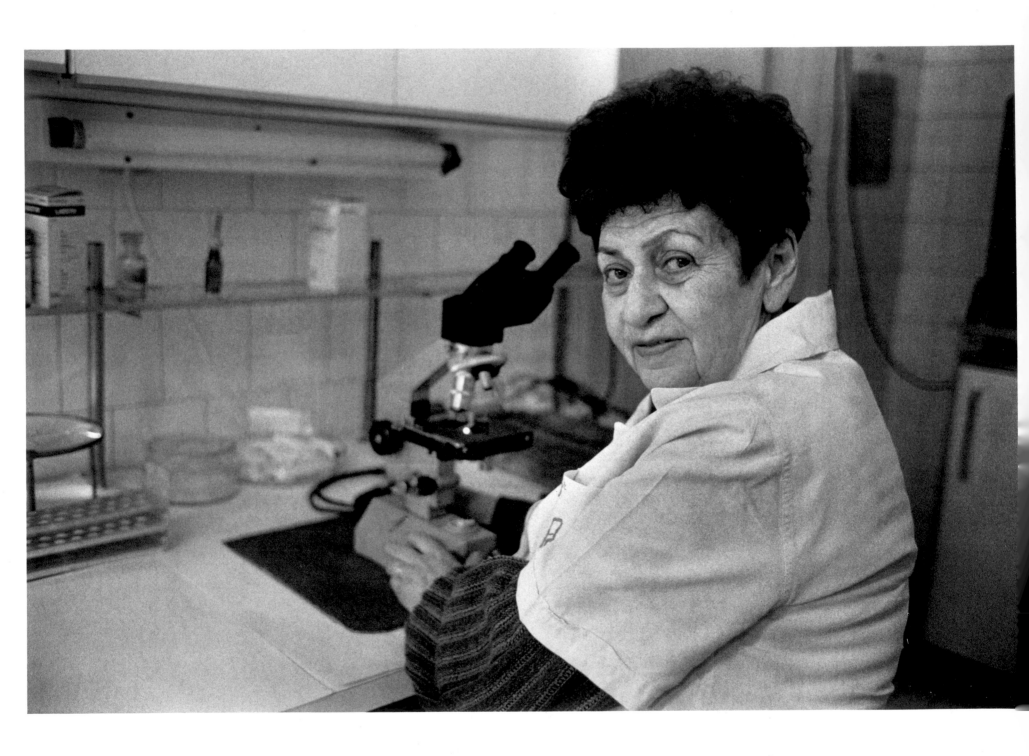

(above) Dr. Lydia Miaailesce, a graduate of the University of Bucharest Medical School, is a physician. She also has a Ph.D. in microbiology.

(facing page) Ilona Benoschofsky, director of the Jewish Museum in Budapest, presides over a treasured collection which was hidden during the war.

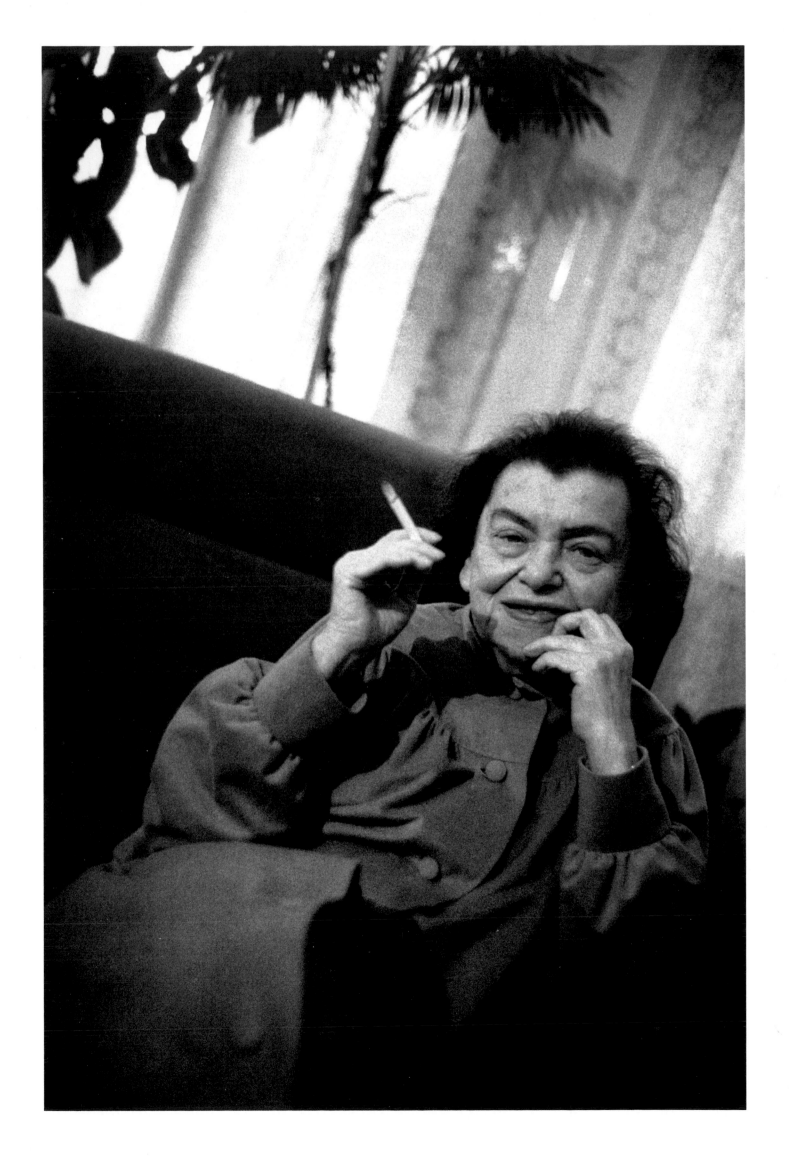

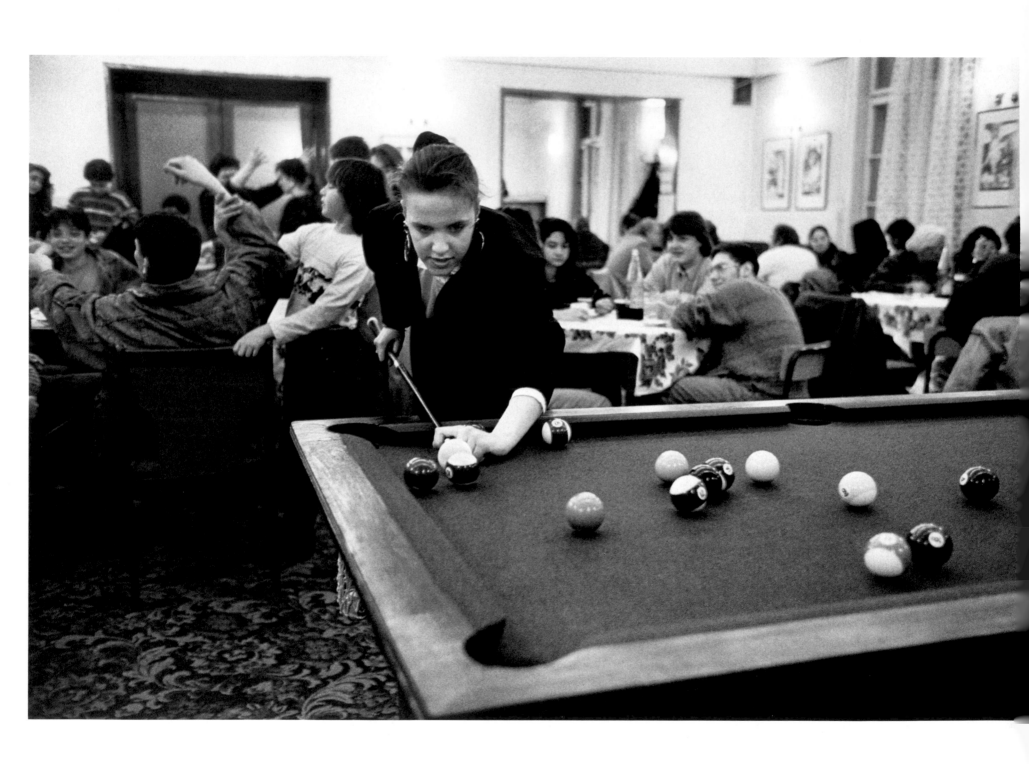

A teenager shoots pool in a Jewish recreation center in Sofia.

Proudly Jewish, these Budapest sisters herald a new generation.

Philosopher and Sanskrit scholar Esther Abraham

Solomon, Ph.D.(right) is admired for her devotion

to education and research. Retired from her brilliant

career as head of the Sanskrit department of Gujarat

University from 1964 to 1987, she remains a leading

authority in the ancient classical language of *Vedas* –

nonbiblical sacred writings. As a proponent of Indian

philosophy, she leads a simple life of contemplative

study and as a result some people refer to her as a

mirabai (devotee). ॐ Whether selling grain in the

marketplace in Ethiopia or practicing medicine in a

hospital in Israel, work outside the home has always

been an essential part of a woman's life.

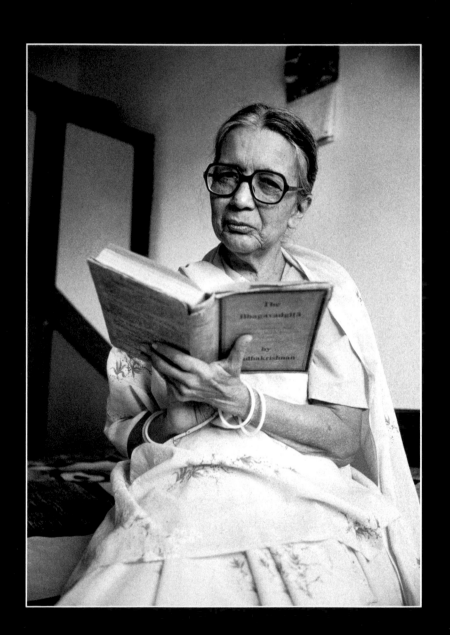

WORK

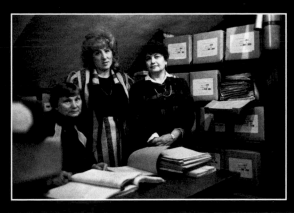

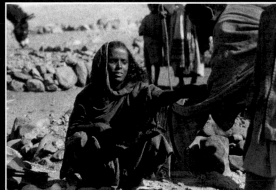

(clockwise from top left)
Doctor and car bomb victim, Jerusalem;
Shopkeeper, Jerusalem; Archivists,
Vinnitsa, Ukraine; Butcher, Budapest,
Hungary; Spinning cotton, Aba
Antonyos, Ethiopia; Painter, Sofia,
Bulgaria; Shoe factory, Berdichev,
Ukraine; Shoemaker, Tel Aviv, Israel;
Selling grain, Teda, Ethiopia.

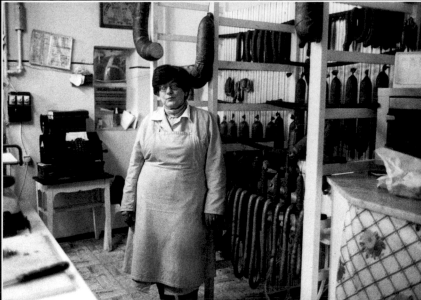

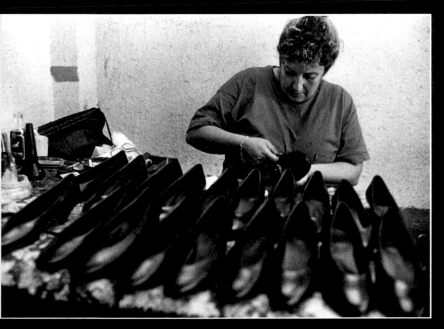

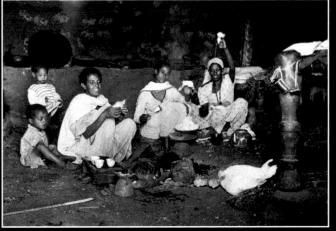

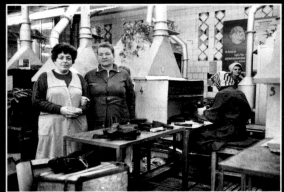

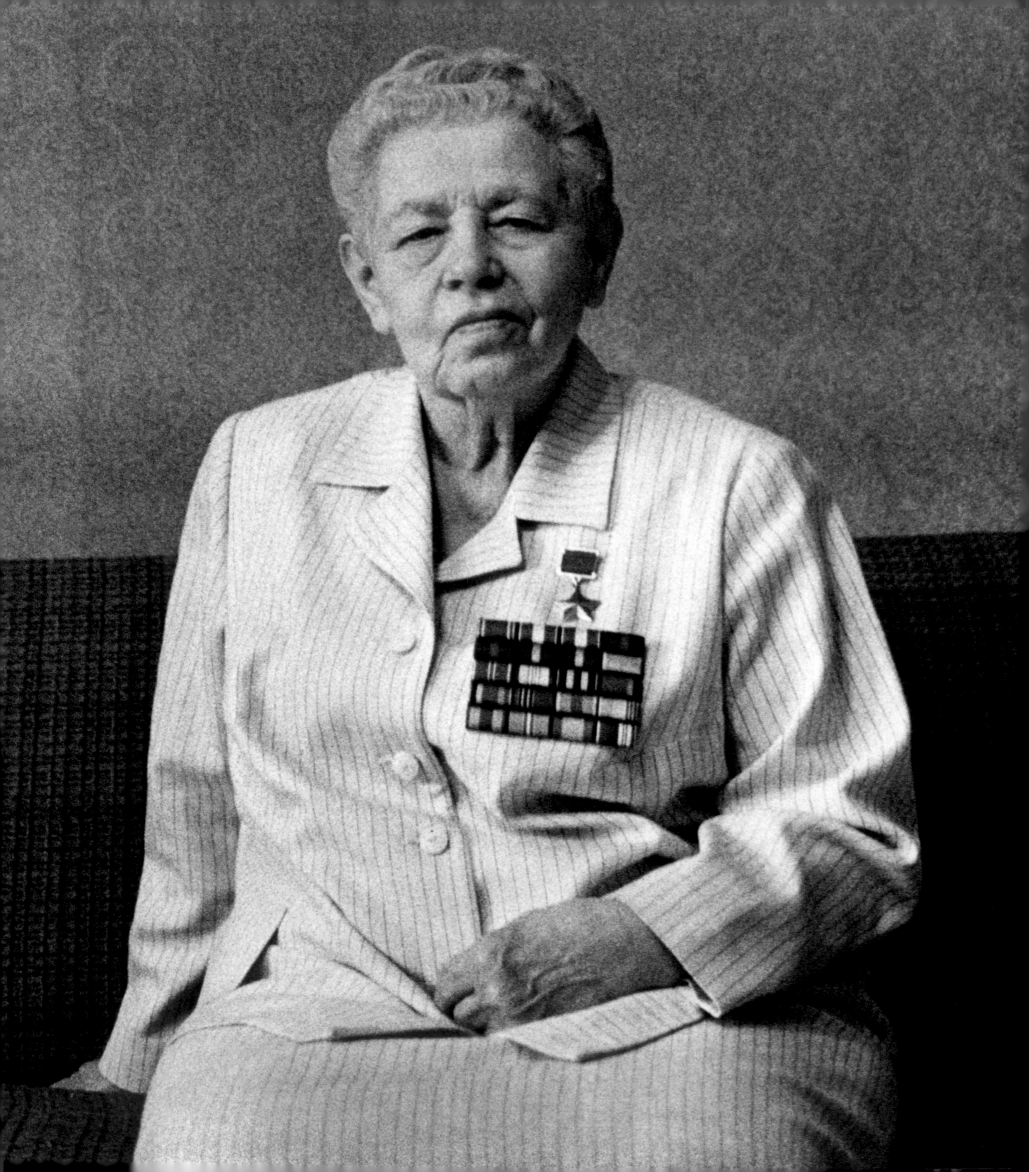

RUSSIA&
UKRAINE

Paulina Gelman, a much decorated heroine and World War II pilot (facing page), received the gold medal of honor at the Kremlin. She grew up in Gomel, a small city in Belarus. Her grandmother occupied a special place in the synagogue and could read Hebrew — she read for all the women — but her children became Communists. ❧ Paulina joined the Air Club and overcame many obstacles before being enlisted in the women's regiment of night bombers. Although women could be admitted to the best institutions and obtain high-level positions, they were still discriminated against as Jews.

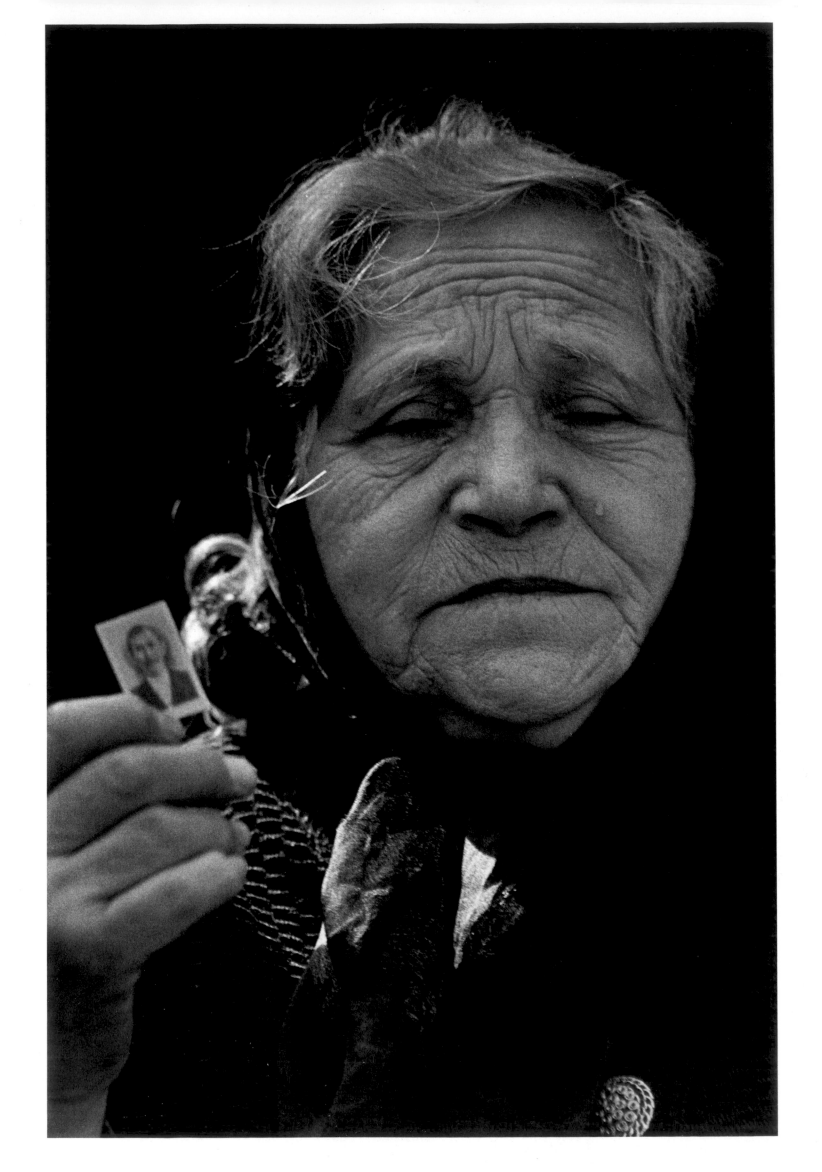

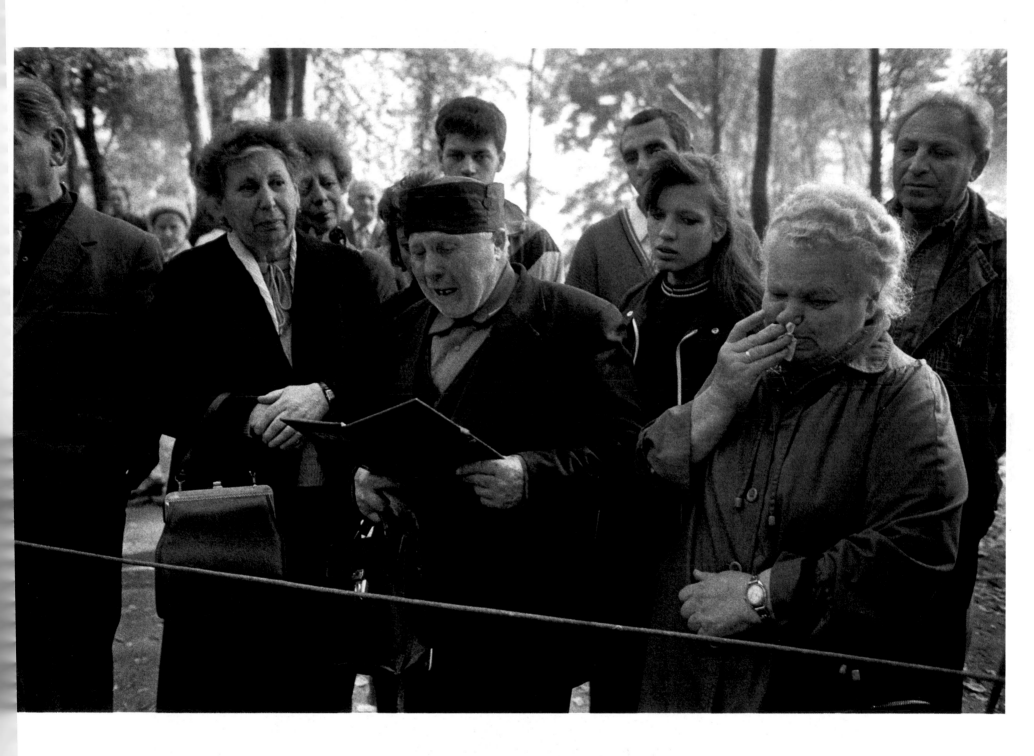

(previous page) Margarita and Elena, at the Pushkin Museum, are caught between a rich intellectual culture and the lure of Israel.

(above) Women pay a man to say *kaddish* (the prayer for the dead) for loved ones buried in a mass grave
among thousands of corpses, victims of the massacre of Babi Yar.

(facing page) Though residents of Kiev knew about the Babi Yar massacre of the Jews, they kept silent out of fear, until September 29, 1991,
the fiftieth anniversary and first commemoration of those who were murdered.

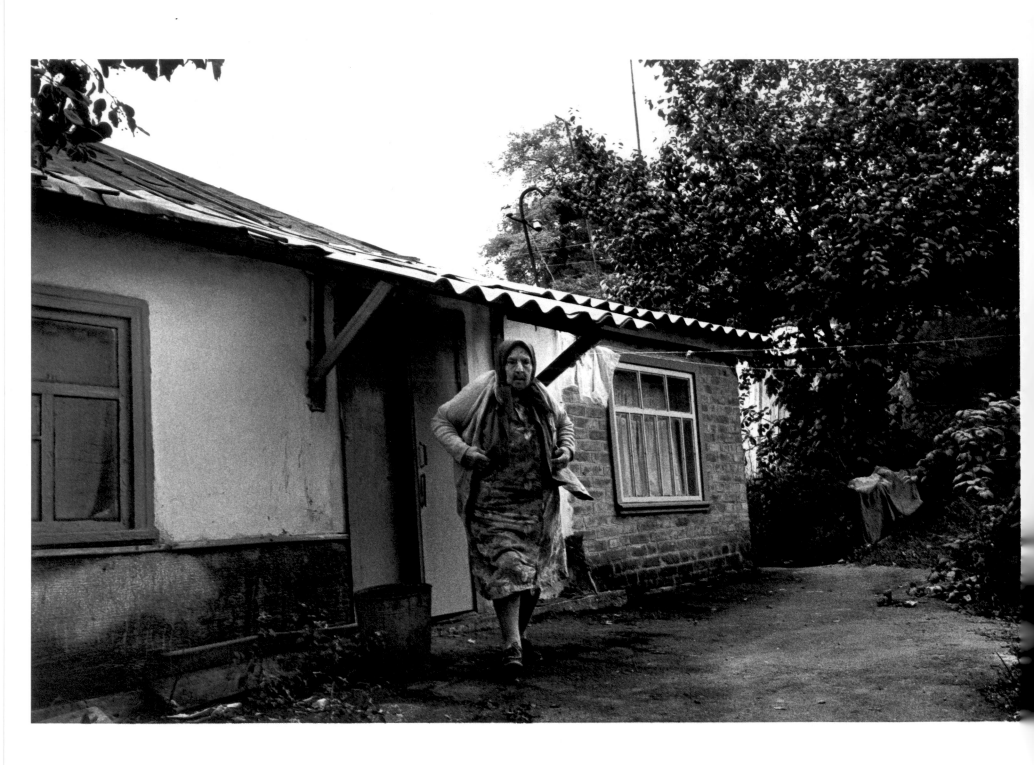

Tarascha, once a thriving *shtetl* (village) in the Ukraine, now has a Jewish population of three, including this woman.

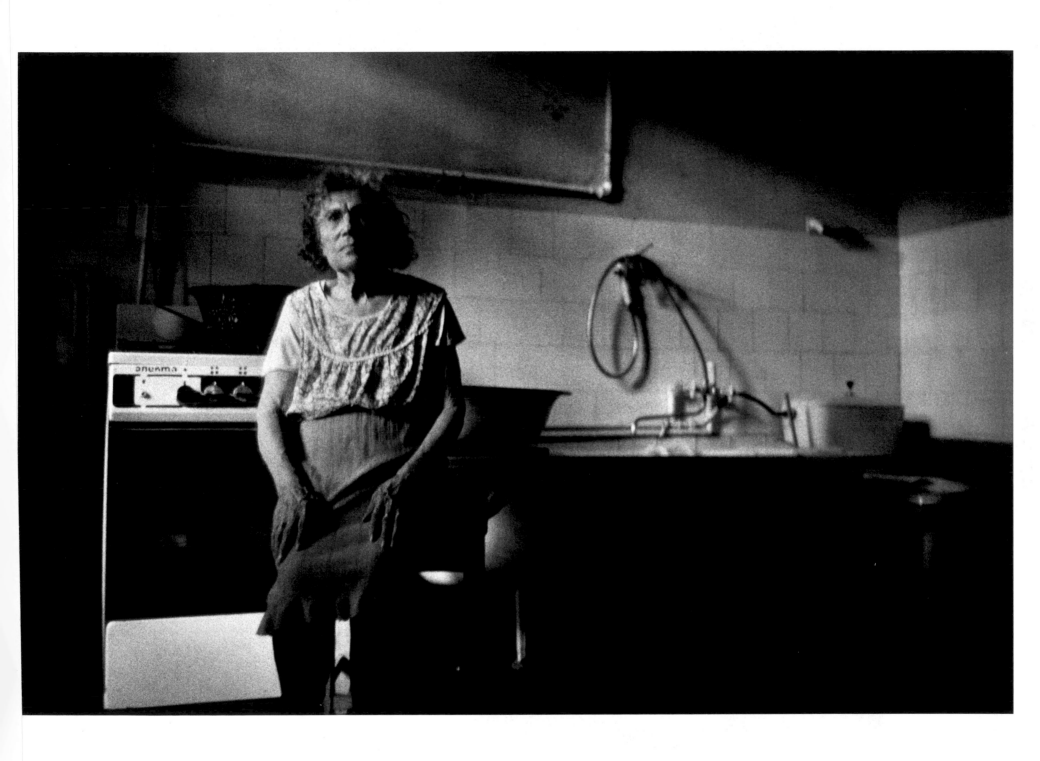

A woman from the city of Lvov still lives in the room she was given under the Communist regime.

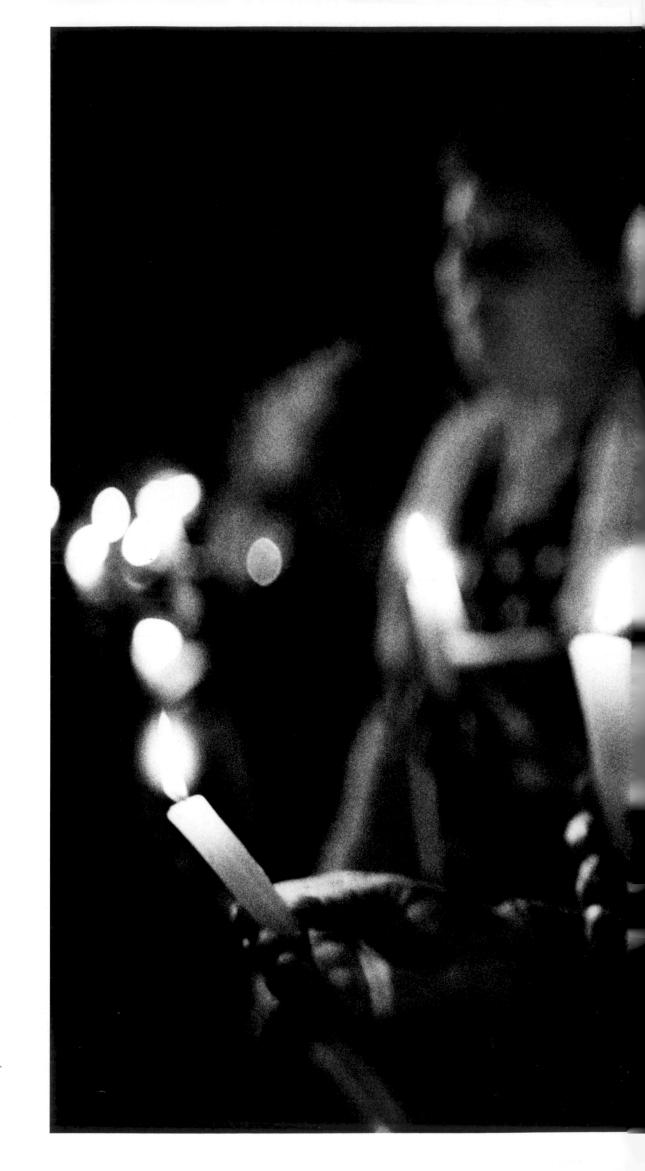

Candlelight ceremony at the International Conference of
Jewish Women in Kiev, 1994.

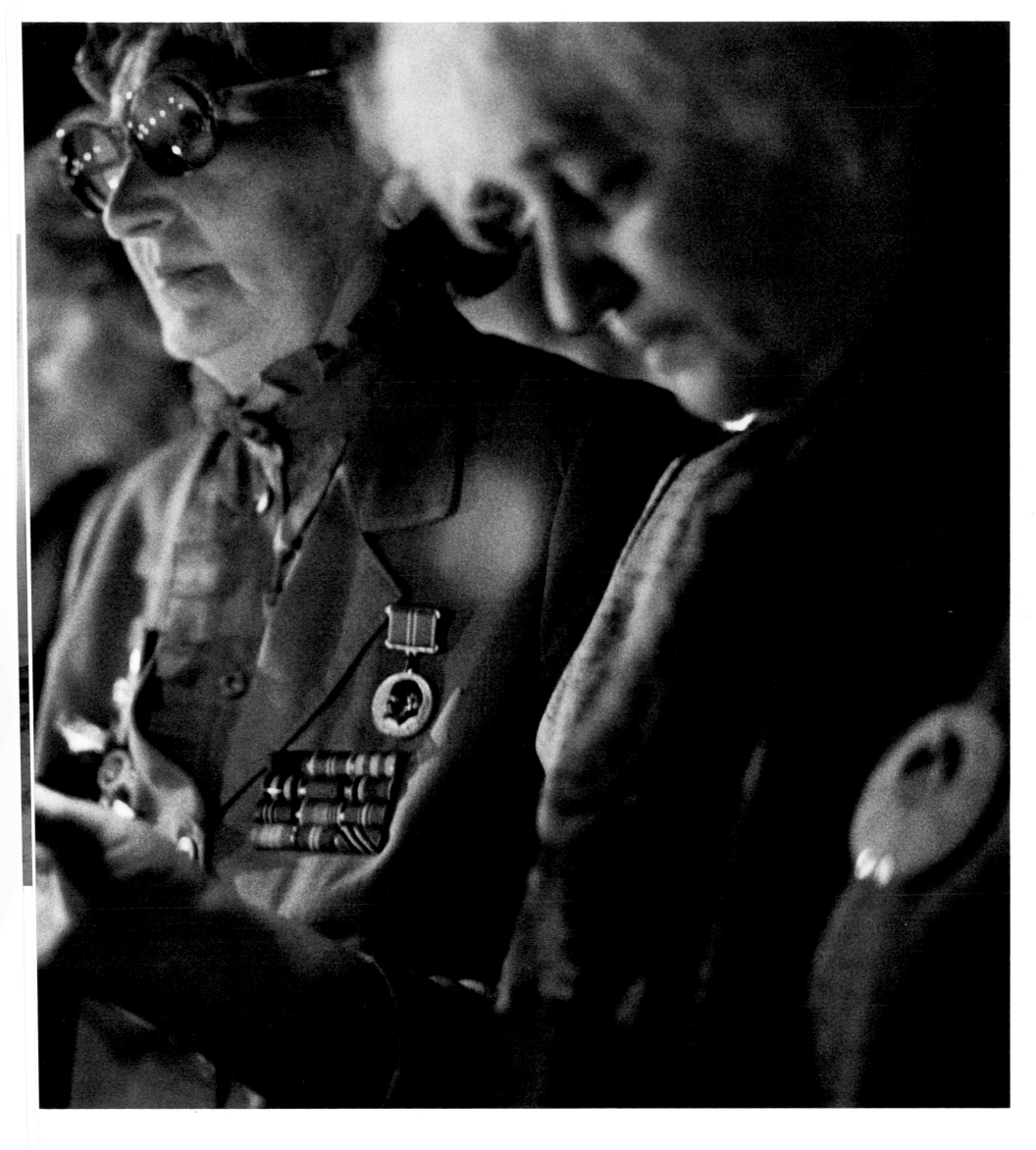

Katya Taran is a student at the recently established Solomon University in Kiev.

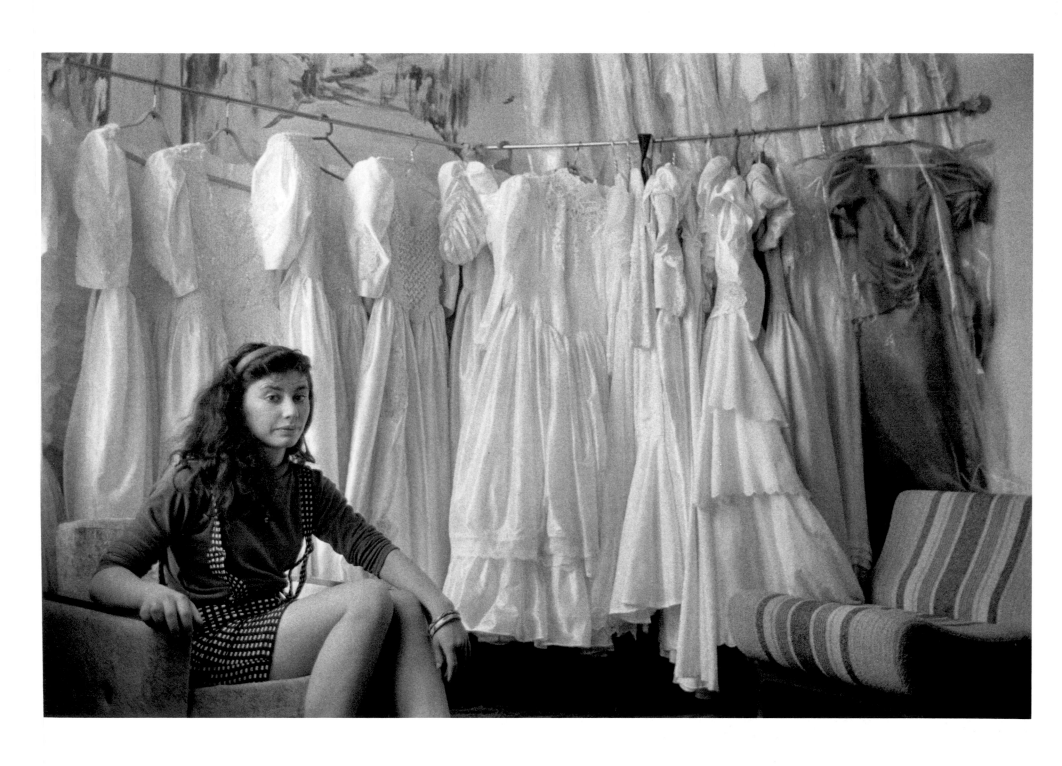

Svetlana Gubenko rents wedding dresses in a boutique at the Central Wedding House in Vinnitsa, where all civil marriage ceremonies are held.

(above) This woman lives in Saltykovka, a Russian village once within the Pale of Settlement (restricted area). Accustomed to always being on her guard, she warm up as the camera catches her gardening amidst the pine trees in front of her *dacha* (summer house), which she shares with non-Jews.

(facing page) Afterwards, she shares a sweet moment with her granddaughter, a student in the Jewish Studies Program in Moscow.

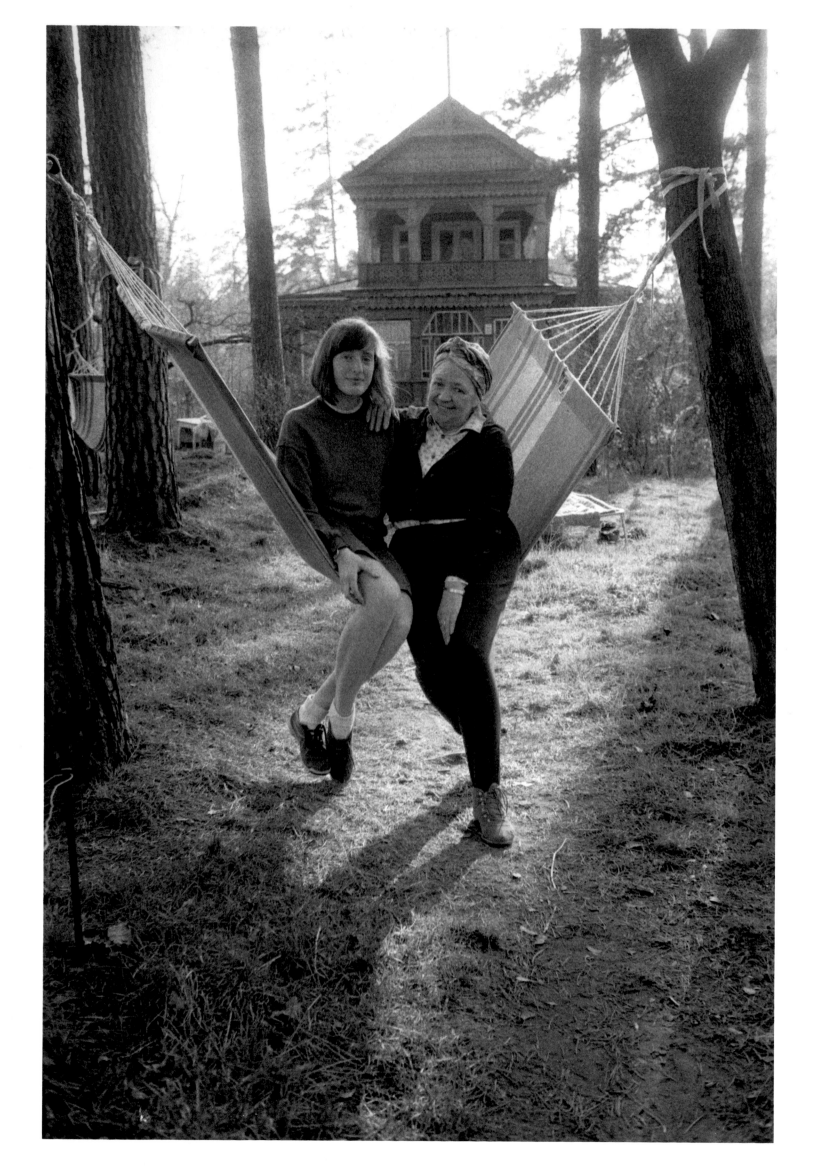

Maria's twin sister emigrated to Israel, but she remains working on the collective farm in Zolotonosha with her husband and son. They will plant thirty-five pails of potatoes. "Enough for the whole year," says Maria.

every mother's vision that the world will be better for

her little girl. It is Bonna's dream that the voices and

rituals of women be formally established as part of the

mosaic of Judaism, that pious women be recognized

and respected as scholars and that women be allowed

to read the Torah at the *Kotel* (Western Wall).

Although some scholars note that the Talmud says

women may perform the public reading of the Torah,

Rabbinic authorities have not yet approved either

M O T H E R S &
D A U G H T E R S

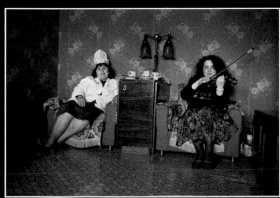
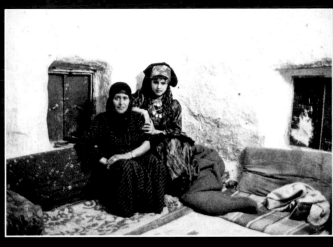
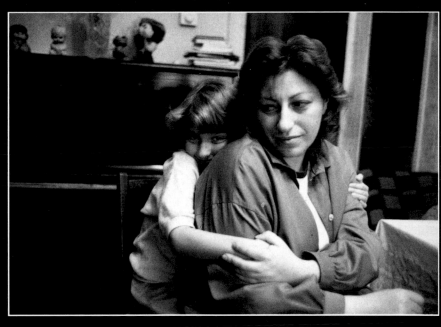
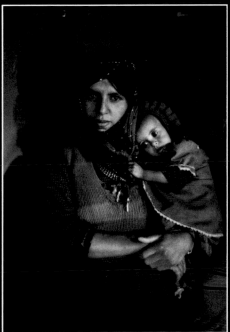
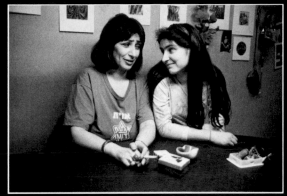
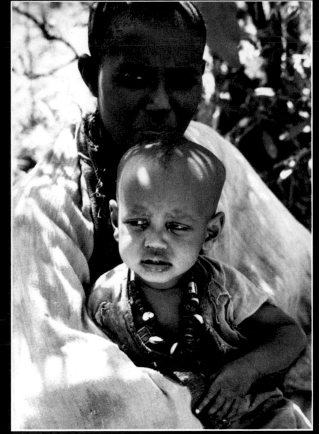

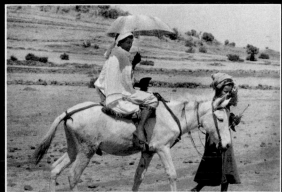

(clockwise from top left)
Sofia, Bulgaria; Ambober, Ethiopia;
Sofia, Bulgaria; St. Petersburg, Russia;
Vinnitsa, Ukraine; Aba Antonyos, Ethiopia;
Saadah, Yemen; Uman, Ukraine; Saadah, Yemen.

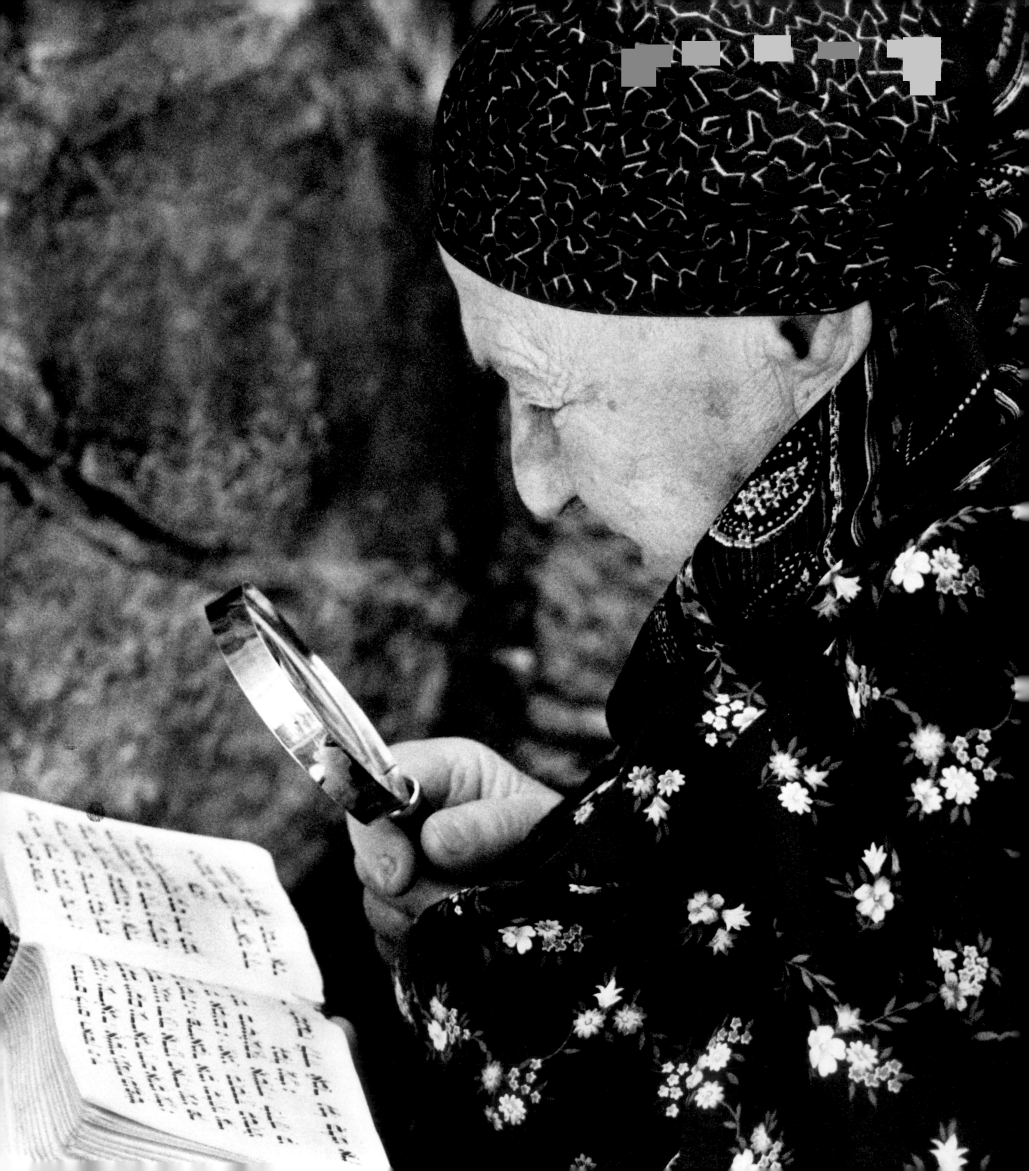

ISRAEL

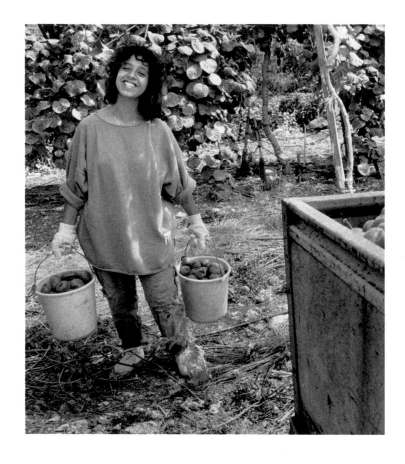

The legacy of this Ashkenazic woman (facing page) gleams through her magnifying glass — enabling her to enlarge her perspective and to go beyond words in prayer. The Psalms beckon her soul while her body is rooted at the foot of the Western Wall. Like the Wall, she reflects the Shechinah (female aspect of God's presence). Having fulfilled an ancestral dream to return to the Holy Land, she yearns to reinforce a deep connection to her foremothers — resourceful women who continue to serve as an example of how to integrate human life into all aspects of the divine.

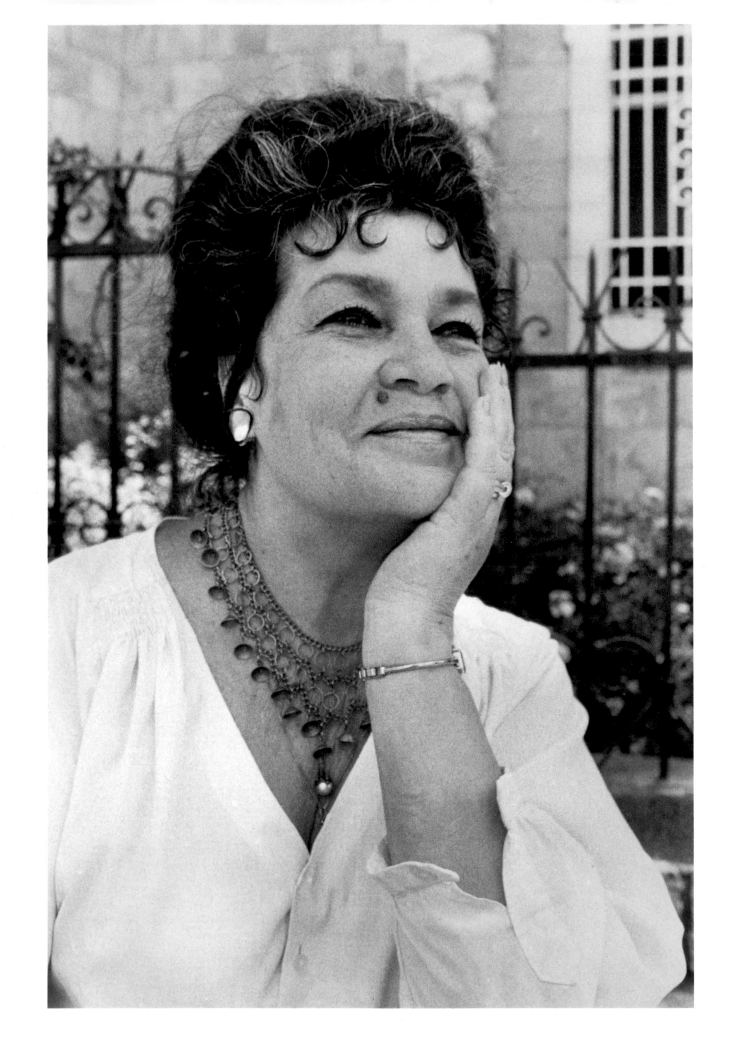

(above) A woman from the former Soviet Union now lives in Jerusalem.

(previous page) Amalia Tzadok picks kiwi fruits on Kibbutz Rosh Tzurim.

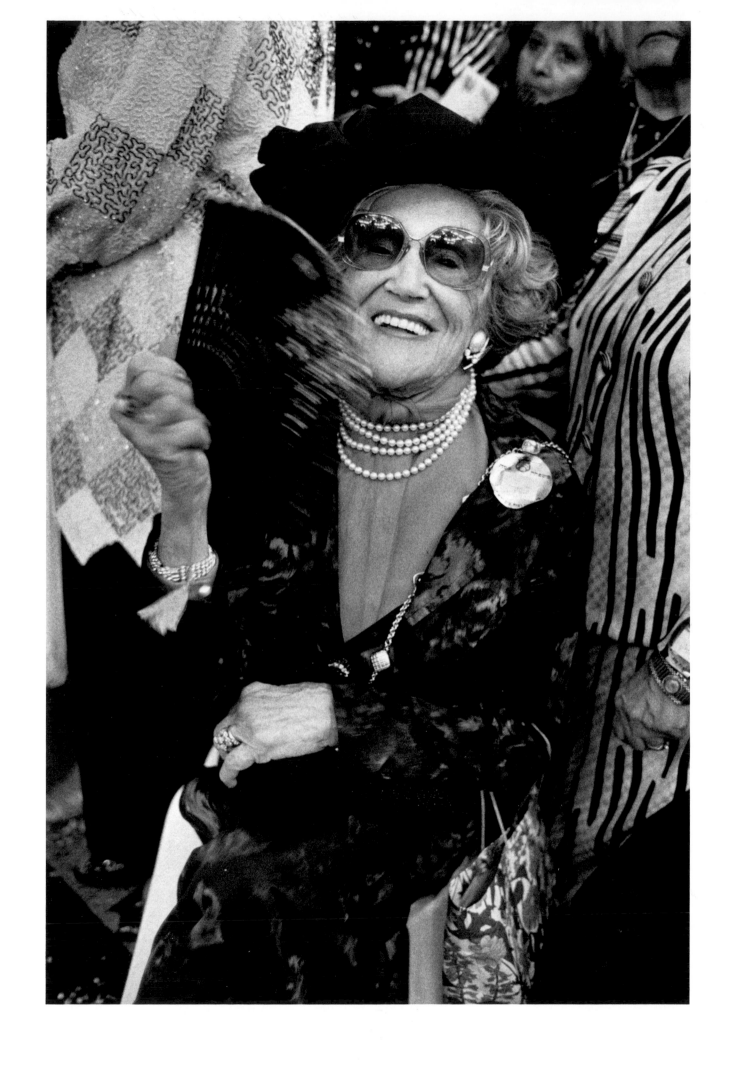

A rebbetzin (wife of a rabbi) in Jerusalem.

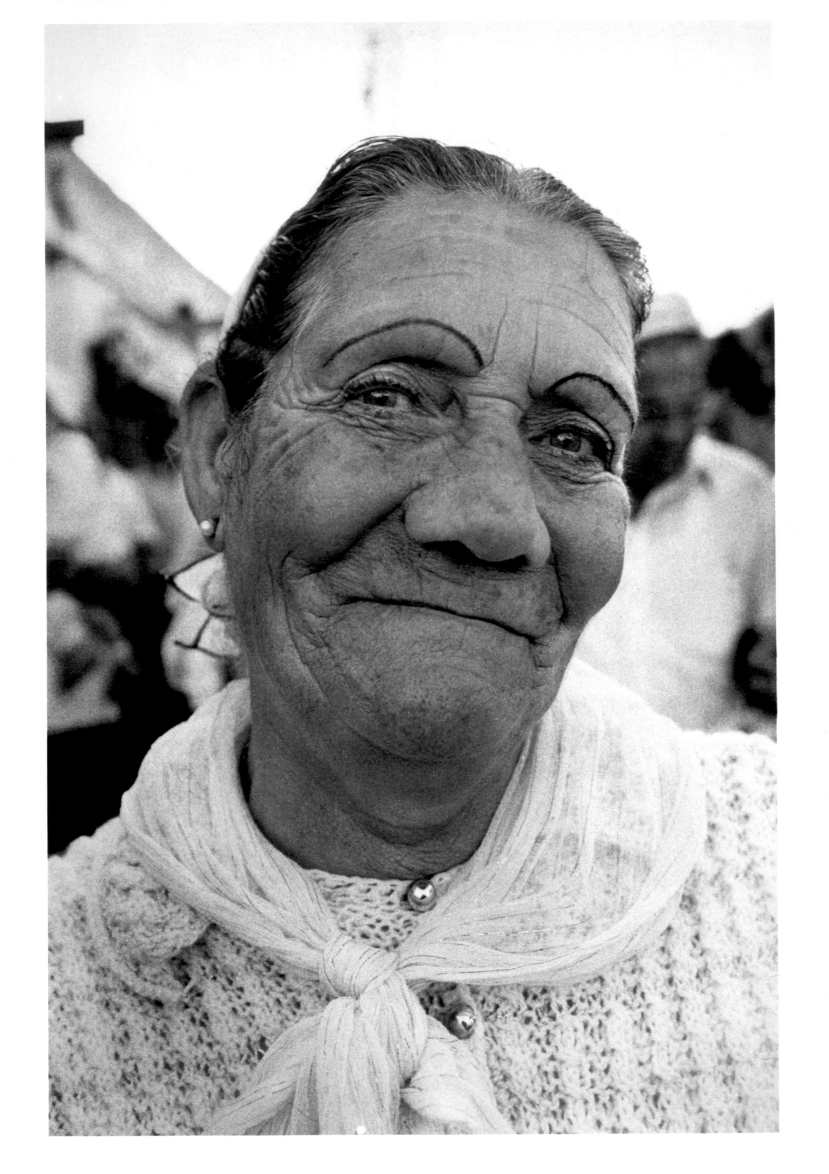

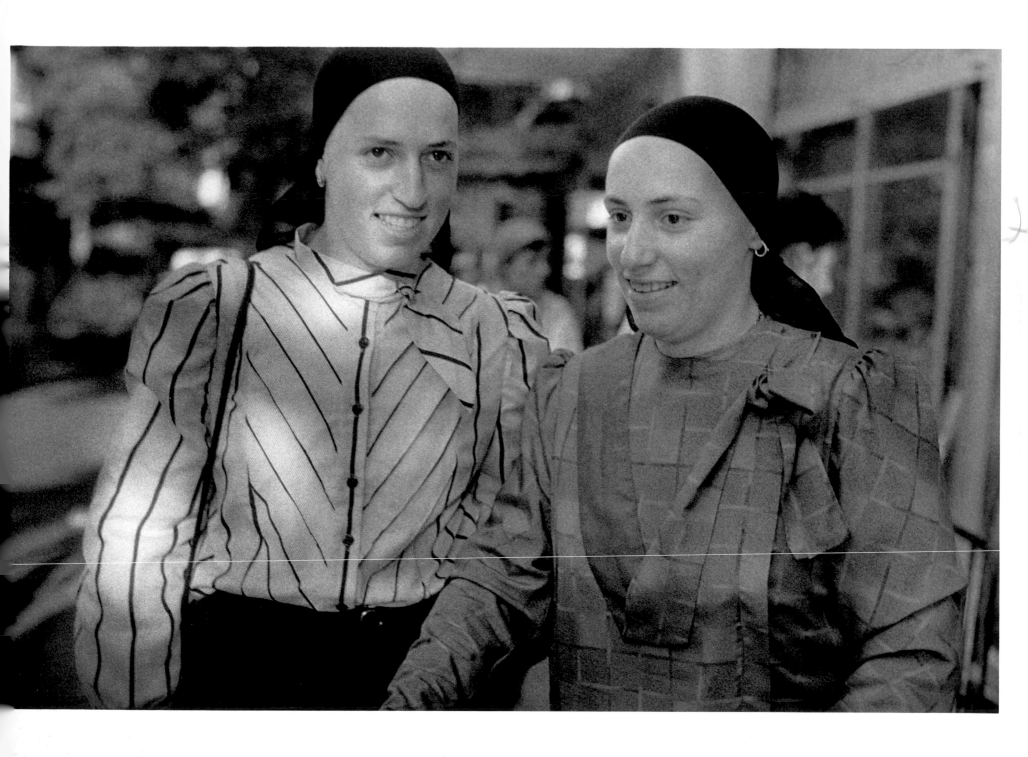

(above) Two women in Meah Shearim, a religious section in Jerusalem.

(facing page) A Moroccan woman in Safed.

(overleaf) Bukharan women cover their heads with scarves, because, they say, "We're not gorgeous anymore."

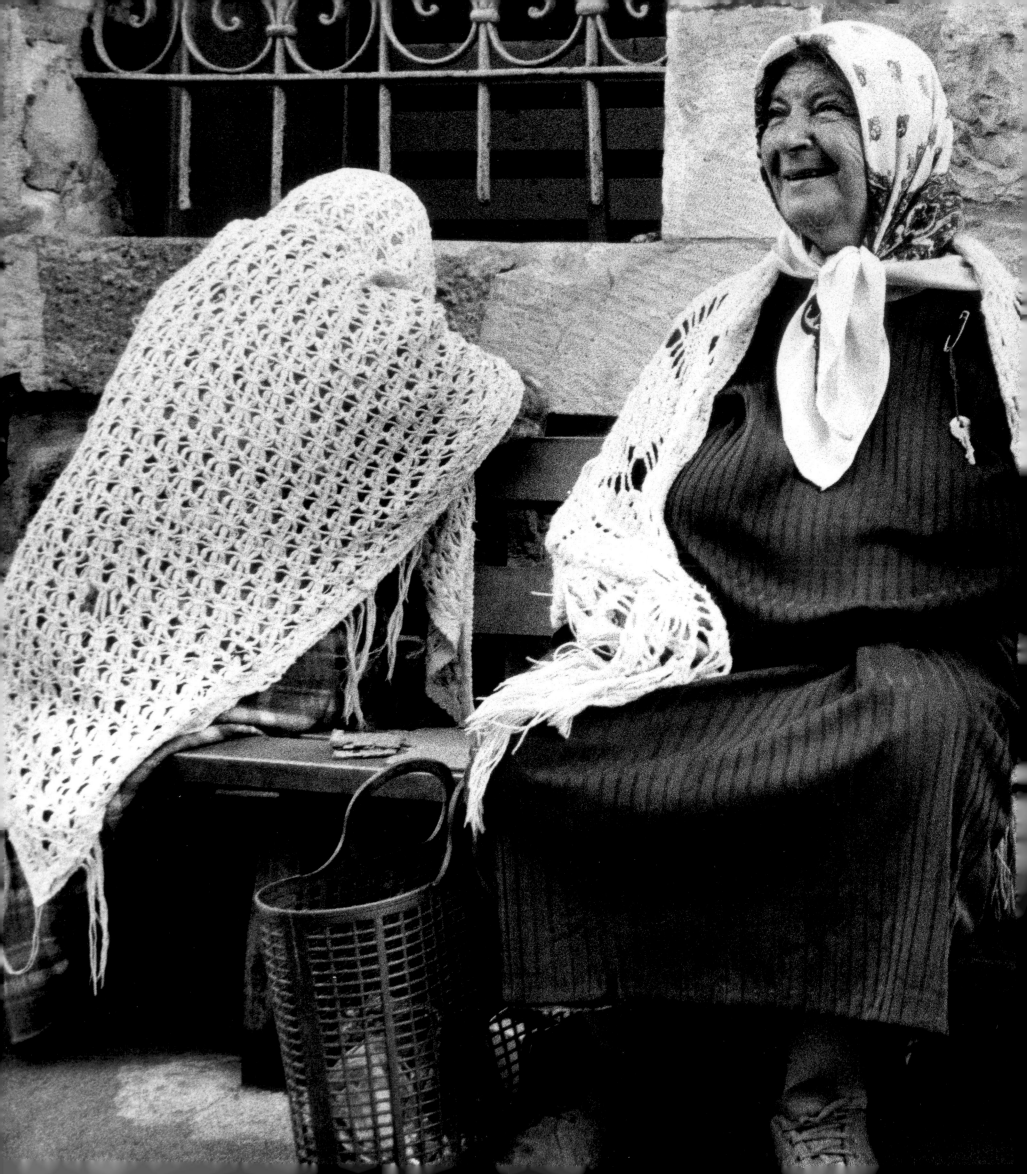

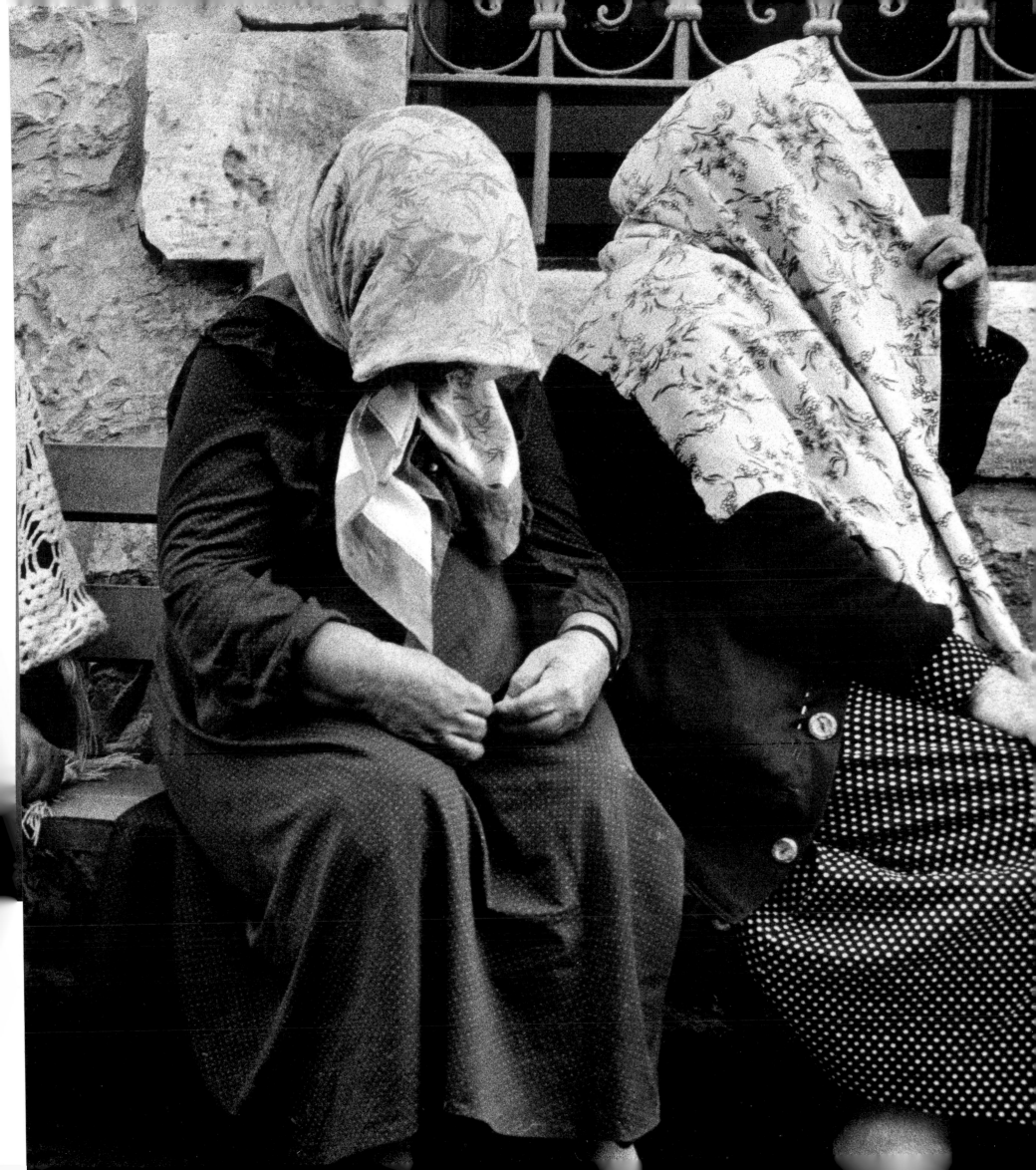

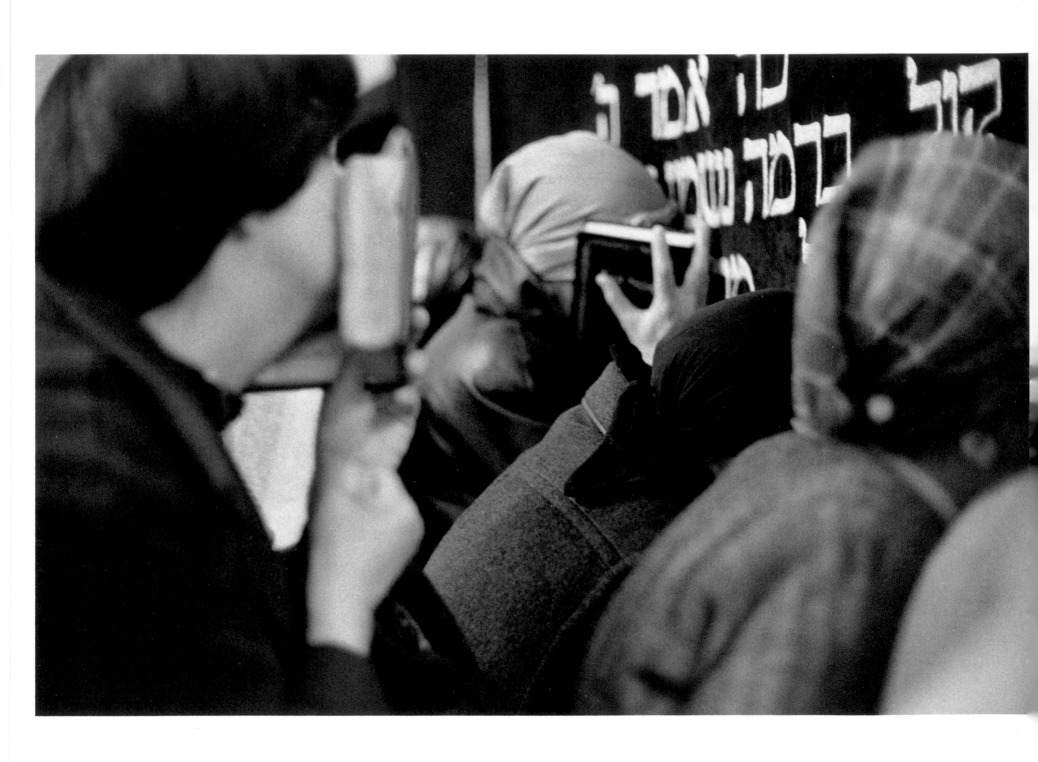

Women seeking to bear children pray at Rachel's tomb.

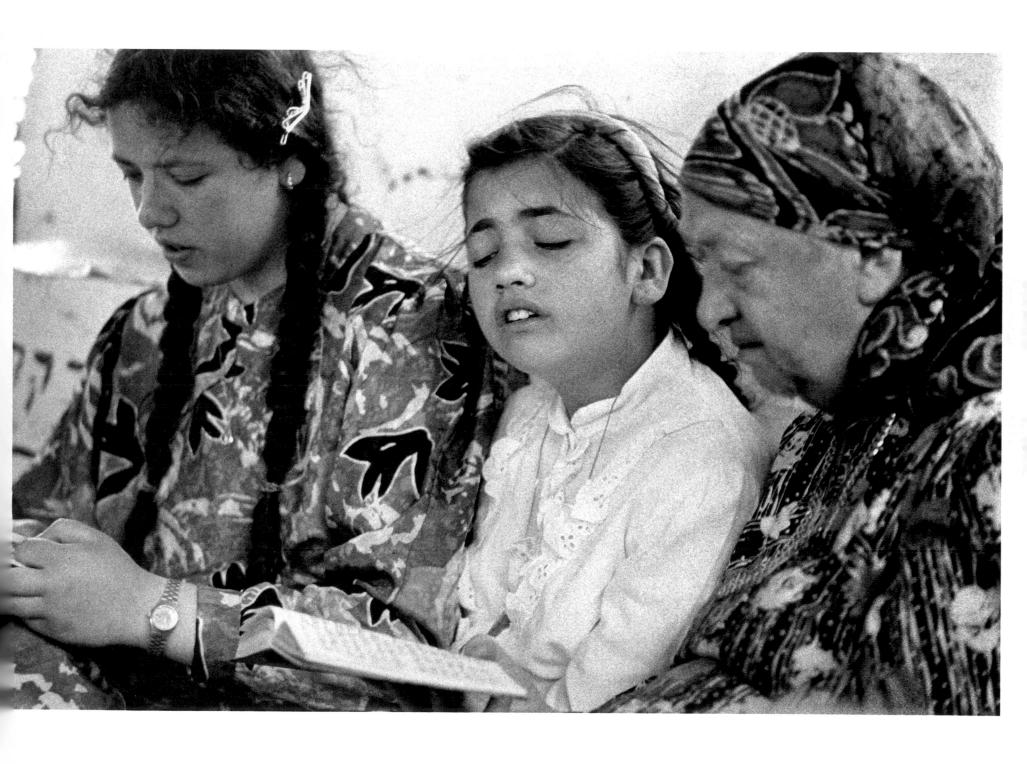

(above) A mother teaches her daughters to pray for a husband at the tomb of the Amuka, the *tzaddik* of matchmaking, in Safed. Women and men travel to his tomb hoping that with his blessing, they will find their soul mate.

(overleaf) Russian brides remarry their spouses in a religious ceremony in Safed.

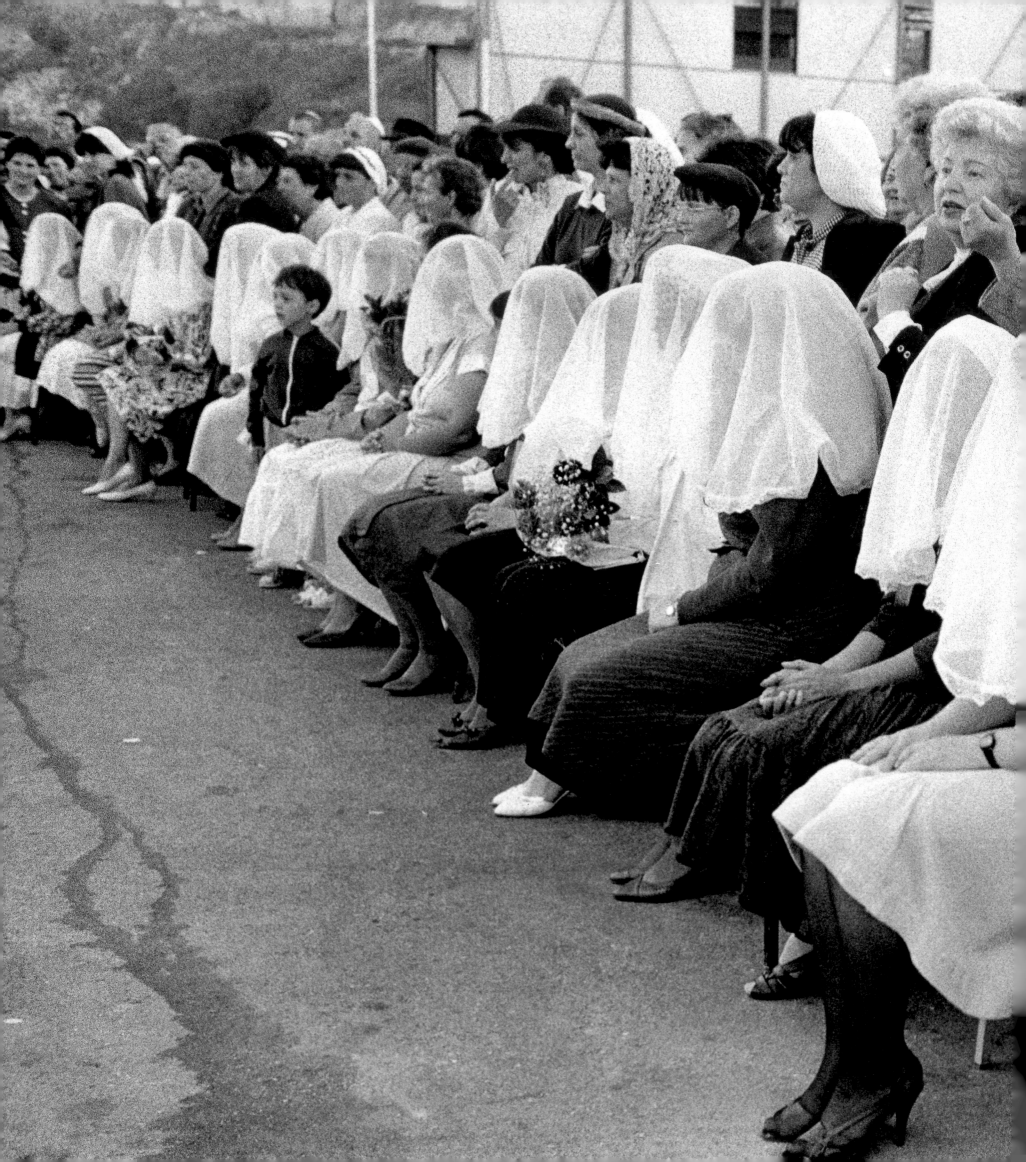

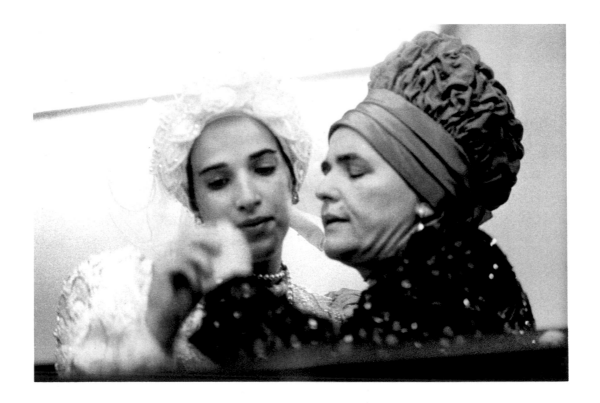

(above) Rebbetzin Sara Rokeach, the matriarch of Belz, dances with the bride, her new daughter-in-law Sara Leah Lemberger. Sara married the Rebbetzin's only son and heir to the Belz dynasty.

(facing page) A Yemenite bride wears the traditional headdress from the city of Sana'a at her *henna* ceremony.

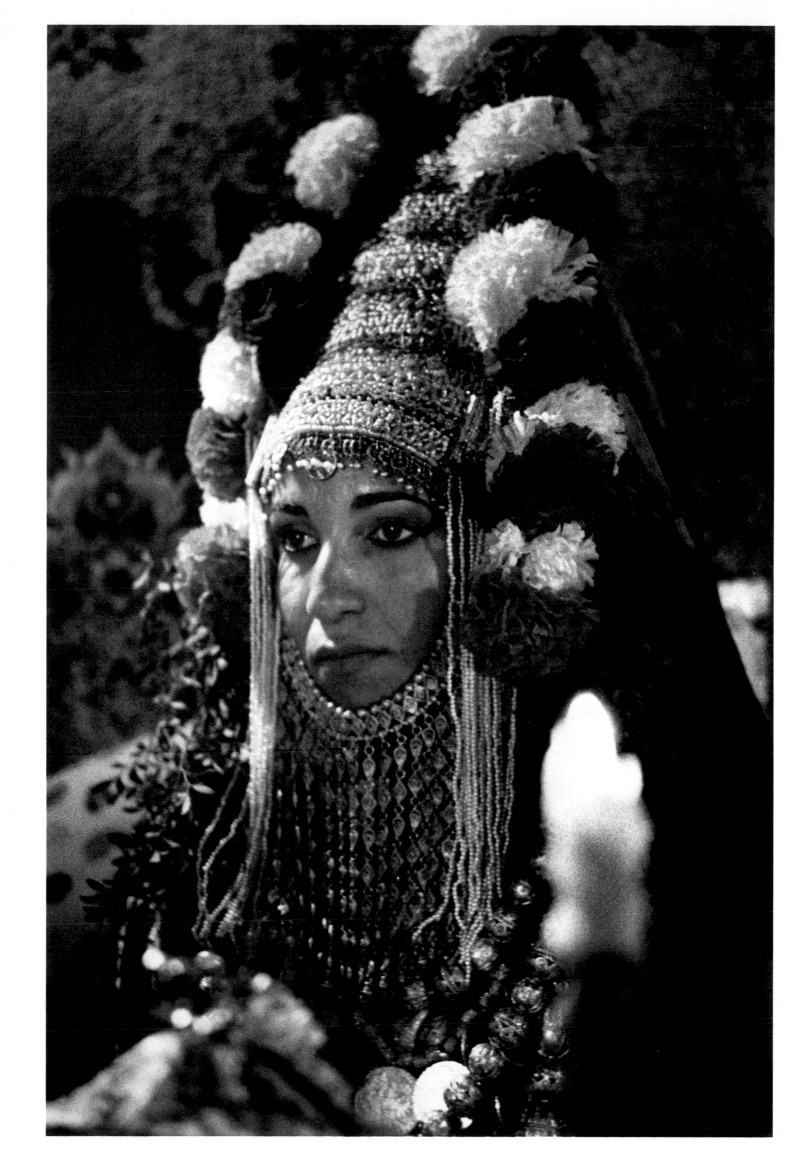

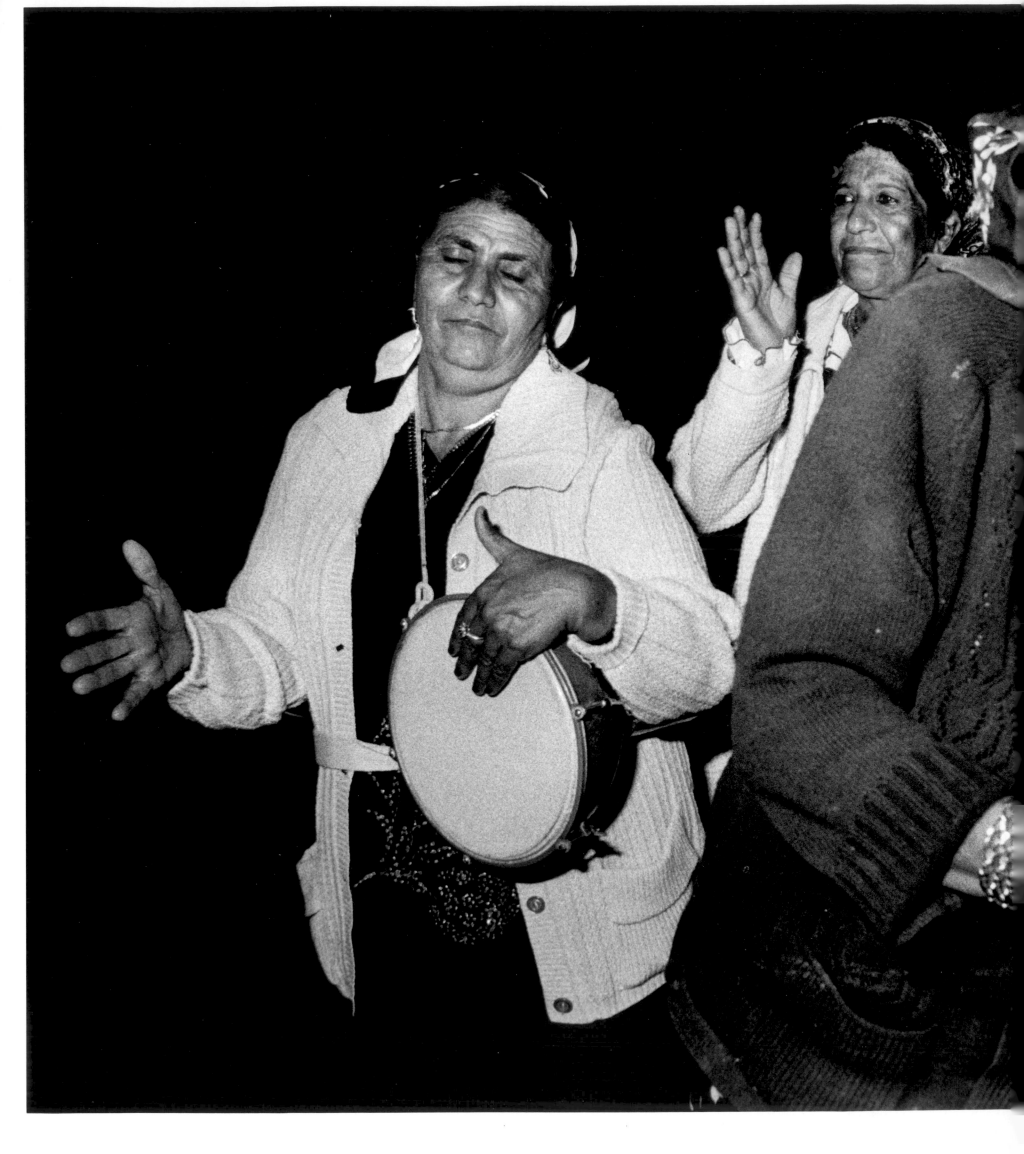

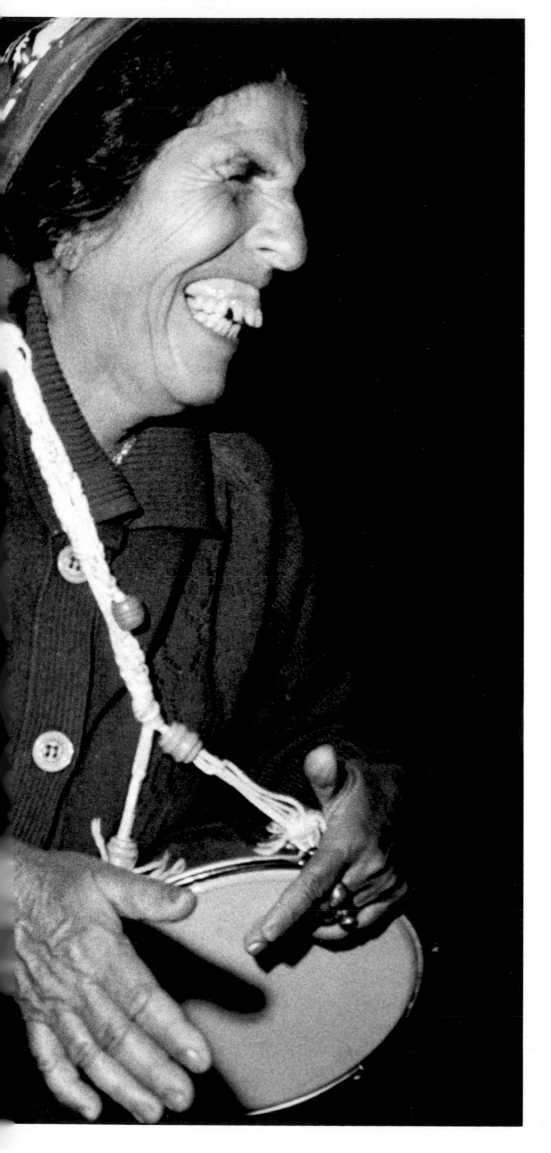

Women dance, sing and play a small round drum at a *henna* ceremony.

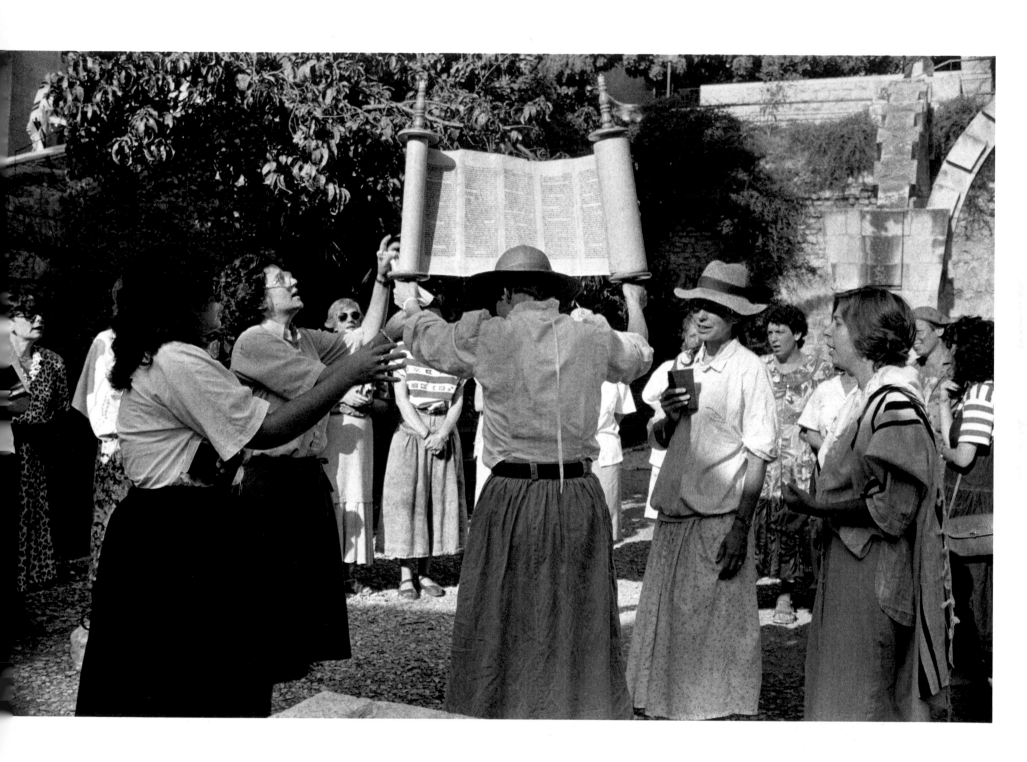

(above) Because Rabbinic authorities do not permit groups of women to pray in unison or lift a Torah scroll in the vicinity of the Western Wall, a group of women known as "Women of the Wall" conduct a *Rosh Chodesh* (new moon, new month) Torah service in Miriam's garden in the Old City.

(facing page) Alice Shalvi is founder and chair of the Israel Women's Network, the country's leading advocate of women's rights.

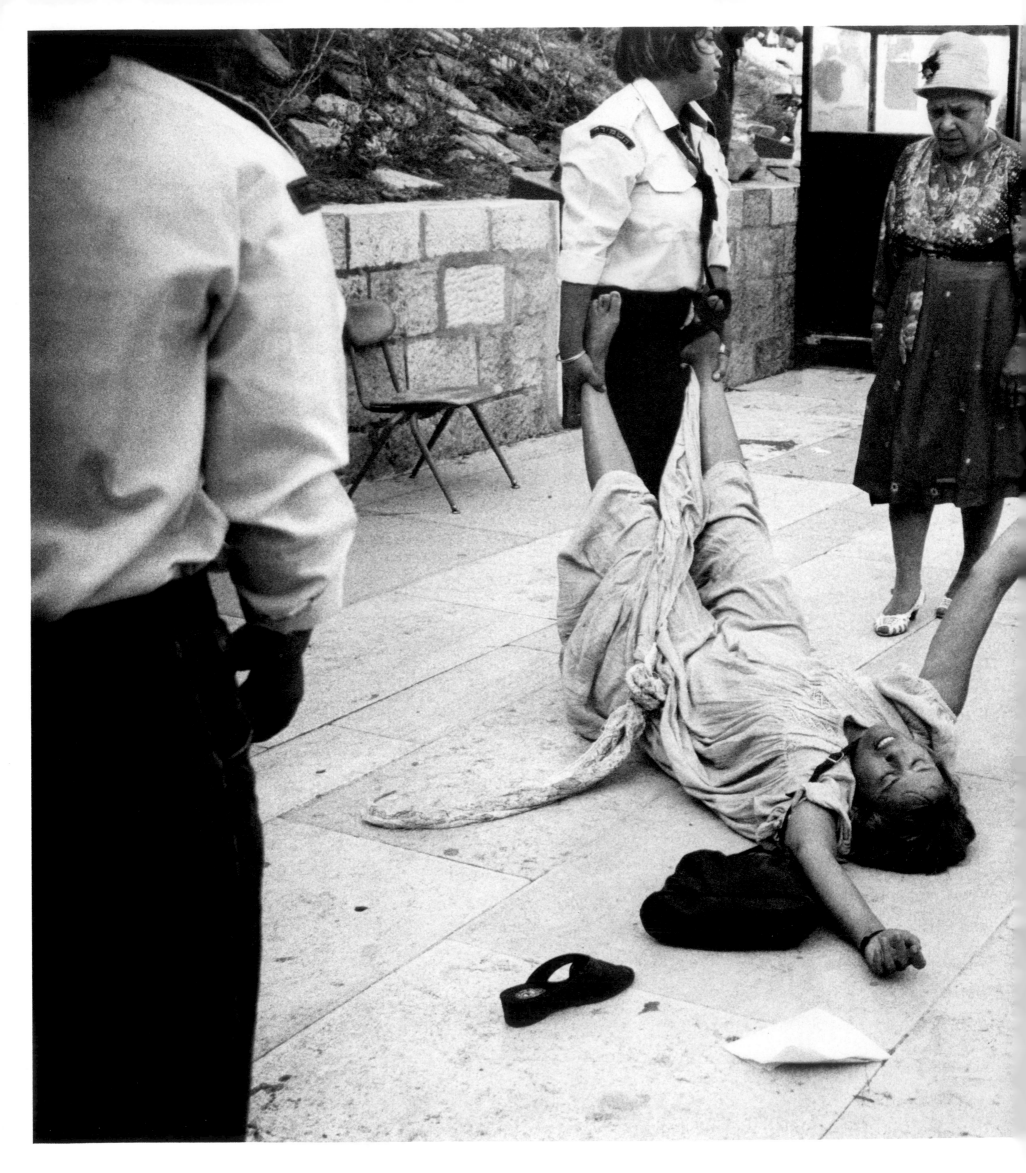

Although women pray individually at the Western Wall, attempts by "Women of the Wall" to pray as a group are met with protests. Female guards remove one of the women who, in an act of passive resistance, is dragged away.

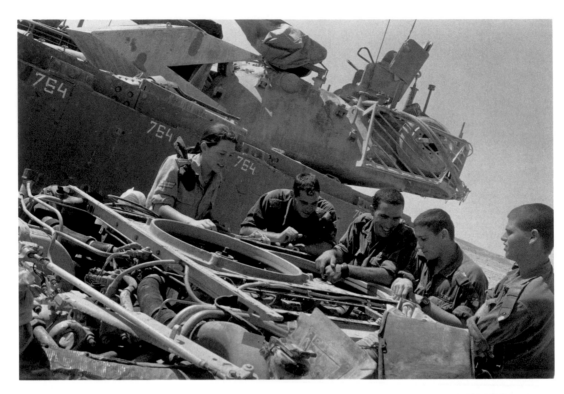

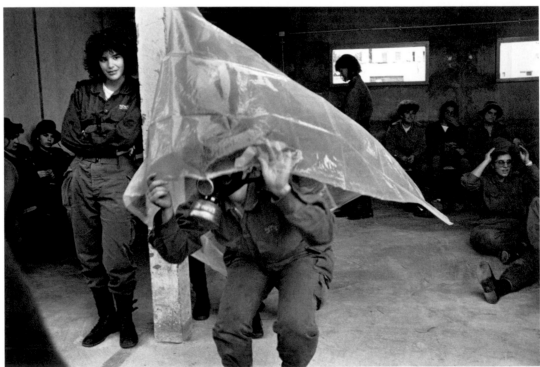

Drafting of women in the armed forces has not necessarily led to equality. A woman might become a tank commander,
but her applied knowledge is as a teacher, not a fighter. In the event of chemical warfare, a female soldier is as well trained as a male,
but her training does not lead to a position of power or high pay outside the army, as it often does with a man.

(top) A tank commander.

(bottom) Preparing for chemical warfare.

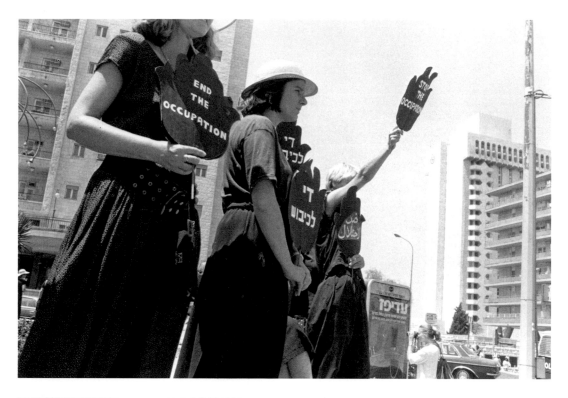

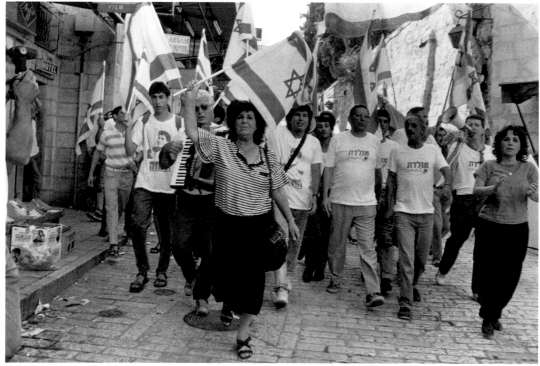

(top) "Women in Black" protest against Israel's occupation of the West Bank and Gaza.

(bottom) Former Knesset member Geula Cohen leads a march through East Jerusalem.

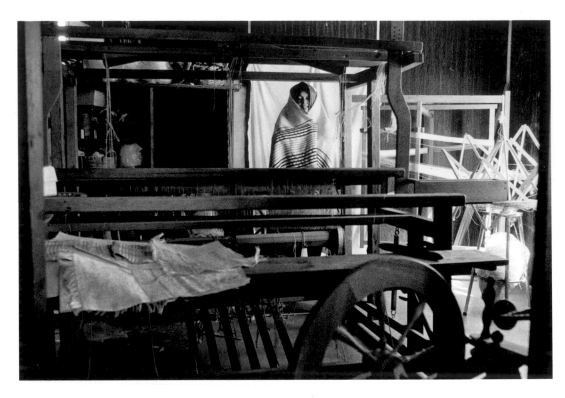

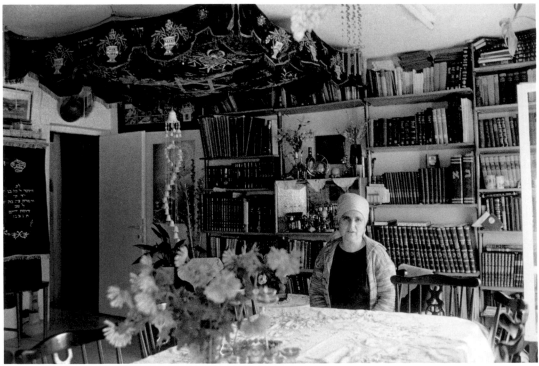

(top) As a member of the Temple Mount Faithful, Jehudit weaves fine cloth *tallit* (prayer shawls) and replicates the vestments of the *Kohanim* for the Third Temple on a loom with 1,480 intricate combinations of pedals.

(bottom) Sarah Nachshon in her living room, which is also a center for prayer. When Sarah buried Abraham, her ninth son, in the old Jewish cemetery in Hebron, she shouted, "Three thousand years ago, Abraham buried Sarah in Hebron, now Sarah will bury Abraham in Hebron."

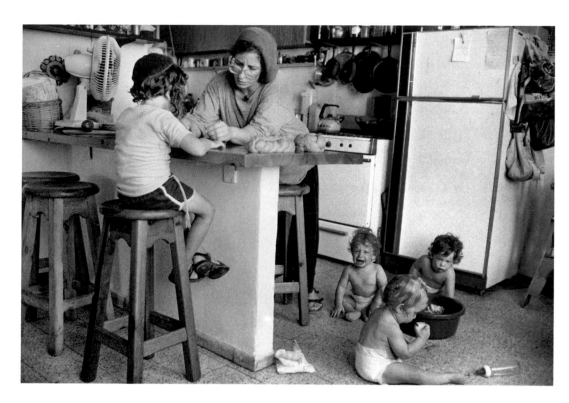

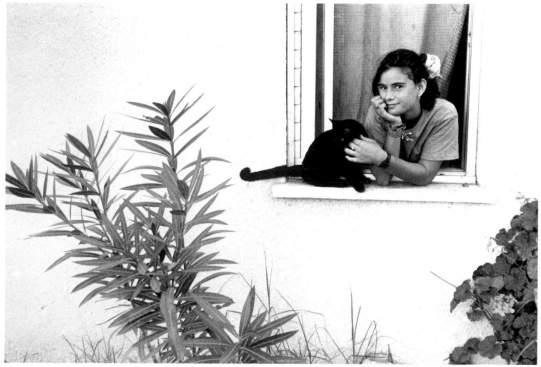

(top) Leah Golomb teaches her oldest son to braid dough for *challah*, while her younger sons, triplets, compete for her attention on Moshav Meor Modi'im.

(bottom) Miriam and her cat on Moshav Meor Modi'im.

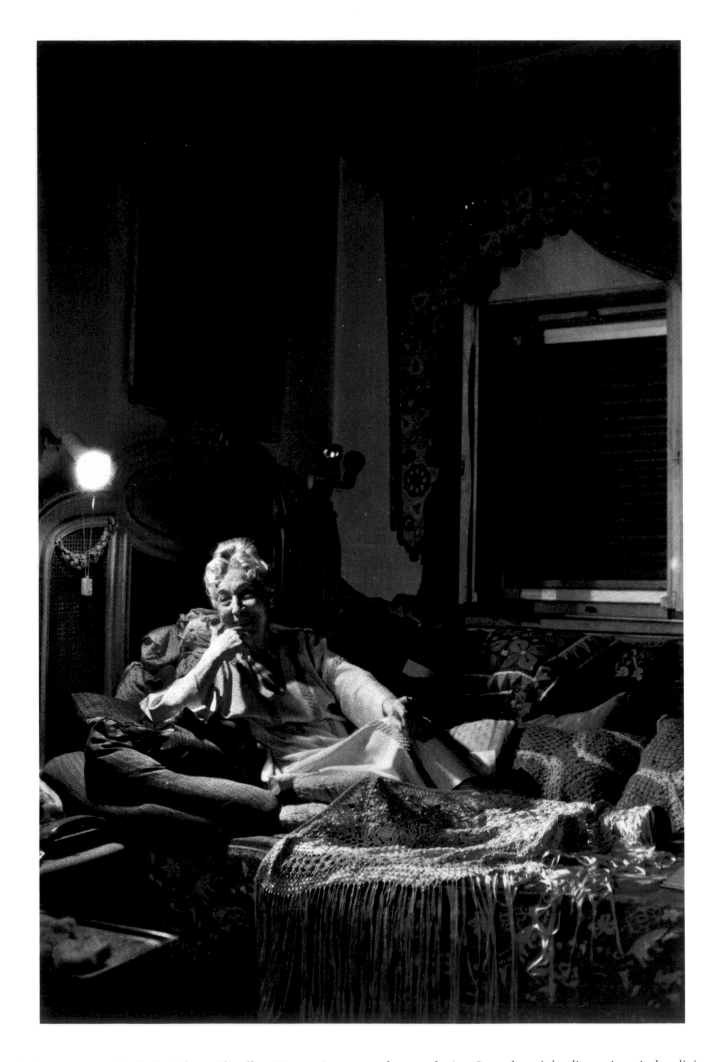

Perched on a queen-size bed, Colette Aboulker Muscat interprets dreams during Saturday night discussions in her living room.

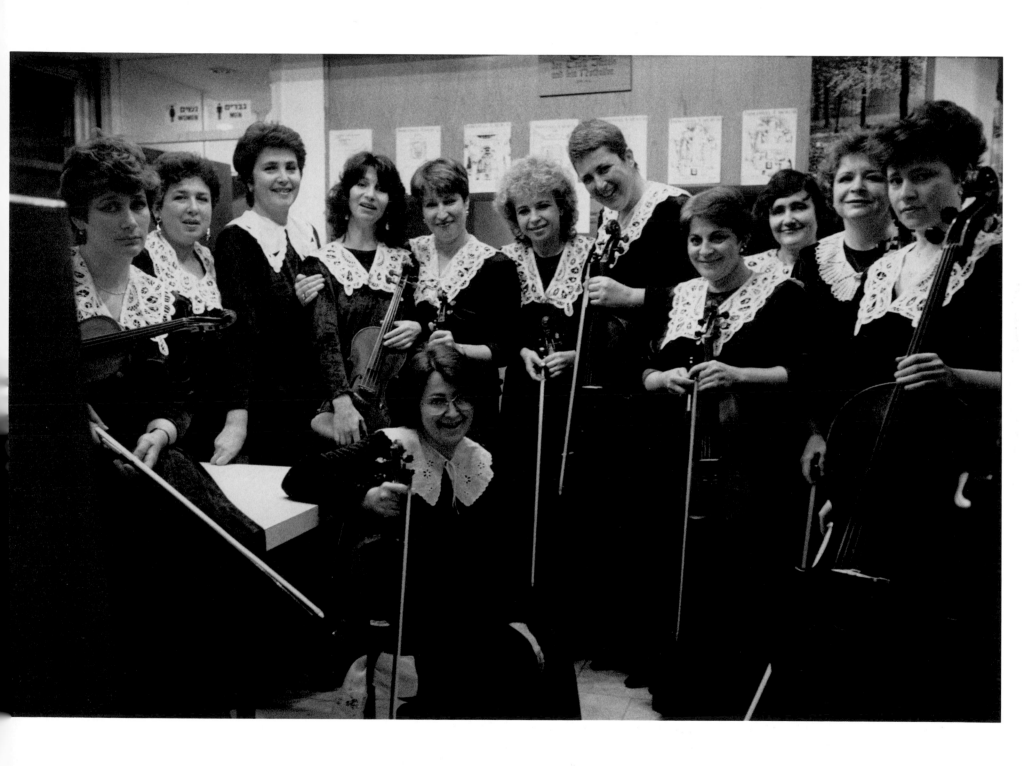

The Camerata Women's String Orchestra before a performance in Tel Aviv.

Yona, a drummer with her own band called Tofa'ah,
plays to audiences of women only.

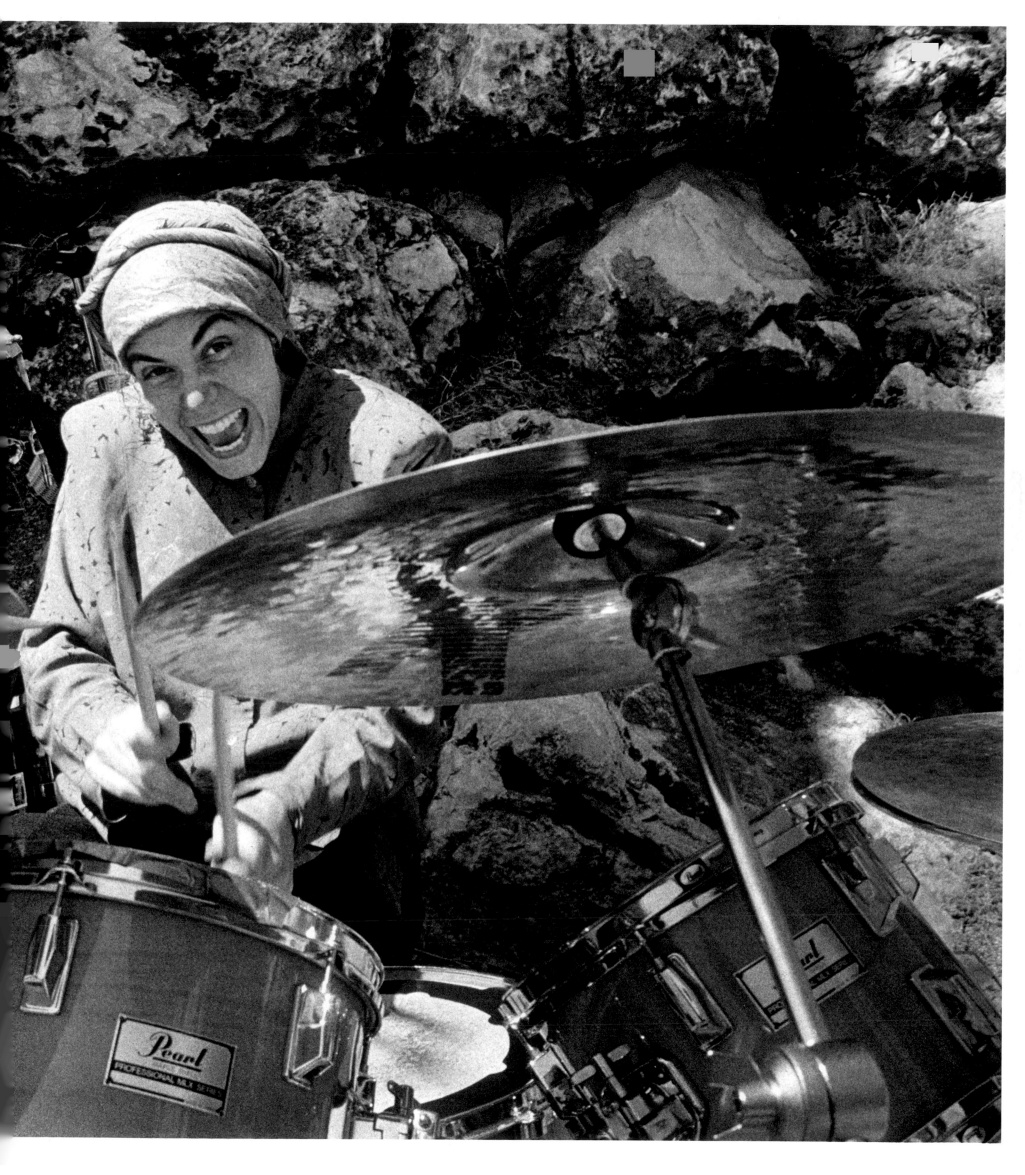

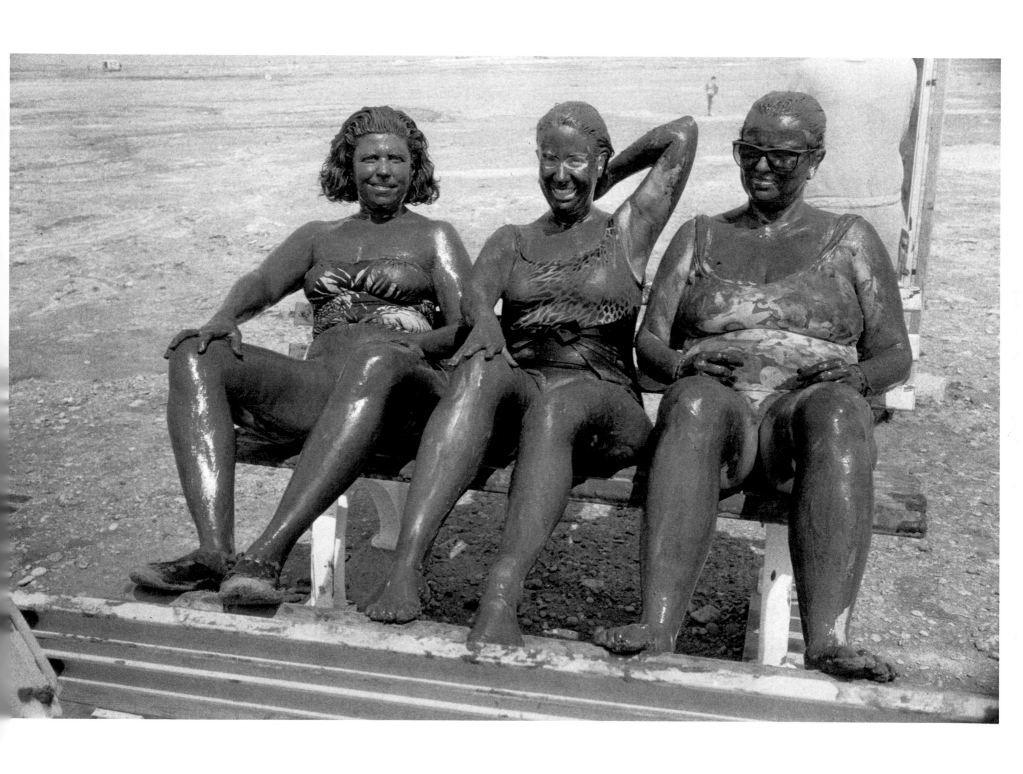

(above) Women rejuvenate themselves with mineral-laden mud on the Dead Sea.

(facing page) "The Women's Beach" in Tel Aviv.

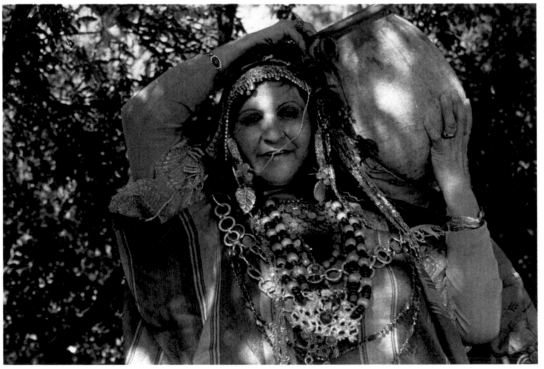

(top, bottom) Hanna Kalfon, from Morocco and Menana, from Tunisia,
wearing traditional dresses from their native lands.

(top) Hanna is a noted makeup artist and costume designer for television and film productions. (bottom) Menana learned to read at age fifty.

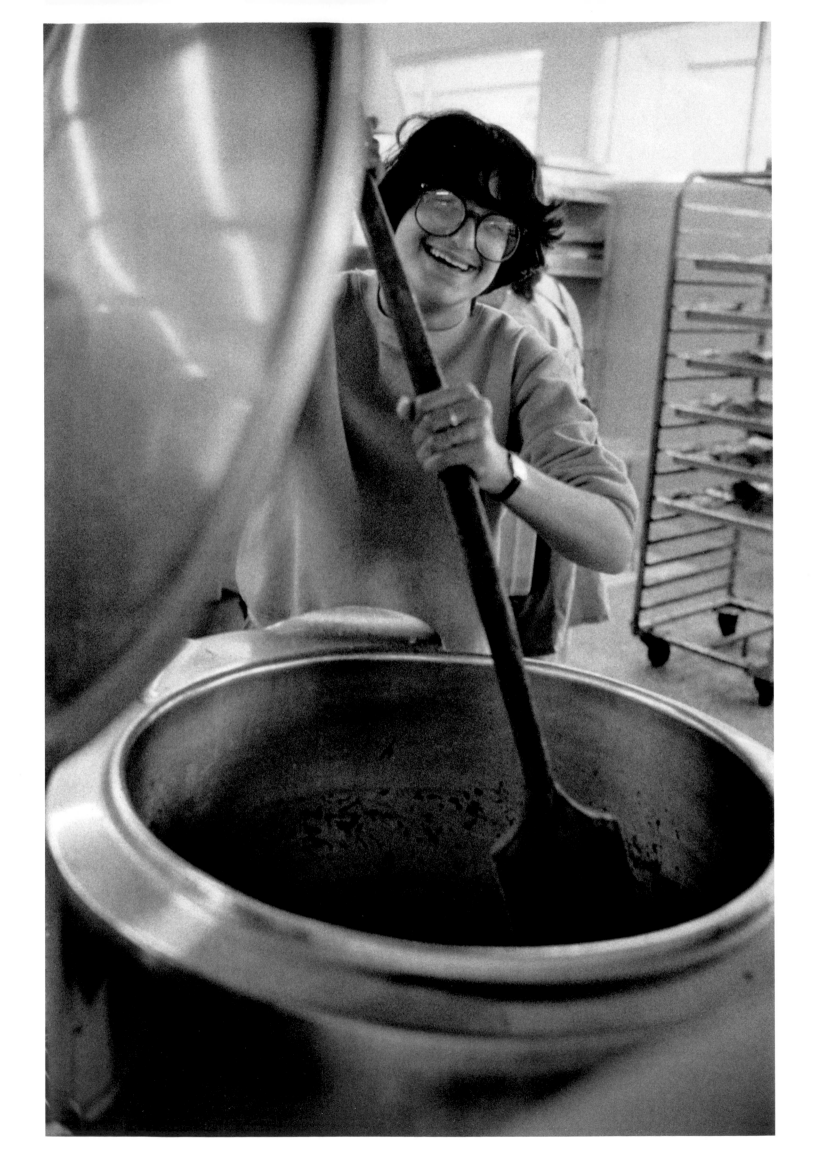

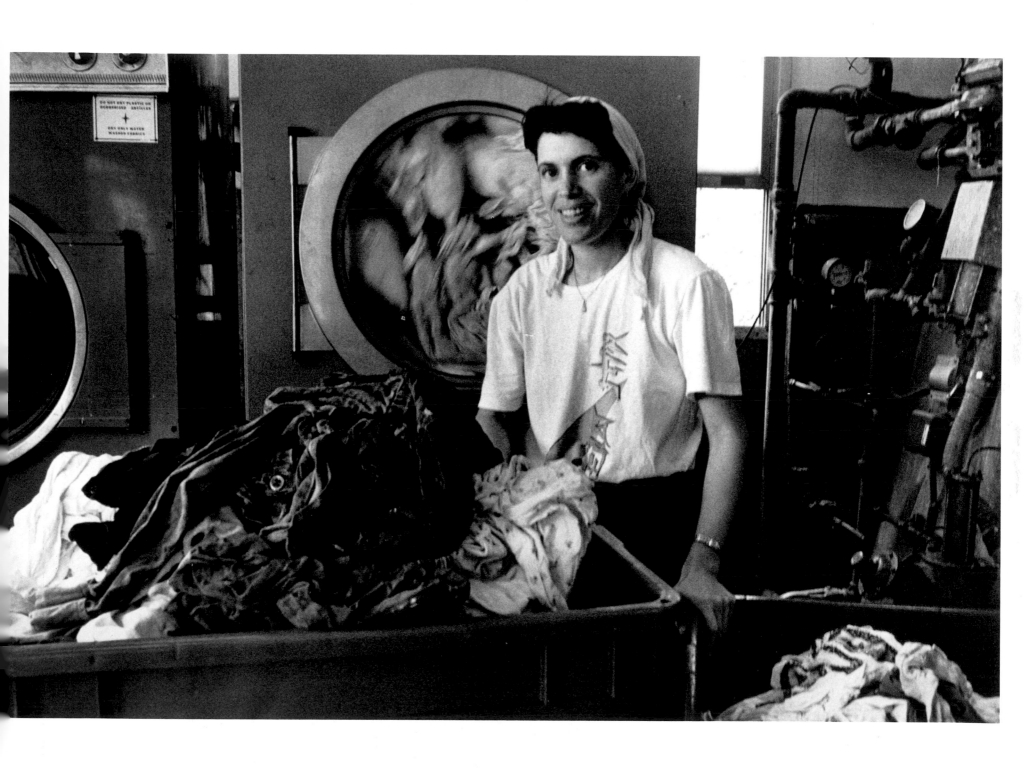

(facing page) It is rare for a *kibbutz* to put women to work outside traditional roles.

(above) This woman has worked two years in the kitchen, three years in the children's house and one year in the laundry.

Jewish and Arab women work together as part of a
grass roots movement toward peace.

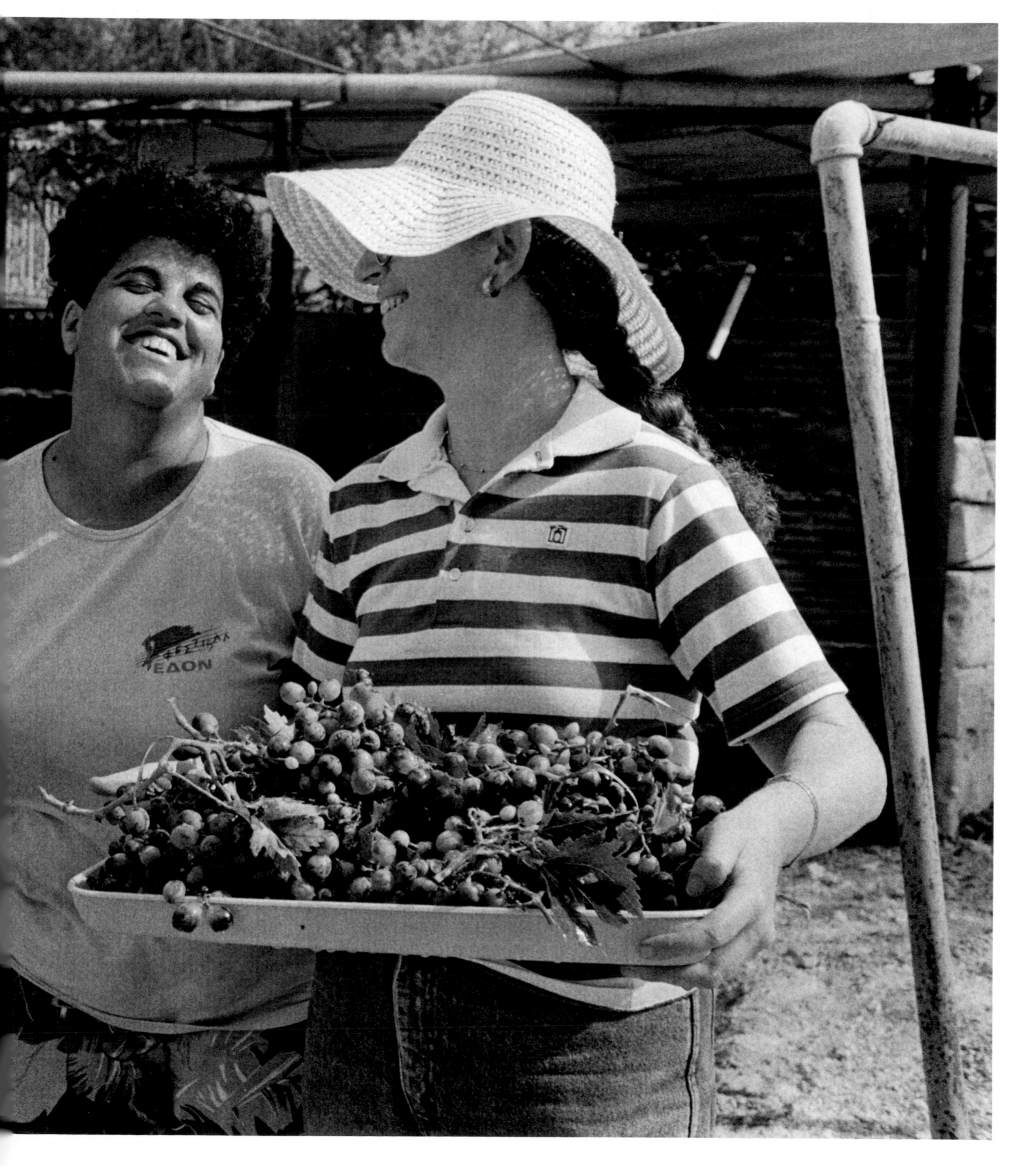

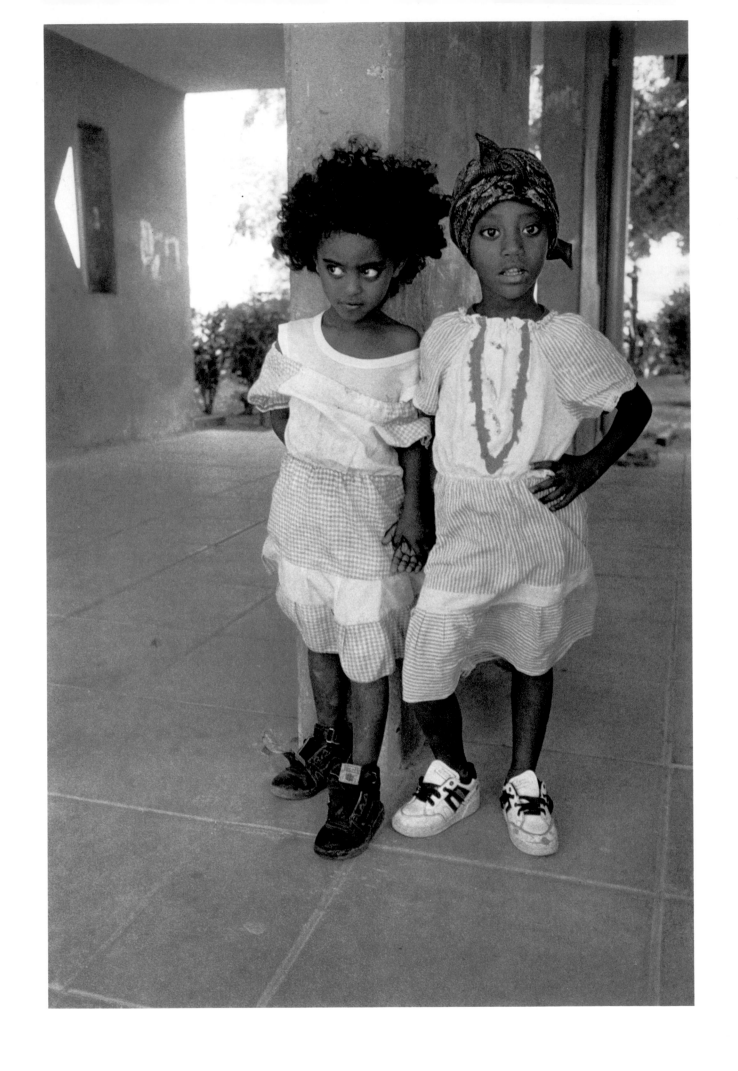

Two Ethiopian girls in a *Merkaz Klita* (absorption center for new arrivals).

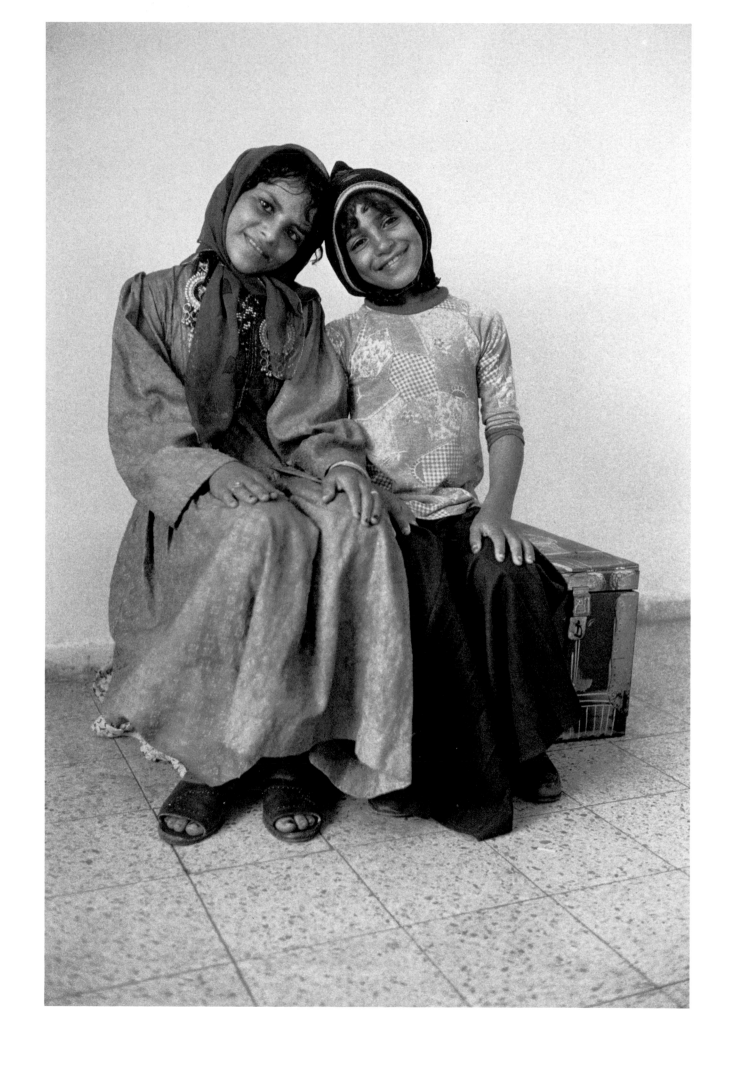

Two Yemenite girls, one married (left), in a *Merkaz Klita*.

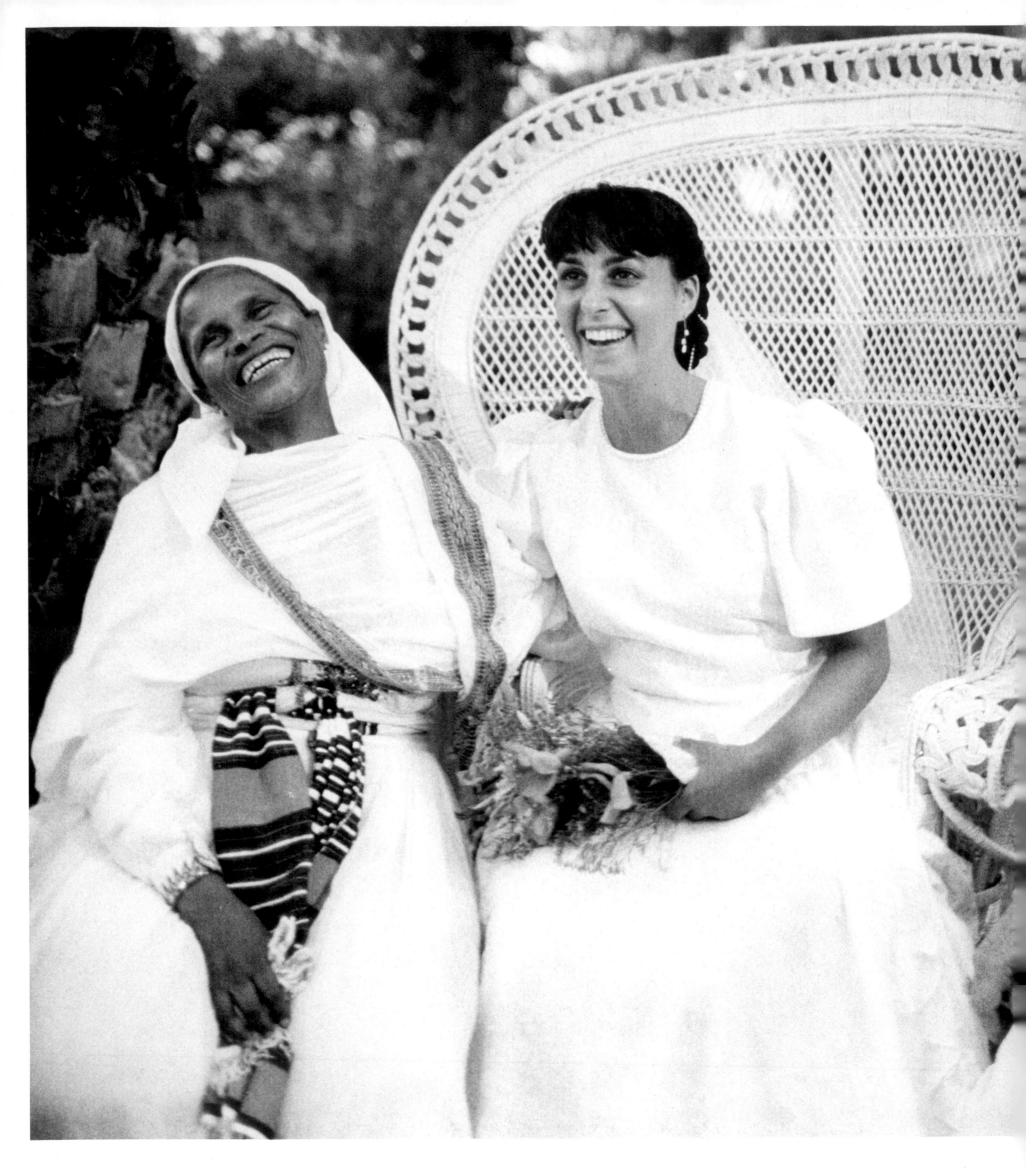

An Ashkenazic bride, accompanied by her mother (right) and future mother-in-law (left), awaits the arrival of her Ethiopian groom at the *bedeken* (face-covering) ceremony.

Natasha, a Russian emigré, waves an Israeli flag on the balcony of her new home.